THE PHOTOGRAPHER'S MASTER GUIDE TO
COLOR

THE PHOTOGRAPHER'S MASTER GUIDE TO
COLOR

JEFF WIGNALL

ilex

First published in the UK in 2014 by:
ILEX
210 High Street
Lewes, East Sussex BN7 2NS
www.ilex-press.com

Publisher: Alastair Campbell
Associate Publisher: Adam Juniper
Managing Editors: Natalia Price-Cabrera & Nick Jones
Specialist Editor: Frank Gallaugher
Editorial Assistant: Rachel Silverlight
Creative Director: James Hollywell
Art Director: Julie Weir
Design: Kate Haynes
Colour Origination: Ivy Press Reprographics

British Library Cataloguing-in-Publication Data
A catalogue record for this book is available
from the British Library.

ISBN: 978-1-78157-982-4

All images © Jeff Wignall unless otherwise indicated.
p2 © Derek Doeffinger, p8 © Mitch Johanson,
p90 © Steven Hyatt, p142 © Rob Greebon

Printed and bound in China

10 9 8 7 6 5 4 3 2 1

Contents

Chapter IV

Technical Considerations

Chapter V

Creative Color

Chapter VI

Color After Dark

Chapter VII

Color-editing Tools & Output

Introduction

AS FAR BACK AS I CAN REMEMBER I HAVE BEEN FASCINATED BY COLOR. AS A KID, MY FAVORITE GIFT ON BIRTHDAYS AND CHRISTMAS WAS ALWAYS A BIG BOX OF CRAYOLA CRAYONS AND THE OLDER I GOT, THE BIGGER THE BOXES BECAME AND THE MORE HUES THEY INCLUDED.

Still, even as the wax spectrum grew larger, I think that I secretly lusted for one magic box that contained all of the known colors in the universe. How could a mere 64 or 128 colors ever hope to contain or transcribe the range of colors that overloaded my very rich imagination? (Little did I know that colors have a more or less infinite range.)

To complicate matters, when I was about eight years old my father (a photographic scientist by profession) handed me a prism and briefly explained the source of color to me and (as Sir Isaac Newton had demonstrated almost three hundred years earlier) that all colors were contained in daylight. My curiosity and my color lust grew (and by the way, half a century later I still own that prism). In fact, I suspect that my decision to become a photographer had far more to do with my obsession for understanding and capturing color than it did with any journalistic or commercial ambitions.

The advent of digital photography well into my shooting career only fueled my passion for color. From the first time that I sat in front of a computer and began exploring Photoshop, I realized that I could now tinker with the very essence of color: hue, brightness, and saturation (topics that we'll examine in detail throughout this book). And when I learned that a computer monitor could display millions of colors, my life's ambition to possess all colors was realized. I'd found the ultimate crayon box.

While we may at times take the ability to see and record for granted, it actually cuts a far deeper subliminal river into our consciousness, our emotions and our very souls than we might imagine. As you will see in the opening chapter of this book, for example, color has a profound ability to tint our mood and our emotional state: we feel blue, we see red, we're green with envy, and we are tickled pink. Indeed, Pablo Picasso once wrote: "Colors, like features, follow the changes of the emotions."

As photographers, we demand tools and techniques that help us to achieve our creative goals. But better tools and more expansive techniques are not enough. In order to record color faithfully (no matter how far we stray from its truth artistically), we must first be able to see it for what it is. We must become aware of how nature continually reinvents the spectrum—through changes in lighting, seasons, and even the weather. And we must be aware of the effects that technical considerations like exposure and contrast have on color. We must also understand the relationships between colors: Why do some colors seem to complete one another while others are locked in fierce visual combat? How does the artist's color wheel relate to photographic technique?

Because photography is largely a technical pursuit, in order to exploit color effectively it's also important that we understand its scientific origins, its technical terminology, and we must recognize the limitations of technology—and how we can use specific techniques (high dynamic range imaging, for example) to burst through those boundaries.

In short, in order to make the most of color we must immerse ourselves in its world. In this volume I hope to share my passion for color, as well as to shed some light on how you can better utilize it in your photography. It's my hope that this book will help you to see the world as your own personal giant crayon box and use those marvelous sticks of creative pigment to interpret the world in your own way.

Jeff Wignall
Stratford, Connecticut

Chapter 1:

Color Basics

We live in an amazing era when the answers to almost any questions that we have about the world around us are just a few clicks of a keyboard away. How deep is the ocean? Do fish sleep? Why do birds migrate? Do stars move? While much about the world and its workings is still wrapped in mystery (and how much more interesting life is because of that?), we have access to a deep well of information that is available almost instantaneously at our fingertips.

Imagine then, living at a time when something as basic to life on Earth as the nature light and color was still a ponderous mystery. For many centuries, the true origins of color and why specific objects had specific colors was a topic hotly argued over by philosophers, theologians, scientists, and even poets. Plato and Pythagoras, among others, believed in the theory of an "active eye" in which light and color emanated from the eyes. Epicurus, on the other hand, believed that light was produced by objects and received by the eye.

As we'll see in the coming pages, it wasn't until Sir Isaac Newton held a prism up to a ray of light and saw the spectrum of the sun unfold in a darkened room that the true source of color was revealed. Of course, science had its skeptics. The great

thinker Goethe (who in 1810 published his 1,400-page treatise Theory of Colours—which is still in print) thought that Newton's discovery was at worse nothing more than a parlor trick—an illusion almost literally of smoke and mirrors—and at best a fluke that could not be recreated.

But Newton's discoveries were far from a lucky accident: he had discovered the true nature of both light and color. And when Newton took his discovery yet further and twisted that spectrum of light into a circle of color, artists (and soon photographers) had the keys to a very deep and accurate understanding of the relationships of color.

As word of Newton's discoveries spread, scientists and artists set to work quickly to delve deeper into this new knowledge. An entire language developed to help describe, define and model specific colors—and it's a language that is still evolving today.

Color vision took another quantum leap when, in 1801 the brilliant Thomas Young (in one of more than 90 lectures he delivered that year) proposed a very accurate theory of human color vision. Less than 60 years later another English scientist, James Clerk Maxwell, combined Young's discoveries with photographic theory in a way that would change photography forever.

Evolution of a Color Theory

PERHAPS THE FIRST TIME THAT THE CONCEPT OF A COLOR THEORY BEGAN TO TAKE SHAPE WAS IN THE MIND OF A CAVE ARTIST WHO, ACCIDENTALLY OR INTENTIONALLY, MIXED RED BERRIES AND GREEN BERRIES AND DISCOVERED THAT HE HAD CREATED THE PERFECT GRAY-BROWN COLOR HE NEEDED FOR THE HIDE OF AN ANTELOPE.

Suddenly a new realm of color thought was born: it was possible to mix several color sources together to create entirely new colors. Such an idea must have been mind-boggling and these primitive artists no doubt found themselves peering over one another's shoulders with fascination as they explored the magic of creating entirely new colors.

Since those first—and no doubt accidental—experiments, humans have wrestled with the notion of the exact origins of color and the realm of artistic possibilities that those colors offer. For thousands of years everyone from philosophers to scientists to artists have been looking for (and continue to seek) a theory of color that provides an explanation for the existence of colors, a set of rules for how various colors are mixed (in both pigment and light) and an orchestrated method for replicating them in various media. And since you are reading this, you are now a part of this quest.

Serious artistic use of color no doubt bean with during the Predynastic period of ancient Egypt (5000–3000 BC) when artisans ground up minerals to decorate pottery, tombs and religious figurines. And there are many references to the Babylonians making use of complex color mixing more than 1900 years ago. But the beginnings a written color theory came from the ancient Greeks. The Greek philosopher Democritus (c460–370 BC), a pre-Socratic thinker who had theories on everything from atoms to ethics to the human soul (no television or Internet in those days to distract one from deep thought), theorized that all colors were obtained through various mixes of red, green, black and white. (Interestingly, the Greeks were able to differentiate more than 800 distinct mixes from these four essential colors.) Like many early color explorers,

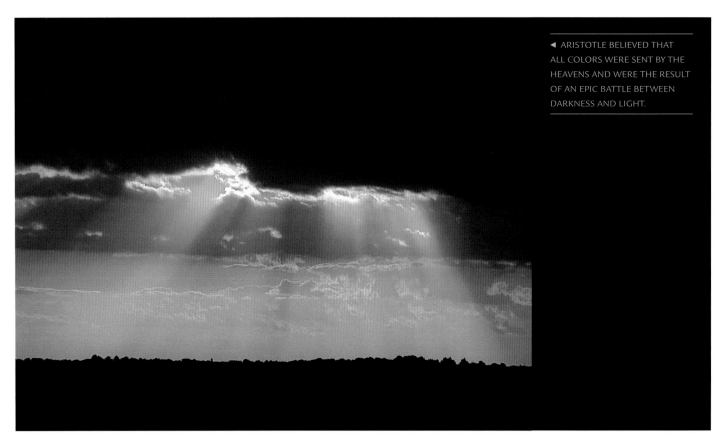

◀ ARISTOTLE BELIEVED THAT ALL COLORS WERE SENT BY THE HEAVENS AND WERE THE RESULT OF AN EPIC BATTLE BETWEEN DARKNESS AND LIGHT.

however, Democritus believed that color was a property of the object itself and if the color of an object changed, it had to be the result of a change in the object.

But it was Aristotle whose thoughts on color made the most lasting impression and he wrote the first known book about color ("De Coloribus"). Aristotle believed that the two main colors were white and black—or simply, light and its absence. Colors, he theorized, were celestial gifts and the result of an endless battle between darkness and light (a concept that just drips with philosophical underpinnings). Further, he believed that the two primary colors other than black and white were yellow (the color of the sun's light) and blue (the color of space). And all colors, he believed, were related to the four physical elements of the world around him: air, water, earth and fire.

Aristotle developed the first linear system of colors that transitioned from white to black and took the following progression: white, yellow, red, purple, green, blue and black. The concept of such a color line came from the fact that Aristotle was an astute observer of the changes in the world around him. Throughout the day Aristotle watched as the blackness of night morphed into yellow light of day, the gold morning light turned into the white light of midday and the afternoon surrendered to the blue and violet of twilight—and then all returned to blackness. Who could argue with his conclusions based on such and observant and rational viewpoint?

But Aristotle like Democritus and other Greek thinkers also shared the concept that color was a property of the object being viewed—and not a creation of light or its interpretation by the human eye. Empedocles actually took the concept a bit further and believed that vision (and therefore color) was the result of beams of particles being shot out through pores in our eyes and mingling with similar particles emanating from the objects themselves. (Though he didn't know it, of course, Empedocles was much closer than he might have guessed to the modern theory of light being a form of radiant energy.)

From about 350 BC to 1500 AD, virtually all scientists, artists and philosophers used Aristotle's theory as the gold standard. It may seem far fetched to consider such theories now perhaps, but how less far fetched would it have been to convince these great thinkers that all light and color on Earth were coming from the sun some 93,000,000 miles away—a theory that would be proven in the early 17th century by one of the world's greatest scientists: Sir Isaac Newton.

| BLANCO | GALLO | ROSSO | VIOLETTO | VERDE | BLU | NERO |

Evolution of a Color Theory, continued

In 1666 Sir Isaac Newton would change the theories of light and color forever with what seems now like a tremendously simple experiment. Newton, who had been experimenting for some time with optics and light, darkened room and allowed light to enter only through a small hole and he placed a small glass prism in the path of that light.

In a letter to the Royal Society Newton describes the experiment: "...In the beginning of the Year 1666 (at which time I applyed my self to the grinding of Optick glasses of other figures than Spherical,) I procured me a Triangular glass-Prisme, to try therewith the celebrated Phænomena of Colours. And in order thereto having darkened my chamber, and made a small hole in my window-shuts, to let in a convenient quantity of the Suns light, I placed my Prisme at his entrance, that it might be thereby refracted to the opposite wall. It was at first a very pleasing divertisement, to view the vivid and intense colours produced thereby."

What he witnessed on the opposite wall was the white light broken down into a band of pure hues that he termed a "color spectrum" (a term he derived from a Latin word meaning "apparition"). He labeled the colors as: red, orange, yellow, green, blue, indigo, and violet. What he had discovered, of course, was what we know is the visible portion of the electromagnetic spectrum. While he noted that the light of the spectrum was continuous and each color gradually merged into the next, he chose to label them as seven distinct colors largely because the number had a mystical significance to the ancient Greeks. (Though Newton included seven hues, most modern descriptions of the spectrum omit indigo and include only the other six hues).

To prove that the light was not being colored by the glass prism, Newton used a second prism set in the path of the spectrum to recombine the separated colors of light back into their original form. Newton wrote: "I have often with Admiration beheld, that all the Colours of the Prisme being made to converge, and thereby to be again mixed as they were in the light before it was Incident upon the Prisme, reproduced light, intirely and perfectly white, and not at all sensibly differing from a direct Light of the Sun."

Newton also did experiments where he passed each color of the spectrum back through prisms individually to see if the could be broken down yet further. He discovered that they could not and that a specific beam, once separated from the spectrum remained true to its color. This proved to Newton (and the world) that he had discovered the true nature of white light. His experiments proved beyond all doubt that color existed in the light itself and was not something that emanated from objects (or from the human eye). It was an astounding discovery and is the basis of all modern theories of light.

But Newton did one more thing that, as you will see in the coming pages, had a profound effect on our understanding of the relationship of colors: he took the linear pattern of colors produced by the prism and joined them into a circle. That circle of visible light became the first color wheel and the model for all of the many variations that followed.

Although the theory of color continues to evolve and we find ever more uses of light (and information about) color—measuring the chemical content of distant stars by recording their spectrums, for example—it was Newton's simple experiment with a glass prism in a darkened room that led to our current knowledge of light and color. Newton published his findings in the book *Optiks* in 1704—considered the first scientific thesis on the subject (and, not surprisingly, the publication of which caused quite an uproar in the scientific community).

Next time that you're feeling that you've had a good day of multitasking around the house, consider this: in the span of only two years Newton discovered and revealed his theory of gravity, introduced calculus as a new form of mathematics and discovered the visible spectrum—all while employed as a lecturer at Cambridge.

◄ A SIMPLE SUNCATCHER HANGING IN MY OFFICE WINDOW PROVED NEWTON'S THEORY. THE SUN STRUCK A PRISM SURFACE IN THE SUNCATCHER AND BROKE THE LIGHT DOWN INTO ITS SPECTRAL COLORS AND SPREAD THEM AGAINST THE WALL BEHIND MY COMPUTER MONITOR. YOU CAN SEE THE SHADOW OF A LAMP IN THE UPPER LEFT CORNER OF THE FRAME.

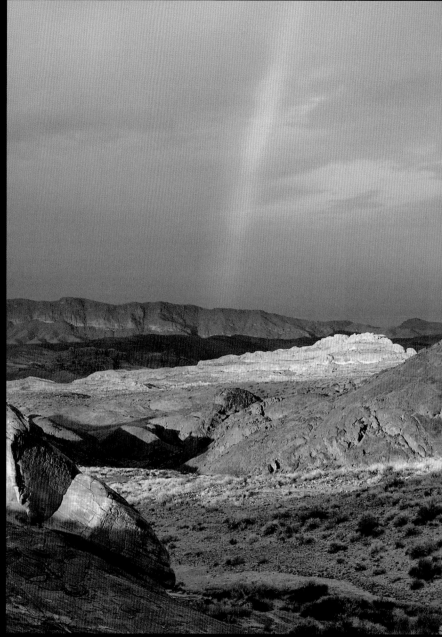

▲ ▶ IT WAS SIR ISAAC NEWTON WHO WAS THE FIRST TO REALIZE (AND PROVE) THAT ALL COLOR WAS CONTAINED IN THE SUN'S LIGHT. A RAINBOW ACTS LIKE A GIANT PRISM THAT BREAKS THE LIGHT DOWN INTO ITS SPECTRAL COLORS.

▼ ▼ NEWTON'S EXPERIMENTS PROVED ONCE AND FOR ALL THAT IT WAS THE LIGHT THAT GAVE OBJECTS THEIR COLOR AND NOT THE OBJECTS THEMSELVES. IF IT WERE NOT FOR THE SUN'S LIGHT CONTAINING ALL OF THE COLORS OF THE RAINBOW, WE WOULD LIVE IN A WORLD OF GRAYS.

The Color Wheel

WHEN SIR ISAAC NEWTON TOOK THE LINEAR ARRAY OF COLORS THAT WERE REVEALED IN HIS PRISM EXPERIMENTS AND BENT THEM INTO A CIRCLE KNOWN AS A "COLOR CIRCLE" OR "COLOR WHEEL" HE CREATED AN IMPORTANT TOOL THAT, FOR THE FIRST TIME, PROVIDED A WAY TO VIEW THE RELATIONSHIPS BETWEEN COLORS AT A QUICK GLANCE.

That apparently simple act (and one that may have seemed at the time like a small wrinkle in his thought process compared to the colossal nature of his overall discovery) has vastly enhanced our understanding of how colors work together.

The color wheel provides a shorthand tool that enables artists and photographers to envision important creative concepts like color harmony and color contrast. If you're trying to create a photograph that is built mainly from "warm" color combinations (concepts that we'll discuss later in this chapter) it's easy to spot the range of yellows, reds and orange that fall into that group.

The specific colors in the modern wheel are, at their core, representative of the colors in the visible spectrum and not vastly different from what Newton observed. There are, however, nearly endless versions of the wheel, ranging from simple circles with the six basic hues to complex three-dimensional models that show many variations (in terms of contrast and saturation—topics we'll cover later in this chapter) of each hue. In some wheels the colors form a continuous band, in others there are distinct demarcations.

Also, while the first color wheels created followed Newton's circular design, today there are designs that range from straight lines to cubes to triangles and even spheres. While a plain circle will provide the information necessary for comparing pure hues,

applications like the graphic and printing trades that rely on using very specific shadings and purities require far more complex models such as the Munsell Color System (shown on the opposite page). In addition, as the illustrations here show, color theorists have devised any number of ways to connect various colors within the color wheels—including triangles, squares, pentagrams, etc. Color wheel design it would seem is pretty big business.

To complicate things a tad further, while some color wheels are designed for use with the pigment-based or reflected-light color models, others are based on transmitted light. Newton of course was trying to explain and demonstrate the nature of transmitted light in its purest form and his primary concern was revealing light from a scientific standpoint. Most artists, on the other hand, use color wheels based on reflected light sources such as pigments since those have more practical applications in their daily work.

As photographers we're caught somewhere in the middle of this riddle. Though we work with the transmitted (red/green/blue) color model in both capturing and editing our images, when it comes time to print our pictures we enter the realm of pigmented colors and reflected light since inks and dyes on paper are examples of reflected color sources. In other words, when you are out shooting (or sitting at the computer editing) you are dealing with transmitted light but when it comes time to print, you have become a pigment-based artist. At first these appear to be contradictory forces (designed it seems to make your head spin), but as we delve more into color models in the pages head things will become a bit more manageable.

All color wheels, regardless of shape or complexity or audience, provide a valuable tool for understanding colors are created and how different pairings or groups of colors can be exploited for creative effect. For most art students (including myself), studying and creating a simple color wheel is an important part of their first year's studies and having to create one from a blank piece of paper and a limited range of pigments is a fun challenge that teaches you a lot about color.

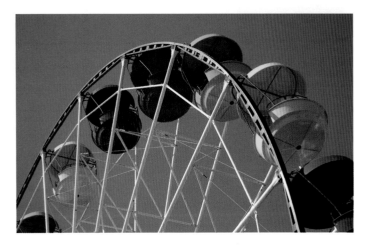

◄ PRIMARY COLORS ARE THE FOUNDATIONS OF EVERY TYPE OF COLOR WHEEL, FOR BOTH TRANSMITTED AND REFLECTED LIGHT BECAUSE IT'S FROM EACH SET OF PRIMARY COLORS (EITHER RBG OR RBY) THAT ALL OTHER COLORS ARE CREATED. THOUGH PROBABLY NOT AN INTENTIONAL NOD TO COLOR THEORY, THIS FERRIS WHEEL CONTAINS THE PRIMARY COLORS OF BOTH TRANSMITTED (RGB) AND REFLECTED LIGHT (RBY) COLOR WHEELS. WE'LL DISCUSS PRIMARY COLORS AND THEIR IMPORTANCE IN GREATER DETAIL LATER IN THIS CHAPTER.

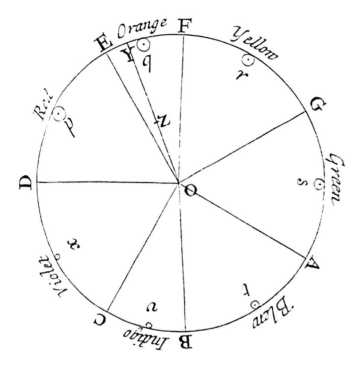

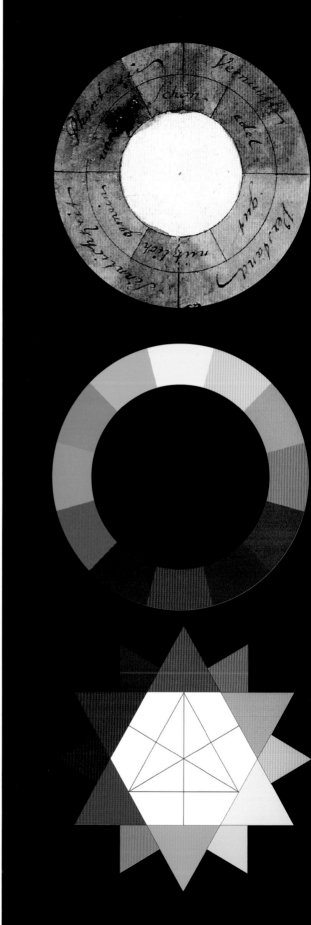

Though Newton was the first to arrange the colors of the visible spectrum in a circle configuration, there have been countless reinterpretations and refinements. Each type of color wheel has its own method of showing the relationships of colors to one another and each has its own unique advantages and uses. Shown here (going clockwise from the upper left) are four of the most significant color models introduced by: Sir Isaac Newton's (1670) asymmetric color wheel that shows the seven colors of the visible spectrum in the order the appear in the rainbow (and that also includes both musical and planetary symbols that he believed were related to colors), Johann Wolfgang von Goethe's symmetrical wheel (1810), the Munsell Circle created by American painter Alber Munsell (1905), and the circle created by French art critic Charles Blanc (1867) who's triangle-based wheel examined the relationships between primary and secondary colors.

The Primary Colors

FOR MOST OF US, OUR FIRST EXPERIENCE WITH PRIMARY COLORS CAME IN GRADE SCHOOL ART CLASSES WHEN OUR TEACHERS TAUGHT US THAT MIXING YELLOW AND BLUE PAINTS TOGETHER WOULD PRODUCE GREEN. THE EXACT SHADE OF GREEN DEPENDED, OF COURSE, ON THE RATIO OF BLUE TO YELLOW.

Similarly, we learned that if you mixed red and yellow you got orange and if you mixed blue and red you got purple. The ability to turn two existing colors into a brand new one was quite a ponderous thought at such a young age and most of us wore home our magically created hues on our hands and faces and sleeves as badges of our newfound color skills. Suddenly we possessed the knowledge to make a whole new palette of colors from paints that we already owned—our personal creative wealth (not to mention artistic vision) had just exploded.

Those three basic colors—red, yellow, and blue (known more commonly as simply RYB)—are the basis for all color mixing with pigmented colors like oil paints or watercolors. It seems hard to fathom, but almost any color that you can imagine (in the neighborhood of 16,000,000 colors if you happen to have a very vivid imagination) can be created by carefully blending just those three simple hues in varying proportions. If you're an artist and have buckets of only those three colors, the rainbow is at your fingertips.

Interestingly, however, RYB is not the only set of primary colors (nor do all artists consider the primary set limited to those three colors) and, in fact, there are two other sets in common use that are more useful in the photographic world. Understanding why there are different primary sets of primaries, what they are and how each of them works is at the core of understanding how colors combine to create other colors.

As we'll see in the following pages, each different sets of primary colors is used in different areas of art, photography and the graphic arts and each has its own unique advantages.

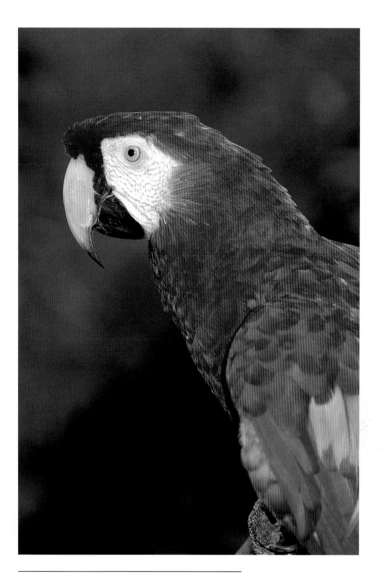

▲ AS KIDS WE'RE TAUGHT THAT WE CAN MAKE ALL COLORS FROM RED, YELLOW AND BLUE PAINTS—THE COLORS THAT MAKE UP MOST OF THE COLORS OF THIS PARROT. BUT THOSE ARE ONLY THE PRIMARY COLORS OF PIGMENTS—THERE ARE TWO OTHER SETS OF PRIMARY COLORS AS WE'LL SEE IN THE FOLLOWING PAGES.

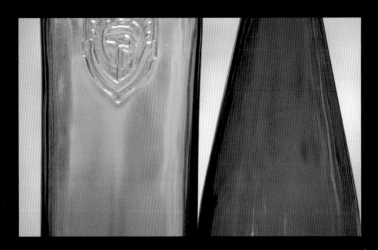

▲ COLORED GLASS WORKS JUST AS THE COLORED FILTERS THAT YOU PUT OVER YOUR LENS WORK: THEY PASS LIGHT OF THEIR OWN COLOR WHILE SOAKING UP OTHER WAVELENGTHS. LOOK CLOSELY AND YOU'LL SEE VIOLET-COLORED STRIPES ON THE RIGHT EDGE OF THE BLUE BOTTLE—THE RESULT OF REFLECTIONS FROM A NEARBY WALL.

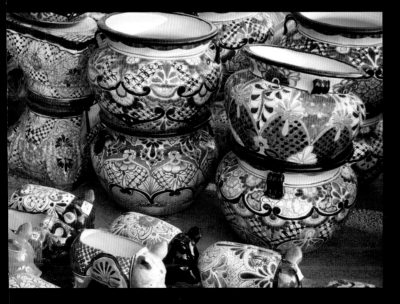

▲ AS ALL ARTISTS KNOW, YOU CAN CREATE MILLIONS OF COLOR VARIATIONS FROM THREE BASIC COLORS. FOR ARTISTS WORKING IN PIGMENTS, THOSE COLORS ARE RED, YELLOW, AND BLUE

◄ BY MIXING PRIMARY COLORS A PIGMENT ARTIST CAN CREATE SECONDARY COLORS. ADDITIONAL COLORS CAN BE CREATED BY MIXING EITHER ONE PRIMARY AND ONE SECONDARY. OR BY MIXING TWO SECONDARY COLORS TO CREATE WHAT ARE KNOWN AS TERTIARY COLORS. BETWEEN PRIMARY, SECONDARY AND TERTIARY COLORS, AN ARTIST HAS A RANGE THAT RUNS INTO THE MILLIONS OF COLORS— A FACT NOT LOST ON THE ARTISTS WHO CREATED THESE BEAUTIFUL POTS THAT I PHOTOGRAPHED IN MEXICO.

Red, Yellow, & Blue—
The Subtractive Primaries

THE COMBINATION OF RED, YELLOW, AND BLUE ARE KNOWN AS THE PIGMENT PRIMARIES OR THE PAINTERS' PRIMARIES BECAUSE THESE ARE THE COLORS THAT ARTISTS USE TO MIX THEIR COLORS.

On a standard color wheel, red, yellow, and blue are equidistant from one another. As you can see in the illustration below, if you connect the three primary color colors, more colors are created.

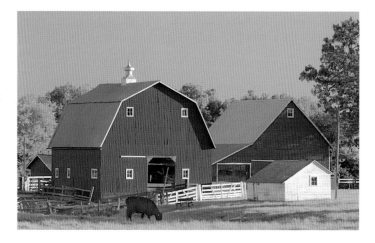

▲ WHY IS A RED BARN RED? BECAUSE THE PIGMENTS USED IN ITS PAINTS HAVE A MOLECULAR STRUCTURE THAT BOUNCES BACK PRIMARILY RED LIGHT WHILE AT THE SAME TIME ABSORBING MOST (NOT ALL) OF THE YELLOW AND BLUE LIGHT. IF THE PAINTER HAD ADDED YELLOW PAINT TO THE RED, THE BARN WOULD BE ORANGE—A SIMPLE COLOR MIXING TRICK MOST OF US LEARNED IN GRADE SCHOOL.

Red, yellow, and blue are also known as the subtractive primaries because the way that they work is by selectively allowing their own colors to reflect back to the viewer. In the shot of the kayaker going over a waterfall shown to the right, for example, the materials used in the various objects reflect back their own color while absorbing the others. The pigments used in the red-colored plastic are allowing red to reflect back to the viewers eyes while subtracting much of the yellow and blue light. The blue materials used for the jacket reflect back the blue light but absorb much of the red and yellow light; the yellow reflects yellow, but absorbs much of the blue and red. The actual amount of light subtracted really depends on the purity of the pigments or other materials in use, and even for a skilled artist mixing the exact same color twice is a pretty steep challenge (which is why, no doubt, painting is an artistic skill and not a scientific process).

This principle is very similar to the way in which we see the color of objects. When you look at a red barn, for example, the reason that it appears red is because the pigments with which it has been painted are absorbing the yellow and blue while reflecting back most of the red light. We'll talk more about this particular concept in the upcoming pages on vision.

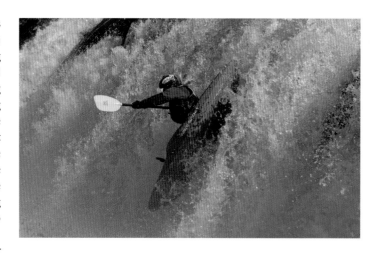

▲ WITH ANY OBJECT, THE COLOR YOU SEE IS WHAT THE OBJECT'S MATERIALS REFLECT. PIGMENTS AND OTHER MATERIALS REFLECT LIGHT OF THEIR OWN COLOR WHILE ABSORBING OR SUBTRACTING OTHERS (THUS THE TERM SUBTRACTIVE COLORS). © DEREK DOEFFINGER

▲ IT'S INTERESTING HOW OFTEN THE PIGMENT PRIMARY COLORS ARE CHOSEN AS A DESIGN COMBINATION BY HUMANS— WE SEEM TO HAVE AN ALMOST SUBLIMINAL ATTRACTION TO THEM.

▶ SECONDARY HUES LIKE THE VIOLET USED TO PAINT PARTS OF THIS COLORFUL METAL SCULPTURE ARE CREATED BY MIXING TWO PRIMARY COLORS—IN THIS CASE RED AND BLUE.

▲ THE FAMED ROSE WINDOW IN NOTRE DAME CATHEDRAL IN PARIS IS ANOTHER EXAMPLE OF SUBTRACTIVE COLORING. SOME OF THE EARLIEST EXAMPLES OF STAINED GLASS DATE BACK TO THE ROMANS IN THE FIRST CENTURY A.D.

The same exact subtractive principle is true when it comes to transparent objects such as glass, by the way: each color of glass allows its own color to pass through while subtracting or absorbing other colors. If you're ever stood and looked at a stained-glass window for example, each of those color panes is passing some colors to your eyes while hold back the rest. The blue bits of glass are allowing blue to pass through while holding back red and yellow; similarly the yellow pieces are allowing yellow to pass through while subtracting out the red and the blue.

Color mixing with pigment primaries works in the same way: When you add red and yellow paint together, for example, you get a shade of orange (orange is referred to as a secondary color because it's made from two primaries) because both the red and yellow paints are allowing a mixture of their own colors to pass while each is subtracting other colors. The result is a blend of reflected colors.

The three secondary colors are:

Red + Yellow = Orange
Red + Blue = Violet
Blue + Yellow = Green

These new colors can then be combined for even more colors called tertiary colors. The ultimate creative power of pigment colors comes from mixing primary, secondary and tertiary colors.

Because each of the subtractive colors absorbs the other two colors, if you mix all three colors together in equal amounts you subtract all of the light and get black (or, more likely in the real world where perfect pigments don't exist, a muddy gray-brown).

Red, Green, & Blue— The Additive Primaries

ERE'S A GOOD MEMORY FOR THOSE OF YOU THAT ARE OLD ENOUGH (AND I AM) TO REMEMBER A CRAZE IN THE EARLY 1960S WHEN WHITE ARTIFICIAL CHRISTMAS TREES WERE ILLUMINATED WITH A LIGHT DEVICE THAT FEATURED A ROTATING DISC WITH A SERIES RED, GREEN AND BLUE PLASTIC FILTERS.

As the disc spun around slowly, the tree turned different colors and it was (or so we were led to believe) very festive and soothing to watch and it saved you all that trouble of stringing colored lights. But if you were a very clever child and decided to play with the speed control of the rotating disc, you could actually make it spin so fast that the colors blended together to form white light. What you ended up with was your white tree seemingly lit by white light.

The reason that this clever little device worked is because red, green and blue light are the primary colors of light and they combine to create white light. And it is this theory of color blending using red, blue and green light that is the color model used in digital photography. These colors are known as the additive primary colors, in fact, because the way that they create new colors is by adding to one another rather than subtracting colors. This is the system that is used to create the colors that you see on television, scanners, computer monitors, and digital camera sensors.

If you were to take a strong magnifying glass, for example, and hold it up to your computer's monitor, you'd see that all of the colors are made of red, green, and blue dots—the pixels that make up the color matrix of your monitor. The same is true of your television screen (and your smart phone, incidentally). And, as we'll see later in this chapter, the RGB model is extremely similar to the physiological system that our eyes use to perceive and interpret color in the world around us.

Additive primaries combine their colors in the following ways:

Green + Blue = Cyan.
Red + Blue = Magenta
Red + Green = Yellow

These three resulting colors—cyan, magenta and yellow—are the secondary colors of the RGB color model. Based on our childhood experiences with paints it seems kind of odd to accept the fact that red and green combines to create yellow, but if you have red and green lens filters laying around, try it sometime. Just overlap the two filters on a light table or in a bright window and you'll see the surprising result.

Stage lighting is another good example of RGB additive color mixing. If you were to just blast an actor or musician on stage with pure white light you would end up with a pale-looking performer—perhaps suitable for the ghost of Hamlet's father, but none too flattering for this blues singer. Instead, the three primary colors of light from several sources are combined to create what appears to be white light. In reality rather they may create a mix of red and pink since those colors produce a warmer cast, but that mixture appears natural, and even inviting, to the audience.

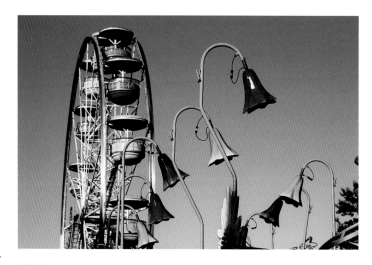

▲ REGARDLESS OF HOW SIMPLE OR COMPLEX THE COLORS IN A SCENE ARE, YOUR DIGITAL CAMERA USES A SENSOR THAT IS SENSITIVE TO JUST THREE COLORS: RED, GREEN AND BLUE TO RECORD THOSE COLORS. ALL OF THE COLORS THAT WE SEE CAN BE CREATED BY MIXING THESE THREE COLORS OF LIGHT IN VARIOUS PROPORTIONS.

▲ THE WAYS THAT TV SCREENS AND COMPUTER MONITORS CREATE COLOR IS VERY SIMILAR TO THE WAY THAT YOUR CAMERA RECORDS THEM: PIXELS THAT OF THE THREE LIGHT PRIMARY COLORS ARE MIXED TO CREATE A HUGE RANGE OF COLORS. © FRANK GALLAUGHER

THE CMYK PRIMARY COLORS

As if you needed another set of primary colors to contend with, there is actually one more set of primary colors: cyan, magenta and yellow (usually used in the presence of black). As you just learned, these three colors are the secondary colors of the RGB primary model and interestingly the primary colors of the RGB model are the secondary colors of CMY. In other words, if you add yellow and magenta together you get red, if you add cyan and yellow you get green and if you add cyan and magenta you get blue. Fascinating, no?

This is another subtractive primary color group and it's very closely related to the RYB model—and it acts in exactly the same way when it comes to color blending. In this model cyan takes the place of blue, magenta take the place of red and yellow remains the same.

The CMY model is the model that is used in all commercial printing and the reason is that cyan, magenta and yellow are much more pure hues and thus can produce exact colors more reliably than pigment primaries. A fourth color—black—is added to this group and creates a model known as CMYK (K stands for black). The reason that the black color is added is partly because using a separate black ink allows printers to create a richer more intense black, but it also because it wastes less ink (and ink is not cheap) than by combining the other three colors to create black.

If the CMYK model sounds familiar to you it's no doubt because these are the colors of ink that your inkjet printer uses to make color prints. So while your camera captures images and your monitor shows you your photographs during editing using the RGB model, you are actually printing them using the CMYK model. And if you're a Photoshop user, you're probably familiar with the fact that you can actually edit (or at least preview) your images in that color model—a topic that we'll discuss later in this book.

Also, when it comes to correcting your images in editing, you've no doubt noticed that you're often making corrections to an RGB image by making adjustments with the CYMK colors. If you're ever used the "Selective Color" option in Photoshop, for example, you'll notice that all the corrections are made by adjusting cyan, yellow, magenta, and black. We'll talk more about these concepts in the final chapter of this book.

Hue, Saturation, & Brightness

IN ERIC HODGIN'S WONDERFUL BOOK *MR. BLANDINGS BUILDS HIS DREAMHOUSE* THERE IS A VERY FUNNY SCENE WHERE MR. BLANDINGS' WIFE IS TRYING TO EXPLAIN TO HER INTERIOR DECORATOR THE EXACT COLOR OF PAINT THAT SHE WANTS USED IN HER LIVING ROOM.

She describes it this way: "The color is to be a soft green, not as bluish as a robin's egg, but not as yellow as daffodil buds. The sample enclosed, which is the best I could get, is a little too yellow, but don't let whoever mixes it go to the other extreme and get it too blue. It should just be a sort of grayish apple green."

Her instructions, ridiculous as them seem, perfectly illustrate the difficulty that exists in trying to describe colors precisely—it's an inexact communication at best. The dilemma lies in the fact that everyone sees colors in their own way and even two people staring at the exact same color will describe it differently. This, in fact, is exactly why very complex 3D color wheels have been created that offer precise naming and numbering of individual shades of a color. Using these models, pigment and ink makers and people in the visual and graphic arts can talk about colors in a very unambiguous

way—without resorting to trying to describe the color of a robin's egg or the particular yellow of an individual daffodil.

For the purposes of most creative photography, however, it's not so important that we are able to describe colors accurately. But it is very important that we learn to see colors for what they really are if we are to have any hope of capturing them, processing them to match our vision and then printing them so that the final prints look the way that the colors appeared in person. (Image-editing software, by the way, has tools offering very precise calibrations that make adjusting colors a vastly more exacting science—if we choose to use them—and we'll talk about those in the final chapter of this book.)

COLOR VOCABULARY

Fortunately there is a language to color and it can help a great deal when it comes to seeing and describing color in a more universal tongue. Color is technically described and defined as having three specific attributes: hue, saturation and brightness or simply HSB (and often referred to as HSV with brightness being replaced with value—a different term for the same thing). These three terms are the vocabulary of color and knowing how to use them will help you

▶ MRS. BLANDINGS' BRAVE ATTEMPTS ASIDE, TRYING TO COMMUNICATE THE SPECIFICS OF A COLOR IN WORDS IS OFTEN A KIND A FUTILE EXERCISE BECAUSE NO TWO PEOPLE WILL DESCRIBE IT IN THE SAME WAY. ONE PERSON LOOKING AT THIS HOUSE MIGHT DESCRIBE IT AS "COLONIAL" RED WHILE ANOTHER MIGHT CALL IT "APPLE" RED.

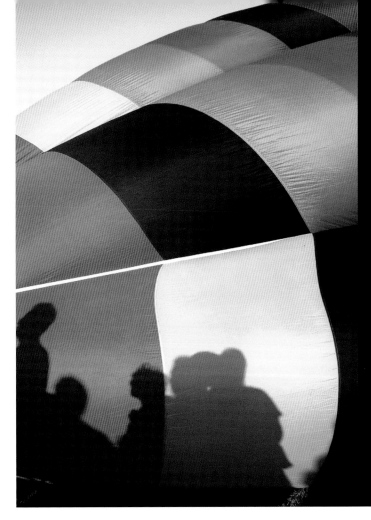

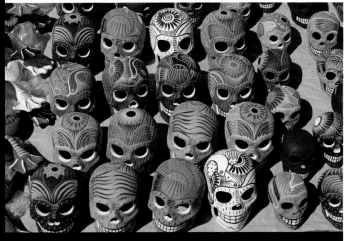

◄ HUE IS NOTHING MORE THAN THE COMMON WORD THAT WF USE TO DESCRIBE A PARTICULAR COLOR. THE RED, BLUE, GREEN, YELLOW, AND ORANGE STRIPES IN THIS HOT AIR BALLOON EACH REPRESENTS A DIFFERENT HUE.

▲ THE RANGE OF HUES USED TO COLOR DECORATIVE OBJECTS OFTEN INSTANTLY IDENTIFIES A PARTICULAR CULTURE. IT'S HARD TO IMAGINE THE VIBRANTLY COLORED HUES—PARTICULARLY ON SKULLS—COMING FROM ANY OTHER COUNTRY THAN MEXICO.
© DEREK DOEFFINGER

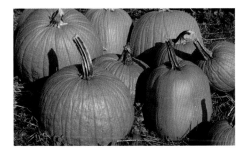

to not only share your ideas of colors with others, but also to identify subtle variations in the colors of the objects and scenes around you.

HUE

Hue is the more accurate term for what people mean when they describe the color of something. The hue of lemon, for example, is yellow and the hue of a red apple is red. Though few of us use the term in casual conversation, "hue" is the word that we mean when we describe the color of any object. The concept of hue gets a bit more complicated when the colors we're trying to describe are blends of various colors or when they the color comes from a palette this is not particularly ordinary—as in the colorfully painted skulls photographed in Mexico by photographer Derek Doeffinger.

▲ LIGHTING AND TIME OF DAY WILL HAVE A MAJOR IMPACT ON COLOR SATURATION WHEN SHOOTING, BUT THE SIMPLEST WAY TO EITHER ADD OR SUBTRACT SATURATION IS AFTER-THE-FACT IN EDITING. IN THIS SERIES THE MIDDLE PHOTO IS APPROXIMATELY THE SATURATION SEEN BY THE EYE IN LATE-AFTERNOON LIGHT. THE VERSION TO THE LEFT WAS DESATURATED IN EDITING WHILE THE ONE ON THE RIGHT HAS HAD THE SATURATION INCREASED— ALMOST TO THE POINT OF POSTERIZATION.

Hue, Saturation, & Brightness, continued

SATURATION

Saturation (sometimes referred to as chroma) is a word that describes the purity of a particular hue. The colors coming out of a prism are fully saturated, but pure colors are relatively rare. A painter can desaturate the purity of a color by adding paint to it (or by mixing it with its complement, which will create a muddier hue). In fact, if you look at most painter's kits, you'll see that the largest tube of paints is usually white because lightening the saturation of color is a key element of paint mixing.

In the photographic world, however, pure colors are rare because they are affected by a lot of impure factors including things like mist or haze, the natural fading of pigmented surfaces (the faded colors of an old barn, for example), and the intensity of the light that is illuminating them. Colors lit by midday light, for example, usually seem more pure because the color of the light is more neutral and because (with certain surfaces, at least) the intensity of the lighting appears to saturate the colors. But too much light can actually take saturation away by creating too much surface reflection—particularly with glossy surfaces. The surfaces of the pumpkins shown on the previous page have a moderately glossy surface and that helps to run the saturation up a bit. Exposure also has an effect on saturation with even slight over- or underexposure often radically altering saturation. We'll talk more about saturate and its causes in the next chapter.

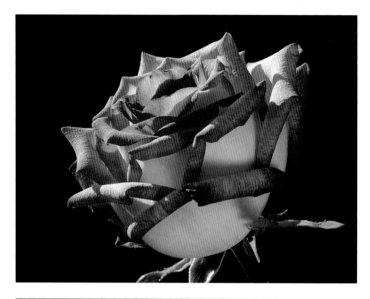

▲ PLACING COLORFUL SUBJECTS LIKE THIS ROSE IN FRONT OF A BLACK BACKGROUND TEND TO ENHANCE SATURATION, PARTICULARLY WITH PRIMARY COLORS, BECAUSE THERE IS NO COMPETITION FROM OTHER COLORS AND THE BLACK INCREASES APPARENT CONTRAST.

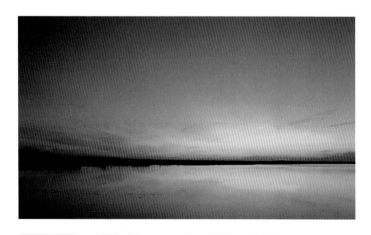

▲ SKIES OFTEN GET MOST SATURATED AT DUSK IN THE TWENTY OR SO MINUTES AFTER THE SUN HAS GONE BELOW THE HORIZON. UNDEREXPOSURE WILL INCREASE THE SATURATION SIGNIFICANTLY. I PHOTOGRAPHED THIS SCENE ON THE GULF COAST OF TEXAS USING AN 18MM LENS AND USED MINUS TWO STOPS OF EXPOSURE COMPENSATION.

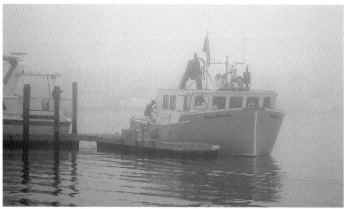

▲ FOGGY SCENES HAVE INHERENTLY LESS SATURATION BECAUSE THE FOG SCATTERS THE LIGHT AND THAT SCATTERING IN TURN DIFFUSES THE INTENSITY OF THE COLORS AND SOFTENS CONTRAST. WE'LL TALK MORE ABOUT FOG AND HAZE AND THEIR EFFECTS ON COLOR IN CHAPTER THREE.

BRIGHTNESS

Brightness refers to the lightness or darkness of a color. The range for brightness, of course, is from black to white and the brightness of particular color is dictated by a few things, most notably the amount of light hitting them (any color seems darker in a dimly-lit room, for example) and also by exposure—with overexposed subjects appearing my lighter in tone. In editing it's a simple process to alter the brightness of a color by simply adding or taking away black. If you have Photoshop, for example, just open the selective color tool and go to the Blacks slider (at the bottom of each color) and either add or subtract black. You can also do the same thing in the hue/saturation tool by using the lightness option at the bottom of the dialog box.

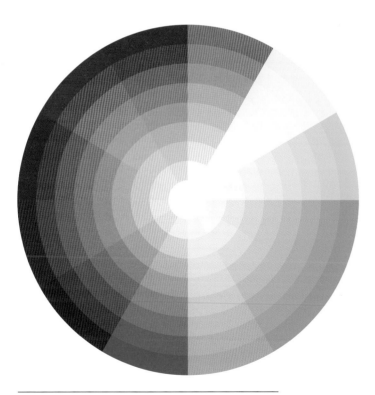

▲ IN A COLOR WHEEL LIKE THE ONE SHOWN HERE THAT INCLUDES VARIATIONS OF A HUE'S SATURATION, THE MOST SATURATED VERSION OF THE HUE LIES AT THE OUTER EDGE OF THE WHEEL AND THE COLOR BECOMES LESS SATURATED AS IT FADES TO WHITE TOWARD THE CENTER.

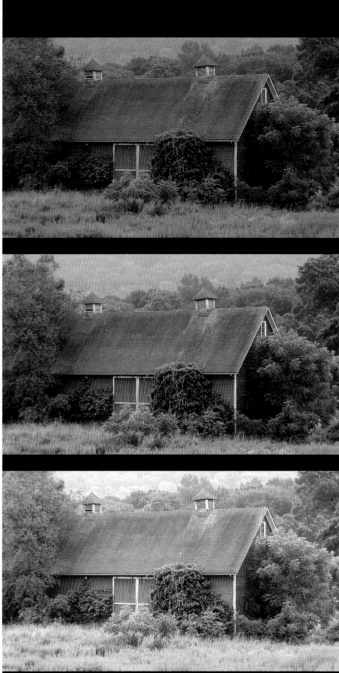

▲ EXPOSURE HAS A PROFOUND EFFECT ON THE BRIGHTNESS OF THE COLORS IN A PARTICULAR IMAGE. BUT BRIGHTNESS IS VERY EASY TO ADJUST IN EDITING, PARTICULARLY IF YOU SHOOT YOUR IMAGES IN THE RAW FORMAT. THIS SERIES SHOWS THE SAME FRAME ADJUSTED FOR BRIGHTNESS DURING THE RAW CONVERSION PROCESS. AS YOU CAN SEE ADJUSTMENTS TOWARD THE UNDEREXPOSED SIDE MUDDY THE HUES AND PUSHES DARKER HUES TOWARD BLACK, WHILE A SHIFT TOWARD OVEREXPOSURE WASHES OUT THE MIDDLE AND LIGHTER HUES.

Human Vision: How We See Color

PERHAPS THE GREATEST WONDER WHEN IT COMES TO SEEING COLOR IS THAT WE ARE ABLE TO SEE IT AT ALL.

Imagine how monotonous and drab the world would be without yellow and red rays soaring into the dawn sky, a rainbow lighting up the sky after a storm or how inedible a bowl of fruit might look sans the red of the apples, the bright yellow of bananas or the rich purple of grapes. Oranges might simply be known as that "gray citrus orb." Imagine a waiter asking, "Would you like some gray citrus orb juice with your drab eggs?"

Human vision is a riddle that physiologists have been unraveling for centuries. And while certain mysteries still persist, today we understand quite a lot about how the eye and brain work together to see and blend an almost infinite range of colors.

All vision begins with light. No light, no sight. Interestingly too, the electromagnetic spectrum that sends energy from the sun to the earth is far broader than the narrow portion we use for vision. In fact, the full range of the electromagnetic spectrum includes many types of radiant energy including radio waves, microwaves, infrared, ultra violet, X-rays and Gamma rays, the visible spectrum that have nothing to do with normal vision. The colors we see coming out of the prism are limited to an extremely narrow band of wavelengths ranging from approximately 390nm (the blue-violet end of the spectrum to 700nm (the red end of the spectrum). (By the way, "nm" stands for nanometers, which are a unit of measure for wavelengths and are equal to about a billionth of a meter.)

When light enters the human eye through the lens it lands on the retina—a light-sensitive inner lining of the eye. Embedded in the retina are two types of receptors: rods and cones. The rods (and

◄◄ HUMAN BEINGS ARE TRICHROMATS—THAT IS, OUR VISION SYSTEM IS RECEPTIVE TO THREE COLORS: RED, GREEN, AND BLUE. THE COMBINATION OF THESE COLORS ALLOWS US TO SEE AS MANY AS 10 MILLION COLORS THOUGH DISTINGUISHING EACH OF THOSE COLORS WOULD LIKELY BE IMPOSSIBLE SINCE NO TWO OF US SEES COLORS IN EXACTLY THE SAME WAY.

► THE THEORY OF TRICHROMACY OR TRICHROMATICISM WAS FIRST INTRODUCED BY THOMAS YOUNG, A YOUNG ENGLISH PHYSICIAN IN 1802 AND LATER DEVELOPED FURTHER BY HERMANN VON HELMHOLTZ, A GERMAN PHYSICIAN. YOU'LL OFTEN SEE REFERENCES TO THE YOUNG-HELMHOLTZ THEORY OF COLOR VISION.

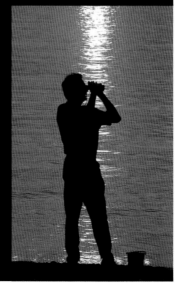

there are as many as 150 million of them in each eye) are essentially colorblind and, while good at helping find our way around in dimly lit locations, they provide no color information to the brain. The cones, on the other hand, are each sensitive to red, blue, or green—the primary colors of light. There are roughly six to seven million of these color-sensitive cones in each of your eyes.

Because each cone contains pigment of only one color it is only sensitive to color of that light. In the shot of the boy skateboarding beside a beach, for example, it's the blue-sensitive cones that gather the color information from the blue bathhouse and the red cones gather information from his shirt, while the green cones gather up the colors of the grassy areas. All of this information is sent to the brain via thousands of individual nerves bundled up in the optic nerve where the color information is gathered, blended and interpreted to provide full color vision.

Your brain creates colors in a way that is very similar to the way that your digital camera or your computer monitor mixes these three colors into a full palette of colors. The cones, however, only respond to color in relatively bright light—which explains why things seem gray and colorless when you're walking around in a dimly lit room or fumbling for your house keys on the front step after dark.

Interestingly, most of the cones in your eyes are gathered in an area that's roughly a single millimeter wide called the fovea. It's here that the bulk of the color information is gathered. The way that your eyes exploit this tiny area is by constantly flitting and moving as they study particular objects or scenes. This unceasing eye motion helps to aim as much color information as possible at the fovea so that your brain gathers very intricate color samples.

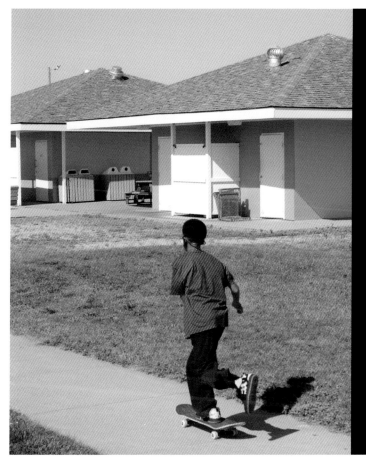

◄ EACH OF YOUR EYES CONTAINS BETWEEN FIVE AND SEVEN MILLION CONES THAT ARE SENSITIVE TO RED, GREEN AND BLUE LIGHT.

► ONLY HUMANS AND A FEW ANIMALS (PRIMATES AND CHIMPS AMONG THEM) CAN SEE ALL COLORS, BUT MOST CREATURES SEE SOME VERSION OF COLOR—AND SOME SEE AREAS OF THE SPECTRUM BEYOND WHAT WE SEE. BEES AND OTHER INSECTS, FOR EXAMPLE, ARE ABLE TO SEE ULTRAVIOLET LIGHT, IN ADDITION TO BLUE AND YELLOW. BIRDS LIKE THE EGRET SHOW HERE CAN SEE BETWEEN FIVE AND SEVEN COLORS. MY CAT, ALAS, SEES JUST YELLOW AND BLUE— AND WEAKLY AT BEST (BUT CATS HAVE EXCELLENT NIGHT VISION), BUT HER EYES ARE STILL ABLE TO PICK OUT A TINY MOTH HALF A HOUSE AWAY.

James Clerk Maxwell & The World's First Color Photo

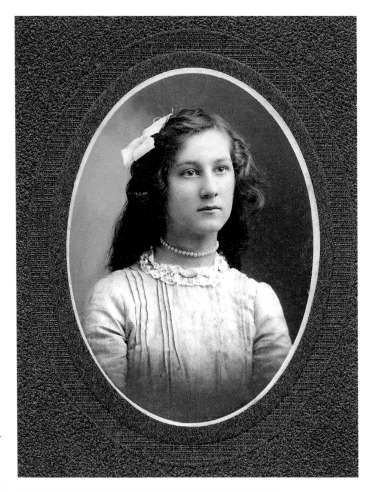

CONSIDERING THAT THESE DAYS MOST OF US REGARD BLACK-AND-WHITE SNAPSHOTS AS FODDER FOR AN EPISODE OF ANTIQUES ROAD SHOW, IT SEEMS SURPRISING THAT COLOR IS ACTUALLY A RELATIVELY NEW ADDITION TO PHOTOGRAPHY.

It wasn't until the early 20th century, in fact, that amateurs had access to a practical method for making color photographs. The slowness in finding a convenient method for making color photos, however, wasn't due to lack of desire—for nearly 75 years it was the driving ambition of almost everyone involved in the photographic world.

From the time that Joseph Nicéphore Niépce created the world's first photo from nature in 1826 (a black and white scene shot from a window of his family's farm in France) photographers and scientists struggled to bring the beauty and realism (and fantasy) of color to photography.

Niépce himself spent many years in search of a color method and was actually successful in adding some color to his photos but, like many of his fellow searchers, he could not get the colors to last. Niépce's own nephew Claude Félix Abel Niépce de Saint-Victor came tantalizingly close to solving the equation and exhibited a selection of his own color photos in 1852. Disappointingly, his photos quickly faded—he had found a method to create images, but they would only survive in absolute darkness.

Unable to find a direct route to creating a color photograph on a single plate, photographers and scientists explored alternate means—back doors that, while not at first practical, might at least provide proof of concept. And in 1861 they got that proof and the person that provided it was a now-legendary theoretical scientist James Clerk Maxwell (the man who created the world's first unified theories of electricity, magnetism and optics—among other achievements).

In May of that year, Maxwell gave a lecture in at the Royal Institution in London trying to demonstrate Thomas Young's theory on human vision. Young had developed the theory that the human eye contained color receptors sensitive to red, green, and blue light and that from these three colors the brain could interpolate all colors. Maxwell had an associate, Thomas Sutton, create three separate images of a tartan ribbon, each one photographed on a black-and-white emulsion through a filter of one of the primary colors of light: red, green, and blue.

The resulting images were chemically reversed to create positives and then were projected in precise registration—each being shown through the same color filter with which it had been shot. The result (and one that apparently stunned the audience far beyond proving

▲ IT WAS THE POPULARITY OF PORTRAIT PHOTOGRAPHY AND THE PUBLIC'S DEMAND FOR SEEING COLORED PHOTOS OF THEIR LOVED ONES THAT SPURRED THE SEARCH FOR A WORKABLE METHOD OF COLOR PHOTOGRAPHY. UNTIL THE TURN OF THE 20TH CENTURY, VIRTUALLY ALL PORTRAITS—LIKE THIS PHOTOGRAPH OF MY GRANDMOTHER LILY GARDNER—WERE MADE IN BLACK AND WHITE.

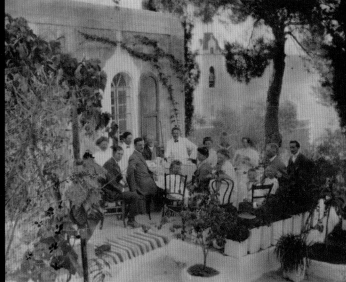

Young's theory) was a full-color slide shown projected on a white screen. By the light of three magic lantern projectors, Maxwell provided undeniable confirmation that Young's additive theory of color could be used to create full-color photographs.

It would be some time before Clerk-Maxwell's demonstration would be developed into a truly practical means of capturing color, but the idea had been planted and the photo world was off to the races. By 1904 the Lumière brothers in France had adapted the concept to create their Autochrome process that became the world's first (and for many years, most popular) practical method of creating full-color photographs.

Eventually subtractive methods of color reproduction were introduced and they became the underlying process used in most modern films. But there is no question that it was Maxwell's startling

projection of that first color image that focused the hunt in the right direction. And more importantly, it was his demonstration of how the combination of primary colors of light could produce full-color images that is the core of how digital cameras create color pictures.

By the mid 1900s portraiture was extremely fashionable and, in lieu of a method for capture color images of family and friends, the art of hand coloring black-and-white portraits surged in popularity. A lot of the colorists were professional miniature artists who had been displaced from their craft by the advent of photographic portraits so you can imagine that they personally were in no hurry to see color photography succeed and take away yet another aspect of their livelihood. But the addition of color was supremely popular with the public and it only heightened the desire for a means to directly record color images.

How Digital Cameras Record Color

ONE OF THE MOST PROFOUNDLY INTERESTING THINGS ABOUT TAKING PICTURES WITH A DIGITAL CAMERA IS JUST HOW NARROW THE LEAP IS BETWEEN THE THEORETICAL CONCEPTS USED BY JAMES CLERK MAXWELL TO CREATE THAT FIRST COLOR PHOTOGRAPH AND THE SCIENCE THAT IS USED IN A DIGITAL SENSOR.

Maxwell could certainly never have envisioned the invention of computers or the revolution in miniaturization of electronics that made digital cameras possible. But he would be entirely familiar with—and probably smugly contented with—the underlying principle of how a digital camera sensor captures color. And his smugness would have been entirely justified.

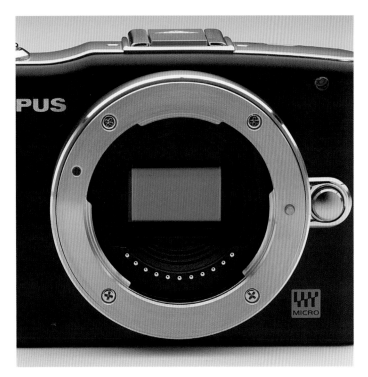

▲ A MARVEL OF MINIATURE ELECTRONICS, THE SENSOR IN A DIGITAL CAMERA CAN CAPTURE AND REPRODUCE A VAST ARRAY OF COLORS.

▲ THOUGH THEY'VE BEEN AROUND BARELY MORE THAN 20 YEARS, DIGITAL CAMERAS HAVE ALMOST ENTIRELY DISPLACED FILM. PHOTO WRITERS ONCE DEBATED WHETHER THE RESOLUTION OF A DIGITAL CAMERA COULD EVER MATCH FILM—A QUESTION THAT HAS LONG BEEN PUT TO REST BY DIGITAL'S EXTRAORDINARY TECHNICAL LEAPS.

In its basic design a digital camera is no different than a film camera: both are essentially a black box with a lens at one end to focus and let light into the camera and a recording device at the other to capture the image formed by that light. In Maxwell's case the recording medium was a light-sensitive emulsion on a glass plate and in your digital camera it's a tiny electronic silicon-based sensor that uses electric current rather than chemistry to capture images.

Each digital sensor contains an array of millions of microscopic light-gathering cells called photosites. Each of these photosites collects and transmits an electronic signal in direct proportion to how much like strikes it—a concept that is not entirely different from the way that grains of silver capture an image in a film camera. The entire photosite is not light sensitive, only a small part of it, called a photodiode, gathers the light information. And while the terms photosite and pixels are often loosely interchanged, a photosite may actually contain multiple pixels.

The image captured by a digital sensor, however, is a purely tonal image—it's a black and white picture made of 256 tonal values ranging from pure white to pure black. So how is color captured? Thank Maxwell for the idea: each individual photosite has a colored filter over it—either red or green or blue (most sensors have roughly twice as many green sensors as red and blue in their array because the human eye is more sensitive to green light). These colored filters are usually arranged in what is called a Bayer pattern (shown on the right), named after the Kodak scientist that invented it.

Each photosite only collects color information for the single color of filter that covers it. A red-filtered photosite, for example, collects only red light and blocks out blue and green. Information about the other two colors (again, in this case blue and green) that were not recorded at that particular photosite are recorded in adjacent photosites that contain the other two color filters. The information from all three areas is then combined and interpolated by the camera to provide an accurate color blend for the photosite that was measured—in this case the red filtered site.

Because the filters over the array correspond to the three colors of light to which your eyes are sensitive and your camera records both the color and intensity of light for each of those millions of photosites, a very realistic image is captured. When processed by your camera and transferred to your computer (or displayed on your LCD screen) a full-color image is created that reveals both accurate color and seamless tonal gradations. In essence your camera is using exactly the same technology—color and intensity recorded in each of the three primary colors of light—that Maxwell used.

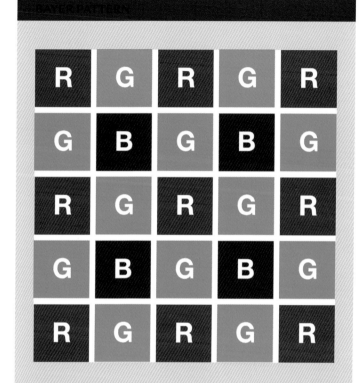

BAYER PATTERN

Named after its inventor, Kodak scientist Bryce Bayer (pronounced BYE-er), a Bayer filter is a checkboard-like array of color filters that sits over the sensor of a digital camera and is what enables the camera to capture images in color. Each square of the grid consists of four filters: two green (placed diagonally across from one another) and one each of blue and red. The reason that there are twice as many green filters is because the human eye is more sensitive to green light and so this configuration captures images that more closely match the way we view the world. Interestingly, the filter was patented in 1976, a year before the first digital camera was patented by Kodak. Each pixel on the sensor is only covered by a single color filter and your camera uses a process called demosaicing to interpret color.

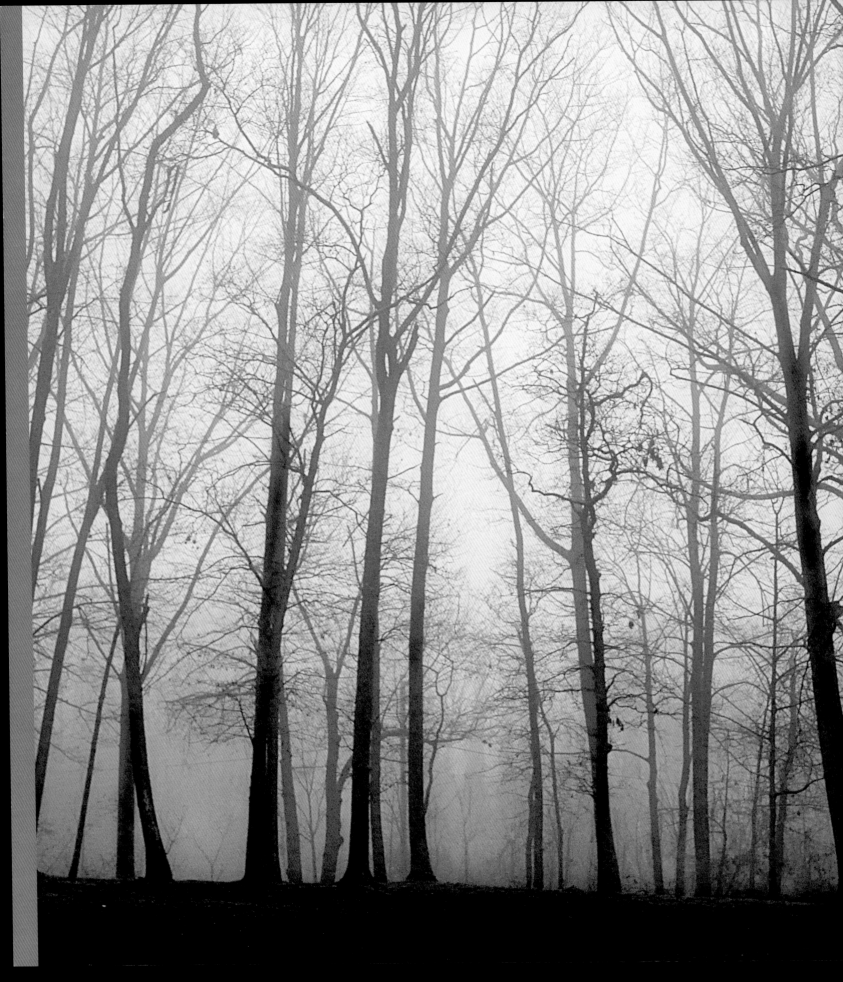

Chapter 2:

Color & Emotional Response

Color is often used as mere decoration—we paint the front door blue or yellow or purple because we like the way that it looks and it goes well with the rest of the house. Choosing and combining colors is a part of almost every aspect of our daily life: the color of the clothes we wear, the furniture we buy, and even the pets we own are all choices that we make based on our personal perceptions of and emotional responses to color. You can imagine the chaos that would break out in malls if every clothing store only sold sweaters in a single, dreary color. What would we wear when we were in a blue mood? Or a cozy woodsy green mood? Or, heaven forbid, a neon pink mood? When Henry Ford first offered his Model T cars his claim was that, "Any customer can have a car painted any color he wants so long as it is black."

It didn't take Detroit long to realize that the car-buying public craved a broader palette of colors. These cars were for Sunday drives, and country picnics—not a funeral procession. Gradually—and cautiously—car companies expanded their color choices. But color really exploded in Detroit in the mid 1950s a young singer named Elvis Presley turned to driving (and giving away) brightly colored pink and red Cadillacs. Elvis' Caddies became icons of a new and more playful car industry and for the red-hot energy of rock 'n roll. And even today just a quick sighting of a red Cadillac puts some of us of a certain age in mind of the King.

Like a deep-running river, color cuts a far deeper path to our moods than mere surface adornment. Elvis' choice of red was making a very symbolic statement: his palette represented the passion and heat of his music, and the electrifying nature of his personality. Whether we realize it or not, color is not only reflective of our personalities and our moods, but it often alters our emotional climate. It's hard, for instance, to look at a colorful bunch of helium balloons at a parade and not feel cheered. Conversely, it's hard to look at the muted colors of a rainy harbor and not be swept into a more contemplative or pensive mood. Color can create and reflect our moods and so it's important not just to accept the colors in front of you, but to seek out the colors that describe and embellish your emotions.

Pablo Picasso, perhaps one of the greatest voices of color in history wrote: "Colors, like features, follow the changes of the emotions." In our search for subjects and colors to photograph, we follow the calling of our emotions—both conscious and subconscious—and understanding how colors relate to and instigate such complex primal responses is fundamental to creating images that resonate with the imagination.

Color & Mood

PERHAPS MORE THAN SUBJECT MATTER, LIGHTING, AND COMPOSITION, COLOR SETS THE MOOD OF A SCENE. MOOD IS OFTEN DESCRIBED AS THE EMOTIONAL CLIMATE OF A PHOTOGRAPH AND CAREFULLY CHOOSING OR ISOLATING PARTICULAR COLORS, OR COMBINATIONS OF COLORS, WILL VASTLY ENHANCE THOSE EMOTIONAL REACTIONS.

In most cases viewers are powerfully affected by the colors of a scene well before they've had a chance to study or even acknowledge the details of the subject.

At first glance, what strikes you about the vibrant bunches of flowers shown on the opposite page is not necessarily technique of the shot or the composition in particular, but their undeniably cheery colors. Vendors at such events count on bright colors putting you in a good enough mood to part with a few bucks to take those happy feelings home.

Colors probe at the imagination on a subliminal level well before conscious thoughts analyze the subject matter—a fact that is not lost on art directors, advertising agencies or clothing designers. If an advertiser wants you to place you in a calm, reflective mood (think of a hotel ad, for example), they'll use soothing colors: soothing warm tones, relaxing earth tones, and the calming blue of the sky. Such calming colors elicit thoughtful and rational personal reflection— exactly the emotional frame of mind that a hotel is hoping you'll identify with their rooms.

Conversely, if an advertiser wants to zone in on the more primal and spontaneous areas of your imagination, they'll spice up the visuals with exciting combinations of bright primary colors—blues, yellows, and reds. And the reason that travel magazines and travel destinations use exotic color combinations is that they want to awaken your spirit of adventure. "Come experience the festive colors of our country and leave your dreary reality behind!" Similarly, carnivals paint their world in garish hues hoping to put you in the kind of light-hearted mood that makes you want to spend more time (and more money) enjoying yourself.

You use color to establish mood yourself in your everyday life: in the colors that you paint your bedroom (rare is the bedroom painted bright red—unless you're a teenager with very indulgent parents), the colors of the towels you choose for your bath, and, of course, the colors of your wardrobe choices. People can often guess the mood you were in when you got dressed for work or school by the color combinations you elected to wear that day.

Interestingly, however, while you might choose specific colors to help establish a mood, there is no guarantee that others will interpret the correct mood. While the cool blue light of the foggy woodland scene shown opposite brings out feelings of introspection or calmness for some people, others might see only the empty loneliness of the scene or even experience anxiety or danger at the overwhelming solitude. In either case, your selection of a specific color palette helps to awake emotional responses.

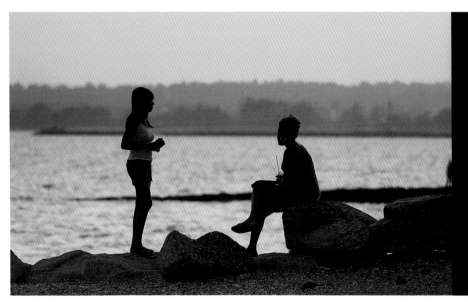

◀ THE WARM TONES OF A SETTING SUN HELP CREATE THE SOFT MOOD OF TWO FRIENDS CHATTING AT THE BEACH. GOLDS, YELLOWS, ORANGES AND REDS ALL HELP TO ESTABLISH OR REINFORCE A MOOD OF WARMTH AND THE POWER OF THESE COLORS IS ESPECIALLY EFFECTIVE WHEN YOU ARE CAREFUL TO WORK WITH VERY A LIMITED PALETTE.

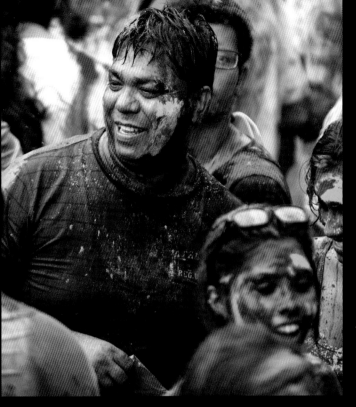

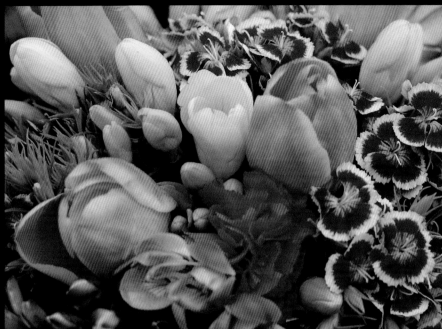

▼ TIGHT CROPPING AND BRIGHT BUT DIFFUSE MIDDAY LIGHTING ACCENTUATES THIS COLORFUL BOUQUET OF FLOWERS. © ZSOLT BICZO

▲ THE EXCITEMENT AND CELEBRATORY ATMOSPHERE THAT A SPLASH OF BRIGHT COLORS EVOKES WASN'T LOST ON THE ANCIENT HINDUS, WHO CREATED THE HOLI FESTIVAL TO WELCOME SPRING WITH ALL THE COLORS AVAILABLE. © DE VISU

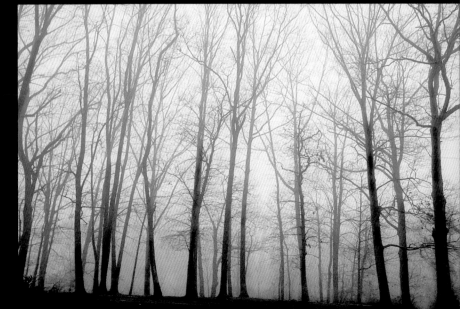

▶ WEATHER CAN HAVE A PROFOUND IMPACT ON THE PERCEIVED MOOD OF A SCENE. RAIN, FOG, SNOW, AND BRILLIANT SUNSHINE EACH IMPART DIFFERENT MOODS. FOG HAS MANY MENTAL ASSOCIATIONS RANGING FROM

Cool vs. Warm Colors

ONE OF THE SIMPLEST AND MOST EFFECTIVE WAYS TO ESTABLISH MOOD IN A PHOTOGRAPH IS TO LIMIT THE PALETTE OF HUES THAT YOU INCLUDE IN YOUR COMPOSITIONS.

By restricting the number of colors and by concentrating certain colors together you can exaggerate a particular mood or emotional climate and, if you choose your color schemes very carefully, you can stage-manage the emotional response to a particular scene. Hollywood is the master at this, of course, and the minute that they want to submerge you in a mysterious setting or perhaps foreshadow a moment of melancholy reflection, out come the blue filters. Conversely, if the director wants to fire up your passions or set the stage for lust and excitement on a tropical beach, they flood the set in brilliant golden light and populate it with women in red dresses, carrying bouquets of yellow and orange flowers.

This not-so-subtle visual manipulation of emotions through color choice works because before your mind even begins to consider what the plot of the story is or what the actors are doing or saying, your conscious and subconscious mind have been seduced by the colors. And the concept behind using warm tones vs. cool tones is something

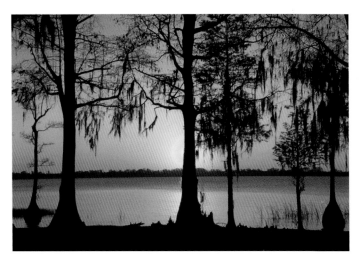

▲ IF YOU'RE LOOKING DRAMATICALLY TO WARM A SCENE, USING THE SUNSET IS A GREAT CHEAT. BECAUSE OF ALL THE SCATTERING OF BLUE LIGHT WHEN THE SUN IS AT A LOWER ANGLE, THE COLOR TEMPERATURE RISES QUICKLY PROVIDING A MUCH WARMER COLOR BALANCE. THE EFFECT IS PARTICULARLY EXAGGERATED AT SUNSET, OF COURSE, AS IT WAS HERE IN THIS SCENE OF CYPRESS TREES IN FLORIDA.

you probably consider in everything from matching clothing items in a particular outfit to deciding what colors to paint your bedroom and the colors in the bedspread you buy. Unless you're 16 it's doubtful that you'll find icy cool violet walls and a brilliant green bedspread restful. Next time you're in a hotel, notice the colors of the fabrics and walls have carefully matched in warm tones.

In photography, manipulating mood through limited color temperature range is a relatively easy thing to do whether you set out to intentionally find such scenes or use your photographic bag of tricks to establish them. A lot of times happenstance and luck are behind such settings, but it's also relatively easy to predict such color combinations if you keep a few simple concepts in mind. Time of day, for example, has a major effect on coolness or warmth: sunrise and sunset produce a cool palette while twilight provides a cooler balance.

COOL COLORS

In terms of the color wheel, the cool colors are those that fall roughly between green and violet and any mix of the colors from that half of the color wheel produce cool-toned images. A quick glance at a color wheel is a good way to know which colors should be included and which should be avoided. While it's fine to have a small area of a warm tone in a cool scene, for instance, there is a risk that the contrast between the larger areas of tone and the small spot of contrasting temperature will unbalance your intentions.

To some degree the brightness of the hues that you choose will also have an effect on the perceived coolness (or warmth) of a scene. When the cool colors you choose lean toward mid-tones or lighter they tend to shift toward a more pastel palette and often evoke feelings of calmness or restfulness—perhaps because most of us tend to think of bright summer lawns a cool green forest as calming. Cool tones in deeper tones, whether created by the situation or by underexposure, can elicit feelings of mystery or suspense, perhaps even foreboding. The deepness of the blue tones behind the fisherman, for instance, gives him a more mysterious quality.

Interestingly, violet, while a cool tone, is a particularly tricky color to work into cooler palettes because, while it is close to blues on one side in its position on the color wheel, it also borders red on the other, which is the beginning of the warmer colors. In fact, artists will often refer to violet shades as border tones. But blues and violets together can be particularly stunning as a cool-color combination, partly because they are so rarely found in nature. In the beautiful landscape shot of lavender fields in Provence, while the mood may be somewhat cool, the scene in its entirety has a very inviting feel.

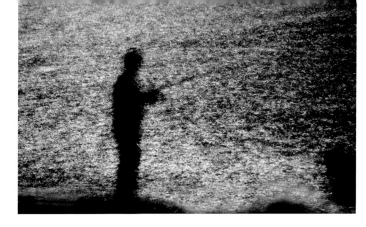

▲ I CAME ACROSS THIS FISHERMAN WHILE WALKING ALONG THE BEACH AFTER DARK AND JUST AS THE MOON WAS RISING. I WAS WITHOUT MY TRIPOD BUT DECIDED TO MAKE THIS PHOTO HANDHELD AT NEARLY TWO SECONDS WITH A 300MM LENS AND FOUND THE SILHOUETTE WITH THE ITS INHERENT SOFTNESS CREATED A VERY MYSTERIOUS AND ICY-COOL IMAGE.

Stormy weather and cloudy days or foggy are often a particularly good source of cool-color scenes and often the sky just prior to or after a story has a bluish-gray cast that bathes the entire landscape. Time of day is also important in finding certain color casts: pre-dawn and twilight are excellent times to find the landscape shrouded in deep cool colors. Try arriving well before sunrise if you're shooting dawn scenes because one the sun has crested the horizon and the golden and red hues poke through the cool colors vaporize quickly.

Speaking of storms, however, there is another side to the cooler palettes that is worth keeping in mind. Most of us associate things like winter, ice, and snow with a cool blue palette and by limiting your color range to cool tones you can exaggerate those feelings in a winter landscape. But bear in mind, for many people (particular people who live in a cold environment but have a deep aversion to winter, like myself) such scenes can be off-putting.

Psychologically and visually, another aspect of cool colors is that they are said to recede in compositions, playing a more docile role than warmer colors that appear to advance toward you. In that respect the cool blue sky before or after a storm or just at twilight may seem to settle into the distance more than a reddish sunset sky that may appear to push to the front of the composition.

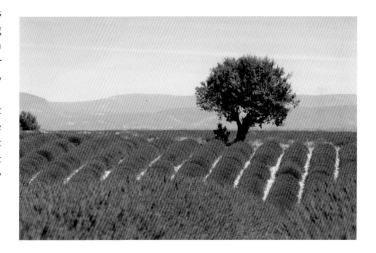

▲ THIS FIELD OF LAVENDER BENEFITS FROM THE COMPLEMENTARY GREEN OF THE TREE. THE MIX OF VIOLET, GREEN, AND BLUE COLORS CREATES A QUINTESSENTIALLY COOL-TONED SHOT. © ULTIMA THULE

▶ STREAKING SNOW AND A BLUE HOUSE PERFECTLY SYMBOLIZE THE COOLNESS OF NEW ENGLAND WINTERS. I SHOT THIS SCENE IN MY NEIGHBORHOOD AT THE START OF WHAT BECAME THE LARGEST BLIZZARD IN CONNECTICUT HISTORY.

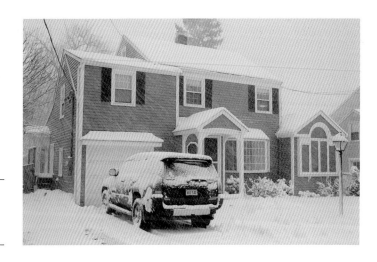

Cool vs. Warm Colors, continued

WARM COLORS

The warm side of the color wheel includes all the hues between yellow and red violet and include yellows, gold, oranges, and reds. Most of us have a natural sense for what the warmer colors are because they are reflective of shared warm experiences, both physically and emotionally—sitting beside the bright red glow of a roaring fire, feeling the sun warm our skin on a summer day or just walking along a garden path in the golden sunlight of the early morning. We've all stood on the beach at sunset, for example, so it's hard to look at the photo of the fisherman on the jetty and not imagine feelings of warmth that the scene exudes.

Even if the subject of a photo has no obvious associations with such memories, well chosen, the colors may still be potent enough to translate feelings of warmth. Jill Reger's photo of a classic American auto may or may not have summer associations for all of us, but the gold color of the car framed by the red of a nearby car elicits strong feelings of warmth. Also, the closer to the red end of the wheel that the colors are the more they tend to ramp up the passion of a scene because red is a color that we associate with extreme passion: the red flag of the matador, pouting red lips begging for a kiss, or (dare we say it) the churning fires of hell.

Time of day plays a major role in establishing a warm palette for outdoor scenes because sunlight both early and late in the day has a preponderance of hotter color temperatures. Often too, that warm lighting helps to ignite existing warm colors in a scene and

that in turn multiplies the sensation of heat. In the desert landscape that I shot in southern Arizona, for instance, the hot golden light of the late afternoon sun is warming the overall view but it is virtually igniting the bright red color of the ocotillos plants that were at the peak of bloom.

The golden hours (see pages 66-67) that follow immediately after sunrise and precede sunset are particularly rich in golden light and that is why photographers seeking to add warmth to their landscapes or portraits often choose to work in that thin sliver of time. Midday is perhaps the toughest time of day to find warm color combination because the light during the peak of the day is inherently blue and will aggressively neutralize the hot colors in a scene—stripping a field of golden grass of its otherwise yellow aura, for instance.

White balance is an important consideration when you're striving for a warm palette because the wrong setting will work against you. If you're shooting a patch of yellow flowers in early morning light, for example, it's best not to use an auto setting because the camera will try to neutralize any excessive warmth by adding blue.

If your white balance function has a color-picker option, you can fine-tune the overall balance by simply selecting a very precise color temperature (see pages 96-97). Another way to exaggerate or even fake a cool palette, of course, is by shooting in Raw and changing the white balance after the fact. We'll talk more about custom white balance settings later in this book.

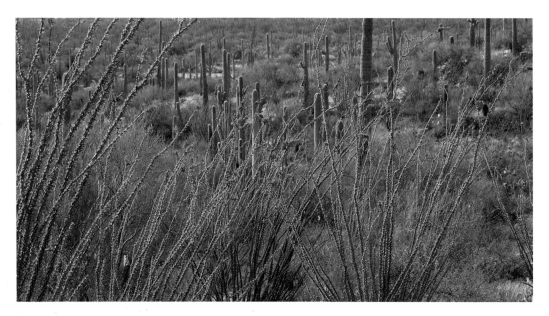

◄ THE SONORAN DESERT SOUTH OF TUCSON, ARIZONA IS NOTHING IF NOT HOT, BUT THERE IS A SURPRISING AMOUNT OF COLOR IF YOU'RE THERE AT THE RIGHT TIME.

► JILL REGER IS ONE OF THE WORLD'S MASTER CLASSIC CAR SHOOTERS AND SHE HAS A GOOD EYE FOR ISOLATING BEAUTIFUL CAR DETAILS AND POWERFUL COLOR COMBINATIONS. INTERESTINGLY, UNLIKE MANY SHOOTERS WHO PREFER WORKING AT THE EDGES OF THE DAY, REGER PREFERS WORKING IN DIRECT AFTERNOON LIGHT. SHE PHOTOGRAPHED THIS AMERICAN-MADE NASH IN A BRIGHT ARIZONA SUN CLOSE TO MIDDAY AND RELIED ON THE COLORS OF THE CARS TO CREATE THE WARM HARMONY.
© JILL REGER

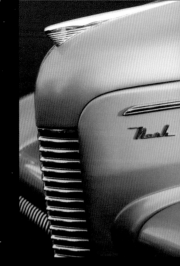

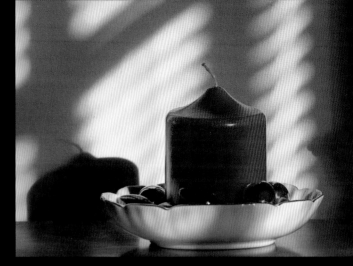

▲ LATE AFTERNOON IS A GREAT TIME TO SHOOT TABLETOP STILL LIFE SETUPS IF YOU HAVE A SOUTH- OR WEST-FACING WINDOW. IN THIS CASE THE WARMTH OF THE LIGHT WAS EXAGGERATED BY THE YELLOW WALLS.

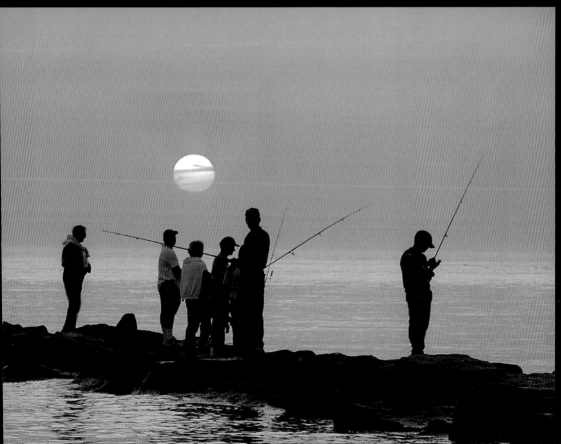

◄ I NEVER TIRE OF PHOTOGRAPHING SUNSETS AND FORTUNATELY I LIVE VERY CLOSE TO A BEACH AND CAN WANDER DOWN THE MOMENT I SEE COLOR FILLING THE SKY. WHILE THIS SCENE APPEARS TO BE FILTERED OR SATURATED IN EDITING, IT'S ACTUALLY THE RESULT OF SHOOTING WITH A VERY ORANGE WHITE BALANCE AND USING A 500MM LENS TO COMPRESS THE COLORS OF THE SEA AND SKY.

Color Contrasts

AS INTERESTING AND ENTICING AS INDIVIDUAL BRIGHT COLORS ARE TO THE EYE, OFTEN THEY BECOME MORE APPEALING WHEN THEY ARE PART OF A SMALL GROUP OF COLORS THAT CONTRAST WITH ONE ANOTHER.

A bright red barn set against a backdrop of freshly plowed brown earth is pretty, but photograph the same barn against a field of tall summer corn the contrast between red and green becomes electric. Color contrasts are strongest when the colors used are opposites, or nearly opposites, on the color wheel. The rich blue sky and bright orange flag in the scene shown here, for example, are opposites on the color wheel. One of the reasons that opposites (and near opposites) make such good contrast partners is that when two colors oppose one another on the color wheel there is always one hot color and one cold one. Interestingly, while opposites do have maximum contrast, the human brain accepts some of these complementary parings as harmonious, as well see in the next section.

Because the idea with color contrast is pit two or more colors against each other, the effect is strongest when the hues are of equal intensity and brightness. Just because red and green are opposites, for example, doesn't mean that there will be a contrast between them if one of the colors is fully saturated and the other is substantially deeper in tone or noticeably brighter. A bright red stop sign front lit by the sun set against a radiant blue sky works well because both colors are at their peak of purity and brightness. But photograph the same scene with the sign in shade and the effect is greatly diminished.

Also, while it's certainly possible to include multiple bright colors and still create a strong design from contrasting hues, such compositions are usually far more dramatic when you limit the range of colors simply because the conflict between color opposites is more obvious. It also helps to keep the areas of color fairly even in size so that there is a fair competition. That said, though, even a small spot of one saturated color can contrast nicely with a much larger field of an opposing color. In fact, this very technique is a prefect way to draw attention to a smaller subject: a single red apple in a bowl of green ones, for instance.

Finally, consider using color contrasts when there is a lack of naturally occurring tonal contrast in a particular scene. On an overcast day, for example, posing your daughter in a brilliant yellow dress against a bright blue wall will create a color dynamic that exaggerates, or even fabricates, the lighting and tonal contrast of the scene.

◄ IT'S ALWAYS FUN TO FIND EXTREME COLOR CONTRASTS AND THAT'S PART OF WHAT MADE PHOTOGRAPHING ARTIST CHRISTO'S GATES INSTALLATION IN CENTRAL PARK SUCH AN EXCITING AND COLORFUL EVENT. I WAS LUCKY TO BE THERE ON A BRIGHT BLUE-SKY DAY AND THE CONTRAST BETWEEN THE ORANGE FLAGS AND THE SKY WAS STARTLING.

▲ RED AND GREEN ARE EXACTLY OPPOSITE ONE ANOTHER ON THE COLOR WHEEL AND CREATE MAXIMUM CONTRAST. IN THIS CASE THE RED IS ALSO SOMEWHAT LIGHTER IN BRIGHTNESS AND THAT HELPS TO EXAGGERATE THE CONTRAST.

▲ WHILE THERE ARE CERTAINLY COLOR CONTRAST TO BE FOUND IN THIS DETAIL OF MEXICAN POTTERY—GREENS AND REDS AND YELLOWS AND BLUES, FOR EXAMPLE—THERE ARE JUST TOO MANY COLORS COMPETING TO ESTABLISH ONE BOLD CONTRAST. IT'S ALWAYS BEST TO LOOK FOR CONFLICTS BETWEEN JUST TWO OR, AT MOST, THREE COLORS.

▲ YELLOW AND BLUE CREATE AN ALMOST ELECTRIC CONTRAST WHEN PITTED AGAINST ONE ANOTHER. YELLOW IS ROUGHLY TWICE AS BRIGHT AS DARK BLUE IN TERMS OF BRIGHTNESS AND THAT INCREASES CONTRAST.

▲ AS COLORS GET CLOSER ON THE COLOR WHEEL THERE IS A DECREASE IN CONTRAST. WHILE PURPLE AND VIOLET/PURPLE ARE SEPARATED BY AT LEAST THREE SHADES OF BLUE ON MOST 12-COLOR WHEELS, THEY SHOW A MARKED DECREASE IN CONTRAST FROM PAIRINGS LIKE GREEN AND RED. ALSO, IN THIS PARTICULAR SHOT, THE FOLIAGE AND THE IRIS BLOSSOMS ARE NEARLY IDENTICAL IN BRIGHTNESS AND SATURATION WHICH ALSO TENDS TO SOFTEN THE CONTRAST.

Extreme Saturation

HAVING THE ABILITY TO EASILY HYPE THE SATURATION OF THE COLORS IN A PHOTOGRAPH IS A TEMPTATION THAT MANY PHOTOGRAPHERS FIND HARD TO RESIST. THERE IS JUST SOMETHING CREATIVELY LIBERATING ABOUT PUSHING THE INTENSITY OF HUES—PARTICULARLY THE PRIMARY HUES—TO LEVELS THAT WOULD SATIATE ANDY WARHOL.

And even if such colors mock reality, more than capture it, extreme saturation is a gimmick that most of us are perfectly willing to accept, at least on rare occasion. There are plenty examples of modern artists (Warhol among them) that have exploited extreme saturation to draw attention to ordinary subjects.

If you flip through photo-sharing sites like Flickr, it's easy to see that saturation—intentionally or unintentionally—has become a part of the way digital photographers see the world. Part of this is due, of course, to the fact that most cameras now have built-in saturation (that's typically turned "on" at the factory) and partly because most of us now edit and print our own images. But you don't have to rely on in-camera adjustments or even post-camera adjustments to find and capture examples of extreme saturation—there are a lot of naturally occurring situations that, when combined with a few simple techniques, lend themselves to super-saturated compositions.

Interestingly, while it may seem like this trend is something that was introduced by digital cameras, all you have to do is look back to color slide films like Fuji's Velvia to see that photographers have long had an addiction to saturation. And camera makers, always been happy to indulge the imaginations and creative fetishes of its customers, know that the livelier the colors, the more cameras they'll sell.

There's nothing wrong with pumping up the volume on color provided you accept a few basic technical and aesthetic concepts. One is that, in most cases, it's very hard for extreme hues to be reproduced accurately in a color print simply because the dyes in inkjet printers are often not pure enough to record those colors. You will go through a lot of very expensive ink in trying to translate these colors from your monitor to a piece of inkjet paper. Also, you may take a lot of criticism from more traditional photographers who see saturation as a cheap trick used to garner attention for otherwise mediocre images. But these are your pictures, so ultimately you get to decide what is fair game creatively.

It's worth noting though that most highly saturated colors are found in man-made settings rather than natural ones simply because, flowers and some birds and animals aside, nature rarely uses such intense hues. Regardless of their source, coming cross

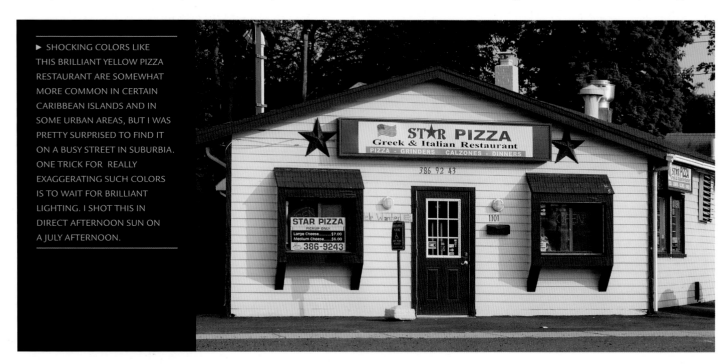

▶ SHOCKING COLORS LIKE THIS BRILLIANT YELLOW PIZZA RESTAURANT ARE SOMEWHAT MORE COMMON IN CERTAIN CARIBBEAN ISLANDS AND IN SOME URBAN AREAS, BUT I WAS PRETTY SURPRISED TO FIND IT ON A BUSY STREET IN SUBURBIA. ONE TRICK FOR REALLY EXAGGERATING SUCH COLORS IS TO WAIT FOR BRILLIANT LIGHTING. I SHOT THIS IN DIRECT AFTERNOON SUN ON A JULY AFTERNOON.

such concentrated colors is often a fairly shocking experience. I quite nearly slammed on the brakes when I first saw the brilliant yellow pizza restaurant (shown opposite) in a suburban Connecticut town so that I could pull over and photograph it.

EXPLOITING BOLD COLORS

Here are some tricks to help you intensify the effects of such bold found colors:

FILL THE FRAME: Brilliant colors work best when they dominate the composition. Don't dilute their shock value by letting lesser colors suck their intensity away.

EXPLOIT BRILLIANT LIGHTING: While midday and direct sun is overpowering and dull in many outdoor scenes, it can actually help saturate colors and works particularly well when bright colors compete with darker ones—as is the case in the shot of the pizza restaurant.

USE BACKLIGHTING FOR TRANSLUCENT SUBJECTS: Backlighting is particularly good at intensifying the colors of translucent subjects like flower petals, autumn leaves or even man-made subjects like hot air balloons.

EXPLORE AFTER A RAIN: Wet surfaces can really help saturate the colors of many natural subjects including foliage and grass. A polarizing filter (see page 104) will help remove surface reflections and help bright out the brightness of the colors in nonmetallic surfaces.

WORK IN THE GOLDEN HOURS: Many natural subjects like red rocks or subjects that have a lot of green in them appear highly saturated in low-angle and warm lighting. I shot the two saguaro cacti shot near Tucson, Arizona in late-afternoon lighting to exaggerate the saturation of the greens and contrast them against the blue of the late-afternoon sky. It might appear that the saturation was turned up a bit in editing, but I actually had to de-saturate the image in editing to get a decent print from the shot.

▼ BECAUSE THEY OFFER NO COMPETITION IN TERMS OF BRIGHTNESS OR COLORS, BLACK BACKGROUNDS OFTEN DRAMATICALLY INCREASE THE PERCEIVED SATURATION OF COLORFUL SUBJECTS.

▲ BY REMOVING SURFACE REFLECTIONS AND DARKENING BLUES SKIES, POLARIZING FILTERS CAN ENHANCE SATURATION IN MANY OUTDOOR SITUATIONS.

Color Harmony

I N THE SAME WAY THAT CERTAIN GROUPS OF MUSICAL NOTES PLAYED TOGETHER FORM A CHORD AND CREATE A PLEASING SOUND, OR THAT MANY VOICES IN A CHOIR MINGLE TOGETHER IN AN APPEALING WAY, COLORS CAN ALSO BE GROUPED TOGETHER TO CREATE VISUAL HARMONY.

Certain colors, or even variations of a single color, create a palette that is perceived by us as calming or that simply seem to produce a naturally satisfying visual relationship. Interior designers are probably the masters at combining colors in an attractive way since most people want their home environment to be a restful place.

While naturally occurring harmonies of color do exist all around us, it's still up to the discerning eye of the photographer to present them in a cohesive way. Most often combing certain colors is the result of carefully choosing which colors to include and extracting them, through point of view or cropping, to isolate them from their surroundings. To get the most impact it's important to exclude colors (or extreme variations of a particular color) that clash with or toss discord into the otherwise harmonic mix—though certainly a small area of discord can add a point of interest without completely destroying the harmony.

There are a number of techniques that you can employ to create harmonic combinations of colors and, once again, it helps to study the color wheel to better understand and visualize how these work. Following are some of the more common ways that colors are grouped in what most of us would see as an aesthetically pleasing way. Keep in mind, however that as cordial as these color combinations may seem they are by no means the most challenging or artistically ambitious ways to arrange colors—as we saw in the previous pages quite often extreme contrast and discordant color is far more interesting.

MONOCHROME COLOR

Limiting the palette of a photo to variations on a particular hue creates a very harmonious feeling regardless of which color you're using. In the photo of the Japanese garden shown opposite, for example, the composition is made up almost entirely of a variety of greens and for most of us it reflects the serenity of the location. The trick to finding monochromatic colors is usually a matter of extracting them from larger scenes. You can find a group of several different reds in a flowerbed, for example, if you use a long lens to crop out other colors that would detract from them. Some natural subjects have monochromatic harmonies built into the—a yellow rose, for example, may have shades of gold or paler yellow at its core

and red or orange at the out fringes of the petals. It's an interesting challenge to try to find subjects that are composed of variations of a single hue—try it next time you're out shooting.

ANALOGOUS COLORS

Analogous are simply those hues that are adjacent to one another on the color wheel. By combining three or four (or possibly more) of these colors together you create a very cohesive blend of hues that the brain perceives as calming. Part of this is due to the fact that most adjacent colors come from either a cool or a warm part of the spectrum. The colors of a sunset, for example, range from yellow to gold to orange and represent the warmest portion of the color wheel. Nature is a particularly rich source of analogous color groupings—think about the yellows, reds, and golds of autumn leaves, for example.

COMPLEMENTARY COLORS

Although complementary colors are opposite of one another on the color wheel very often they fall together is a way that is very pleasing to our eyes. While green and red are opposites on the color wheel, for example, they are also the colors of Christmas and most of us perceive them as a comforting combination. Again, much of this

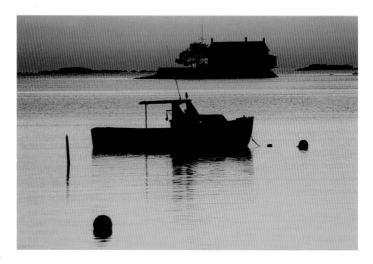

▲ SUNSETS ON A CALM HARBOR ARE A GOOD SOURCE OF MONOCHROME HARMONY BECAUSE THE WATER ACTS AS A MIRROR FOR THE SKY. IN THIS SCENE BOTH THE WATER AND THE SKY ARE NEARLY IDENTICAL IN HUE AND ONLY VARY BY THEIR BRIGHTNESS.

▲ THIS FORMAL GARDEN SCENE SHOT IN KATONAH, NEW YORK, IS MADE UP ALMOST ENTIRELY OF VARIOUS SHADES OF GREEN WITH JUST A FEW AREAS OF VERY CLOSELY RELATED YELLOWS. BECAUSE THE CONCRETE STEPS ARE NEUTRAL THEIR PRESENCE HAS NO EFFECT ON THE MONOCHROME COLOR SCHEME.

▼ IF YOU'RE LOOKING FOR GOOD EXAMPLES OF ANALOGOUS COLOR HARMONY, GARDENS ARE A GREAT PLACE TO FIND THEM. IT'S NOT BY ACCIDENT THAT THIS GARDENER CHOSE TO PUT PINKS AND PURPLE PETUNIAS IN THE SAME ARRANGEMENT—THE COME FROM THE EXACT SAME AREA OF THE COLOR WHEEL.

▲ ▼ I FOUND THIS ANALOGOUS-COLORED COUPLING ON AN OLD RAILROAD TRAIN WHILE WANDERING AN OLD TRAIN YARD IN NEW ENGLAND AND TOOK A SERIES OF SHOTS OF THE INTERESTING MECHANICAL CONNECTION. A MOMENT LATER I STEPPED AROUND TO THE OTHER SIDE OF THE TRAIN AND FOUND THAT THE RAILROAD COMPANY'S LOGO SHARED THE SAME COLOR COMBINATION.

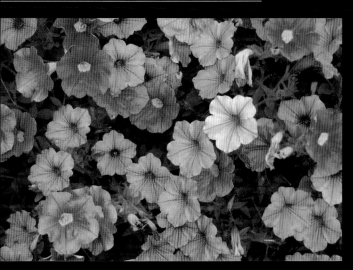

Color Harmony, continued

is no doubt a learned psychological reaction to these colors since most of us regard Christmas and the holidays a pleasant time of year. Similarly, while orange and blue are opposites, in the desert twilight scene shown opposite, the blue of the sky and the lingering orange of the sunset blend together nicely.

In fact, almost all complementary pairings can be made to have harmony but only if the brightness and saturation of the two colors are relatively similar. For instance, while yellow and violet are polar opposites on the color wheel, you can find a harmonious blend if the brightness of the yellow is toned down to more closely match the brightness of the violet (or if the violet is lightened in order to compete with the brightness of the yellow). In garden photos, for example, yellow and blue flowers often create a pleasant color harmony if their brightness is similar. Yellow and violet are also the traditional colors of Easter—yet another psychological association that helps make opposites pleasing in combination. Many flowers (like violets) also include both yellow and violet colors.

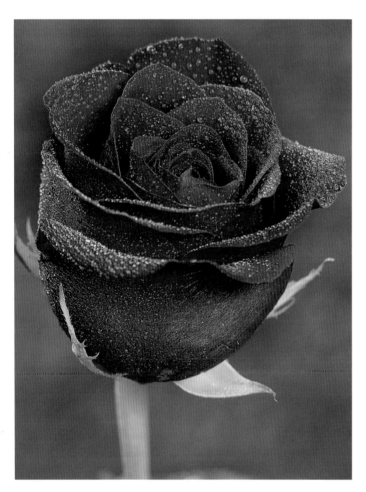

▲ RED ARE GREEN ARE POLAR OPPOSITES ON THE COLOR WHEEL BUT THAT DOESN'T STOP US FROM LIKING THE COMBINATION OR GETTING A GOOD VIBE FROM SEEING THEM—WHETHER IT'S A ROSE AND A GREEN BACKGROUND OR RED AND GREEN AT CHRISTMAS TIME.

▲ WHEN COMBINING OPPOSITE COLORS, TAKE THE BRIGHTNESS OF THE DIFFERENT COLORS INTO ACCOUNT. BECAUSE THE YELLOW DAFFODIL IS TWICE AS BRIGHT AS THE PURPLE HYACINTHS, IT WAS IMPORTANT TO MAKE IT A RELATIVELY SMALL PART OF THE COMPOSITION.

TRIADIC COLOR SCHEMES

Triadic color combinations consist of three different colors that are equidistant from one another on the color wheel. It helps to visualize these groupings if you imagine (or take the time to draw) an equilateral triangle that joins all three colors. One of the benefits of using a more complex combination of colors is that you are able to use more of the color wheel in your compositions and increase contrast among colors while still retaining a feeling of balance. In the garden photo shown opposite, for example, the three main colors are the blue-violet of the iris, the orange of the poppies and the green of the foliage. If you look at the color wheel you'll see that these three colors fall equidistant from one another.

In most cases its preferable if you make one of the colors dominant (letting it take up more space, for example, or placing it at a key spot in the composition) while letting the other two colors play supporting roles. Again, with the shot of the poppy the poppy plays the dominant role while the iris and foliage, while the other two colors remain out of sharp focus. As with complementary pairings, it helps if the brightness and saturation of the colors are similar.

THE AFTER IMAGE

One question that occurs right away is: If these colors are opposites, why do they create a feeling of harmony? Johann Wolfgang von Goethe was a great explorer of color and, in particular, the topic of color harmony. He believed that color harmony is interlinked to the "after images" that the brain creates after looking for a long time at one particular color and that the creation of these images was due to the brain's desire to establish a balance of colors (in hue, intensity and brightness). If you've ever stared at a particularly strong color—a woman in a red dress is a typical example—for many seconds and then looked away, you may have noticed that a ghost image of that color's complement (a woman in a green dress) seems to float in front of you (see the examples here) and those are exactly the images that so fascinated Goethe. If his theory is correct (and many leading artists and color theorist believe it is), then it means that complementary combinations satisfy the brain's thirst to complete certain connections around the color wheel. The result: color harmony.

▲ PHOTOGRAPHER DEREK DOEFFINGER PHOTOGRAPHED THESE TWO PERUVIAN WOMEN IN COLORFUL CLOTHES WITH THEIR ANIMAL COMPANIONS. IF YOU SEARCH THIS IMAGE CAREFULLY YOU CAN PROBABLY FIND ONE THAN ONE EXAMPLE OF TRIADIC HARMONY.
© DEREK DOEFFINGER

► VIOLET AND YELLOW COULDN'T BE MORE OPPOSITE IN TERMS OF THE COLOR WHEEL, BUT THEY ENJOY A PEACEFUL AND VERY PRETTY COMPANIONSHIP IN TWILIGHT SCENES LIKE THIS ONE THAT I SHOT SOUTH OF TUCSON, ARIZONA.

Muted Colors

DESPITE MOST PHOTOGRAPHERS' INCLINATION TO LEAN HEAVILY ON THE SATURATION SLIDER, COLORS DO NOT HAVE TO SCREAM OR DANCE OR DO COMBAT WITH ONE ANOTHER TO GET OUR ATTENTION OR TO EVOKE DEEP EMOTIONAL RESPONSE.

Often, in fact, it's the understated and subdued colors that awaken our deepest feelings and stir the imagination. These scenes, typically marked by a reduction in contrast and a lack of any saturated colors, speak in more hushed and restrained tones, tempt our eyes to explore the substance of these compositions more carefully. Rather than just quickly assimilating and accepting the brilliant flashes of color that signify a Caribbean beach scene and then moving on to the next image, for instance, muted compositions beg us to consider the lines, textures and visual weights more carefully.

Interestingly, too, with the exception of a summer garden perhaps, the world around us has far more muted palettes for you to choose from than brilliant ones. Browns (dirt, rocks, mud), rust tones (aging city buildings, decaying industrial areas) and deeper tones of green and blue (forest interiors and ocean scenes) are far more prevalent than primary colors. By consciously choosing to work with a more subtle combination of hues and tones, you vastly broaden your range of potential subjects.

All colors become more muted and take on a deeper tonality as the light and/or exposure is reduced, so often just exploring at the

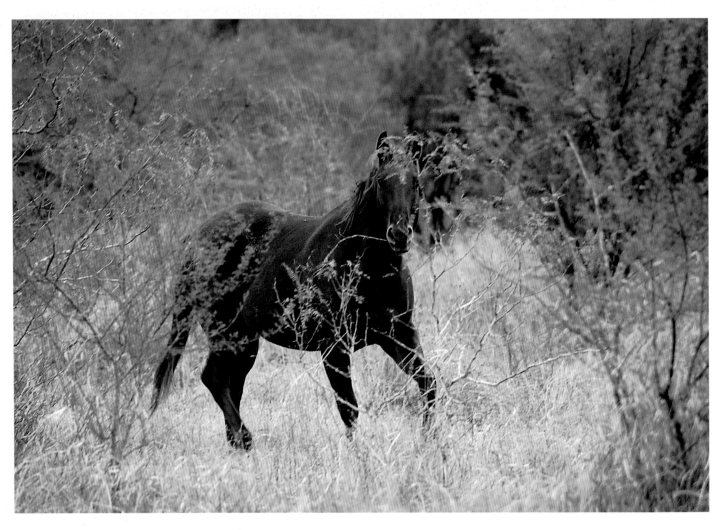

edges of the day and using a slight bit of underexposure will lead to more muted hue combinations. The best time to look for muted compositions out doors is just before dawn and in the hour or so of dusk. If you're exploring a city, for instance, rather than putting cameras away once the sun has slipped below the horizon of tall buildings sucking all the bright colors with it, look more carefully into the pale and less obvious color compositions that remain.

As handily as brilliant sunshine and blue skies have the power to intensify colors, inclement weather has tremendous power to quiet them. Haze, mist and rain shush colors quite efficiently and in so doing evoke a more romantic mood. It's helpful when you begin to work with such softened hues that you thematically match the colors to the subject.

It's easy to turn down the volume of colors by using slight underexposure using your exposure compensation control. By underexposing scenes a stop of more you effectively add diminish the brightness of all hues and so drain them of their saturation. Also, if you are working with a muted composition, be sure that you have any built-in saturation enhancements turned off in your camera's software.

▲ PARIS HAS ALWAYS SEEMED TO ME A CITY OF SOFT AND GENTLE GOLD AND YELLOW HUES AND THAT THEME WAS REFLECTED IN THIS SHOT OF GLASSWARE TAKEN A SIDEWALK CAFÉ LATE ON A SUNDAY AFTERNOON.

◄ I SHOT THIS PHOTO OF A WILD HORSE ON THE KING RANCH IN KINGSVILLE, TEXAS. THE WEATHER WAS HAZY THE ENTIRE TIME I WAS THERE AND IT TURNED OUT TO BE A BLESSING—THE OTHERWISE BRUTAL TEXAS SUN WAS HIDDEN AND THE PALETTE OF THE LANDSCAPE SOFTENED.

▲ AS THE LIGHT FADES ON A LANDSCAPE, THE COLORS NATURALLY MUTE. I SHOT THIS TWILIGHT SCENE AT A MARSH IN FLORIDA AFTER THE SUN HAD SET. THE FOREGROUND FELL INTO SHADOW BUT A PALE VIOLET REMAINED ON THE SURFACE OF THE WATER.

Neutral Colors

I N OUR NEVER-ENDING QUEST TO DISCOVER AND CAPTURE THE ENDLESS ARRAY OF HUES SUPPLIED BY THE COLORS OF THE SPECTRUM, IT'S EASY TO OVERLOOK THE FACT THAT THERE ARE THREE MORE COLORS THAT TECHNICALLY DON'T APPEAR IN THE SPECTRUM AND YET ARE A HUGE PART OF BOTH OUR VISION AND OUR PHOTOGRAPHY: BLACK, GRAY AND WHITE.

These three colors are regarded as "neutral" because in their purest form and when correctly exposed, are free of casts or tints. Unless they take up a prominent area of a composition or are the focal point of a composition, however, the eye tends to ignore neutrals because colors—even faded or highly muted colors—are just more seductive to the imagination. In lesser roles, though our brain appreciates the help given by neutral colors, we tend to ignore their presence.

There are, of course, lots of neutral colors in the world around you and many of the photos that you take will inherently include at least one and often all three. In fact, including areas of neutral tone helps enhance the appreciation of colors in a scene. A black shadow in a landscape or a close-up, for instance, can help to make the colors around it more vibrant. Studio photographers use white or gray backdrops for still life photos because their neutrality helps to focus our attention on the subject. Pitted against almost any color, neutral colors recede into the background both visually and psychologically. In the photograph of the jazz great Sonny Rollins, for example, the black background and off-centered placement in the frame adds push his figure forward in the frame, much as his music reaches forward to the audience.

Here are some tips for using each of the three neutrals:

WHITE
In terms of light, white is the combination of all colors in the visible spectrum—as Newton proved in his prism experiments (see page 12). In a photograph white subjects are particularly difficult to keep pure because they make excellent reflectors of both general and localized color casts. The overall color temperature of the light has a particularly strong effect on white subjects which is one of the things that makes it difficult to keep white subjects free of color casts.

When it comes to photographing outdoor scenes, time of day is a crucial consideration in photographing white subjects. In photographing a snowy landscape, for example, while daylight is most neutral at midday, the light is also the most harsh and more likely to blow out the fine details. If you choose an earlier or later

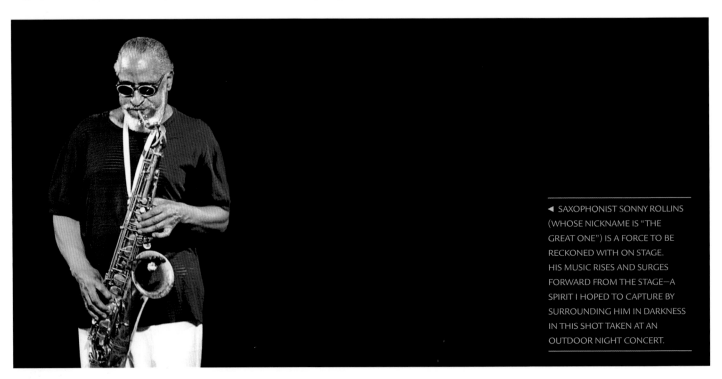

◄ SAXOPHONIST SONNY ROLLINS (WHOSE NICKNAME IS "THE GREAT ONE") IS A FORCE TO BE RECKONED WITH ON STAGE. HIS MUSIC RISES AND SURGES FORWARD FROM THE STAGE—A SPIRIT I HOPED TO CAPTURE BY SURROUNDING HIM IN DARKNESS IN THIS SHOT TAKEN AT AN OUTDOOR NIGHT CONCERT.

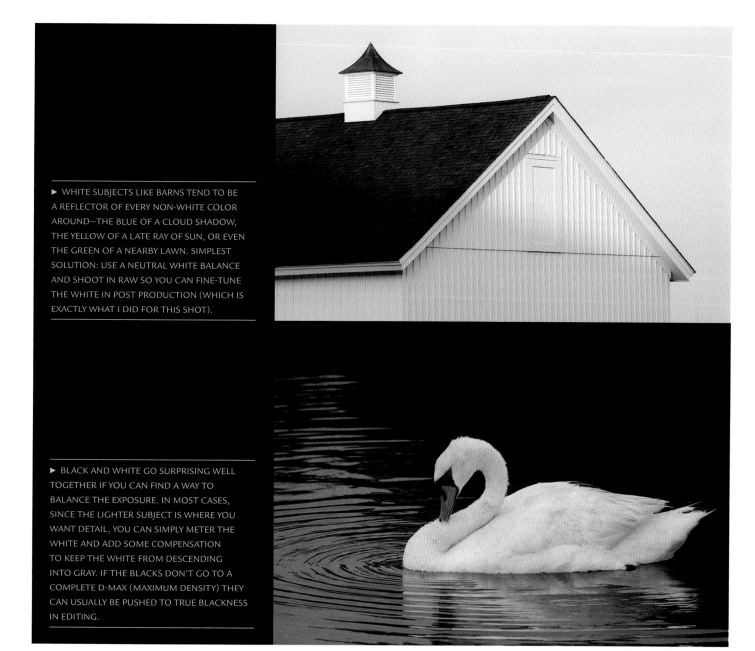

▶ WHITE SUBJECTS LIKE BARNS TEND TO BE A REFLECTOR OF EVERY NON-WHITE COLOR AROUND—THE BLUE OF A CLOUD SHADOW, THE YELLOW OF A LATE RAY OF SUN, OR EVEN THE GREEN OF A NEARBY LAWN. SIMPLEST SOLUTION: USE A NEUTRAL WHITE BALANCE AND SHOOT IN RAW SO YOU CAN FINE-TUNE THE WHITE IN POST PRODUCTION (WHICH IS EXACTLY WHAT I DID FOR THIS SHOT).

▶ BLACK AND WHITE GO SURPRISING WELL TOGETHER IF YOU CAN FIND A WAY TO BALANCE THE EXPOSURE. IN MOST CASES, SINCE THE LIGHTER SUBJECT IS WHERE YOU WANT DETAIL, YOU CAN SIMPLY METER THE WHITE AND ADD SOME COMPENSATION TO KEEP THE WHITE FROM DESCENDING INTO GRAY. IF THE BLACKS DON'T GO TO A COMPLETE D-MAX (MAXIMUM DENSITY) THEY CAN USUALLY BE PUSHED TO TRUE BLACKNESS IN EDITING.

time of day (or work on an overcast day), however, you will almost certainly confront issues of either very warm or very cool light coloring the snow.

As an example, I photographed the white barn shown above late in the afternoon and while some of the barn hard a local area of yellow light falling on it (toward the peak) much of the barn had a faint blue cast created by the shadow of a passing cloud. I had not just one but two color casts to contend with, but I was able to neutralize the much of the bluish cast in editing and return the barn to more clean white. The pocket of yellow in the upper part of the image was realistic and so I kept it. In a situation like this is virtually

impossible to get a pure white in the camera and so you either have to accept the cast or make some corrections in editing.

Another difficult aspect of capturing white subjects is exposure. Even a slight amount of overexposure will cause a loss of detail and underexposure will shift the subject to gray. Since there is no way to recall detail lost to overexposure it's important to keep an eye on the histogram when shooting white subjects. As soon as you see the graph bunching up against the right border of the histogram you'll know that some areas have blown out; the only solution is to either reduce exposure or come back when the light is softer or less brilliant and highlights are simpler to control.

Neutral Colors, continued

BLACK

Black represents the absence of all color and while we rarely go out looking for black subjects to photograph, black can be a useful and creative element in many types of color compositions. Black works particularly well as a backdrop for close-up subjects, for instance, because it makes showcases the primary subject. I used a deep shadow background and slight underexposure to photograph the poppy buds shown below to focus attention on both the plant's texture and color. Black also works surprisingly well in combination with a white subject (again, see the swan image shown on the previous page, for example) because the contrast makes the subject more prominent.

When it comes to photographing silhouettes, black shapes can actually become the primary element of a composition and any colors that are included (as in the sunset behind the fishing boat rigging) become secondary.

In many compositions (particularly when you intend to print the results) a solid black becomes the tonal foundation of the image. It's important then that however you use black, whether primary or supporting role, that it's a true black—any hint of detail or gray undermines the authority of the black. While some black subjects (an asphalt road, perhaps) benefit from having some detail or surface detail, blacks will start to pick up a color cast in many situations if they're not properly exposed and this takes away from their strength. It's easy to think your blacks are rich when looking at them on a monitor with lots of contrast, but once printed they often show up as a dark gray. It's important therefore that you use your editing controls to be sure you've got an absolute black free of any detail.

GRAYS

A true gray in photography, what photographers often refer to as "middle gray" is a tone that is actually halfway between pure black and pure white. Having this knowledge can be very practical when it comes to setting exposure because all meters are calibrated to give their most accurate readings from a pure middle gray. If you take a reading from a middle gray source (an 18-percent gray card, which we'll discuss on page 120), for example, all of the remaining tones will be exposed correctly (within the limits of the dynamic range of the sensor). Not all grays that you see in the natural or man-made worlds are a middle gray, of course, since by definition grays can fall anywhere between black and white.

One of the benefits of having grays in your photographs, particularly when they occupy a large area, is that they help to

▲ AN ALREADY-DARK BACKGROUND IS FURTHER OBSCURED BY BEING OUT OF FOCUS, AND THUS DIRECTS ALL ATTENTION TO THE DELICATE TEXTURES OF THE SUBJECT.

▲ RUSTY OLD CAST IRON SUBJECTS LIKE LOCOMOTIVES OFTEN HAVE A BEAUTIFUL WARMTH THAT IS HARD TO FIND IN MOST MAN-MADE SUBJECTS. I WANDER OLD RAIL YARDS A LOT LOOKING FOR INTERESTING BITS OF RAILROAD HISTORY.

create a neutral core in the image. Gray becomes a sort of road map for your visual system and from it your brain can detect true white true black and the real values of the remaining colors. That's the good news.

The bad news is that it's rare that you'll find such a perfect gray to photograph, since grays are completely dependent on the amount of light hitting them and that changes moment to moment. What is important is that by keeping your eye on the surroundings and the color temperature of the light, you can prevent unwanted color casts from shifting grays to another color—and again, at more extreme times of day, that can be a tall order. There is nothing inherently wrong with a gray area shifting to a warmer or cooler tone, but it's something to stay aware of when you're shooting.

If you're photographing a gray weathered barn on an overcast day, for example, you're likely to end up with a barn that is more blue than gray. There are three solutions to that problem: come back when the lighting is more neutral, use lens filters to correct for the excessive blue light or (and this is by far the simplest solution) shoot in Raw and adjust the white balance and color balance of the image after the fact.

▲ GRAY SKIES ARE A GREAT NEUTRAL SUBJECT BECAUSE THEY NOT ONLY PROVIDE A SIMPLE BACKGROUND BUT THEY ADD DRAMA TO OTHERWISE COMMONPLACE SCENES.

▲ METERING SNOW IS TRICKY. BEST BET: FIND A MIDDLE-GRAY SUBJECT LIKE THIS HEADSTONE AND TAKE A CENTER-WEIGHTED READING. LOCK THAT READING IN YOUR MANUAL-EXPOSURE MODE AND YOU'RE GOOD TO GO FOR ANY SCENES THAT ARE IN SIMILAR LIGHTING.

▲ LOTS OF SCENES HAVE NEUTRAL TONES BUILT INTO THEM. I FOUND THIS STREET IN THE LITTLE TOWN OF AMBOISE, FRANCE AND WAS SURPRISED THAT ALMOST EVERY BUILDING WAS A PERFECT MIDDLE GRAY—WONDERFUL FOR METERING.

Exploiting a Dominant Color

WHILE IT'S TEMPTING AND CERTAINLY CHALLENGING TO SEARCH OUT INTERESTING COMBINATIONS OF COLORS— TO CREATE CONTRASTS OR TO EMPHASIZE A WARM OR A COOL COLOR THEME, FOR INSTANCE—NOT EVERY PHOTOGRAPH HAS TO OFFER A RAINBOW OF COLORS TO BE INTERESTING.

Many appealing compositions, in fact, can be built around a dominant single color and often a single color—particularly a bold hue—can have more drama than an image that has a full range of colors. Pictures that boast just a one color are usually quite eye catching and often they take people by surprise because it's so rare that individual colors are isolated. Also, single-color images displayed side-by-side in groups can create a nice web gallery or print collection. I've found at least one Flickr (www.flickr.com) group based on this idea and some of the photos are extremely creative.

There are a few different ways to approach capturing a single color. As we saw in the previous pages, you can use variations of a single color to create a monochromatic harmony where one color permeates the entire composition. Used in this way restricting the scene to a single color has a unifying quality that pulls together the various graphic elements of the composition.

You can also use the power of a single brightly colored object to startle the viewer by giving it unexpected dominance. Something as simple as a lone pumpkin becomes a bold graphic statement that is more about the color of the object than the object itself. The human

▼ FOR A PHOTOGRAPHER THERE'S NOTHING QUITE SO EXCITING AS STUMBLING UPON A RADIANT COLOR EXAMPLE. IN THIS CASE I WAS COMPLETELY TAKEN BY THE BLUE WALL BUT HAD TO SEARCH TO FIND A DETAIL THAT WOULD CREATE A PHOTO—THE DRINKING FOUNTAIN WAS THE PERFECT SOLUTION.

▼ ORANGE IS A COLOR THAT'S SOMEWHAT HARD TO FIND IN NATURE—BUT THERE SOME GREAT EXAMPLES TO BE FOUND— AUTUMN LEAVES, ORANGES, ORANGE FLOWERS AND, OF COURSE, PUMPKINS.

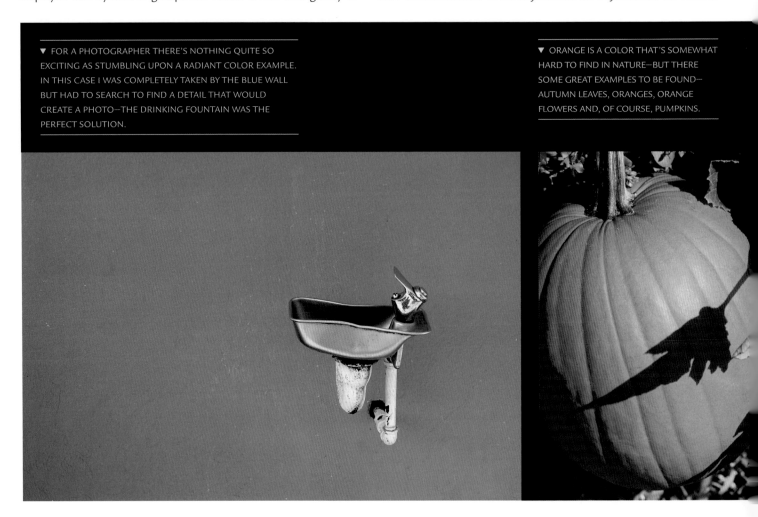

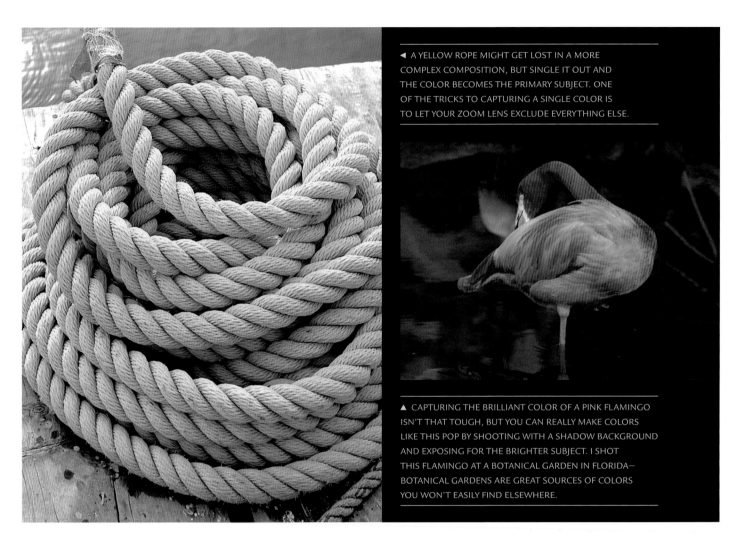

◀ A YELLOW ROPE MIGHT GET LOST IN A MORE COMPLEX COMPOSITION, BUT SINGLE IT OUT AND THE COLOR BECOMES THE PRIMARY SUBJECT. ONE OF THE TRICKS TO CAPTURING A SINGLE COLOR IS TO LET YOUR ZOOM LENS EXCLUDE EVERYTHING ELSE.

▲ CAPTURING THE BRILLIANT COLOR OF A PINK FLAMINGO ISN'T THAT TOUGH, BUT YOU CAN REALLY MAKE COLORS LIKE THIS POP BY SHOOTING WITH A SHADOW BACKGROUND AND EXPOSING FOR THE BRIGHTER SUBJECT. I SHOT THIS FLAMINGO AT A BOTANICAL GARDEN IN FLORIDA— BOTANICAL GARDENS ARE GREAT SOURCES OF COLORS YOU WON'T EASILY FIND ELSEWHERE.

mind also makes immediate and largely subconscious associations with particular colors based on our own experiences or cultural backgrounds. For most of us red means stop, green means go and yellow means caution—we barely need the words on such signs to complete the thought.

The trick to isolating single colors, of course, is to use either lens choice or vantage point, or both, to isolate the subject from its surroundings. Exposure can also play a role too if there is sufficient contrast between the primary subject and its background. In the case of the pink flamingo, for example, I intentionally underexposed the scene to create a bolder contrast between the brightly colored bird and the muddy background. Essentially the image becomes one

about the flamboyant color of the bird and its shape rather than a traditional wildlife shot.

In either case, when you underscore a single color it's important that the subject has other design qualities that hold the interest— shapes, forms, textures, for instance—in order to hold your viewer's interest. It's easy to grab someone's attention with a shocking color, but if the photo has no other depth or meaning, it runs the risk of just becoming so much visual bubble gum and has no lasting appeal. Though abstraction (as we'll see later in this book) often uses bold colors and shapes without the need for additional justification.

Patterns

THERE IS SOMETHING ABOUT PATTERNS, PARTICULARLY PATTERNS BUILT UPON OR THAT INCLUDE THE REPETITION OF COLORS, THAT IS VERY SEDUCTIVE TO THE HUMAN IMAGINATION.

Go into a fabric store sometime and you'll see walls of patterned fabrics that are just calling out to be examined and admired (not to mention bought). We're attracted to patterns partly because they're pretty and interesting, but also because they appeal to our need for stability and balance in the world around us, as well as our deep sense of curiosity. Whether man-made or natural, patterns cause the eye to linger and explore: Where does this pattern begin? Where does it end? What is its purpose? Landscape designers are masters at using the repetition of colors to lure us from one garden bed to the next with an almost magnetic force that begs us to explore.

Patterns can be created from any graphic element that repeats itself—lines, shapes, forms, texture and, of course, colors. The strongest patterns are built from several graphic elements combined—color and shape or color and texture, for instance—and this combination of repeating elements reinforces the design and makes it even more irresistible. In the shot of the lobster floats that I photographed beside a Rhode Island harbor, for instance, the shape of the floats provides one level of repetition while the single color helps to unify and reinforce the pattern. The shot would have worked just as well had the floats been of several colors, but strongest if a small group of colors repeated themselves in some sort of regular pattern—repeating triplets of red, green, blue, for instance.

Patterns are probably easier to find in man-made subjects simply because humans design and build things using repetition as both a structural and design element. Objects like lace, the brickwork of a

patio or the rows of seats in a baseball stadium are all created by repeating certain elements whether for structural or purely aesthetic reasons. And because architects and structural designers understand the influence and power of color, it is often built into these patterns for purely decorative reasons. Other times colorful patterns are built into man-made structures because they provide some reinforce or reveal some significant social or cultural influence—as in the intricate mosaics used in the design of mosques, for example.

Finding patterns is sometimes just a lucky event and you stumble upon them—a colorful row of umbrellas at a bus stop, for example, but more often you have to put on your visual detective glasses and search them out. Nature, for example, is an abundant source of patterns but again, often they're so familiar to us that we ignore the beauty. Fern fronds have wonderfully intricate and exacting repetition, but often you have to hold a plant up the light or against a dark background to see that pattern.

One of the keys to seeing patterns is to learn to look beyond the object itself and try to explore it in terms of its structure and then find a vantage point that helps bring out that design. In the shot of the giant agave plant photographed at a Texas botanical garden, I was first attracted by the size and color of the plant, but when I got closer to it I was caught by the spiral pattern of its blades. By isolating just the core of the plant the eye is drawn immediately to the pattern.

▼ SOME PATTERNS DON'T EVEN EXIST UNTIL YOU BRING THEM OUT THROUGH A CREATIVE EXPOSURE. THESE LIGHT PATTERNS WERE CREATED BY USING EXPOSURES OF .8 SECONDS AND 1.3 SECONDS.

◄ PATTERNS POP UP WHERE YOU
LEAST EXPECT THEM. I FOUND THESE
CANDLES IN VERY ORDERLY ROWS IN
NOTRE DAME CATHEDRAL IN PARIS.

◄ NATURE IS A GREAT LOVER
OF PATTERN. THINK ABOUT THE
MANY PATTERNS YOU CAN FIND IN
YOUR OWN YARD: SPIDERS WEBS,
FLOWER PETALS, FROST MARKS ON
A WINTER WINDOW, AUTUMN
LEAVES IN ON THE LAWN—ALL
WAITING TO BE DISCOVERED.

Chapter 3:

Time of Day, Weather, & Seasons

Although the light of the sun may leave that star and head toward the Earth as an equal-opportunity illuminator, by the time it reaches our eyes (and your camera's sensor), many factors will profoundly change the actual spectrum of colors that we see. In fact, one of the most mysterious and humbling aspects of how daylight affects our surroundings is that there are no two days, not even any two instants, when the world will look exactly the same. And while such constant change is great fodder for philosophical meanderings, it's even better news for photographers looking for new interpretations of the world around us.

One of the primary factors that effects how we perceive daylight and color is, of course, the time of day. Though the shifts in light and color may sometimes occur too slowly to notice, and our eyes are wonderfully adept at canceling out most minor changes, daylight is perpetually re-inventing the world from the time that the first rosy sprays of dawn begin etching the horizon until the last purplish glimpses of the dusk yield to the blackness of night. Daylight changes continually in its direction, its intensity, and in its quality and with those changes come transformations in the texture, shape, form and, of course, color of everything that surrounds us.

If you want to witness just how brazen the changes in light are over just a single day, plant your camera on a tripod and shoot one frame every ten minutes from dawn until darkness. You'll be surprised at just how stark the differences are from hour to hour. Changes in weather have an equally radical effect on the way that light, colors, textures, and even shapes are perceived. And those changes, in turn, alter our psychological perceptions. A harbor filled with boats that has a calm, upbeat cheerfulness on a sunny summer afternoon is spun with mystery and romance in the bluish glow of a morning fog and becomes positively sinister in the thrashing and gray-green light of a violent thunderstorm.

But perhaps the most stunning changes of all occur with the slow-motion passage of seasons: In spring the blue-green mist of an emerging chlorophyll curtain descends on the dormant shapes of trees and then is quickly replaced by a thousand shades of green in summer. And in autumn, those same leaves enter the next phase of their life cycle and ignite the landscape in a torrent of red, gold, and orange. Then, as if to remind us that all life is a cycle, the stark shapes of the trees return as winter recalls the Earth to rest. When you look at the world around you through the eyes of change, whether swift or protracted, it's hard to imagine that you could ever be bored with a camera in hand.

Morning & Afternoon Light

PERHAPS MORE THAN SUBJECT MATTER, LIGHTING, AND COMPOSITION, COLOR SETS THE MOOD OF A SCENE. MOOD IS OFTEN DESCRIBED AS THE EMOTIONAL CLIMATE OF A PHOTOGRAPH AND CAREFULLY CHOOSING OR ISOLATING PARTICULAR COLORS, OR COMBINATIONS OF COLORS, WILL VASTLY ENHANCE THOSE EMOTIONAL REACTIONS.

In most cases viewers are powerfully affected by the colors of a scene well before they've had a chance to study or even acknowledge the details of the subject.

The hours between the morning golden hour and mid- to late morning, and then again between mid-afternoon and the start of the afternoon golden hour are probably the prime picture-taking times for most people simply because that is when we are most active. If you're traveling or have the day off from work, you're between meals and you can turn your thoughts to more important matters—like shooting a lot of interesting pictures.

These two time periods are when light is most abundant and also when there are fewer tough decisions to make about exposure since the lighting, in both direction and intensity, remains fairly constant for longer periods of time. This slower pace allows you to devote more energy to considering things like vantage point, composition and exposure. While sunrise and sunset may be more colorful and certainly more dramatic, they also demand much faster decision making behind the camera. Also, since there are no dramatic color tints as there are at dawn/dusk or during the golden hours, there are fewer choices to be made about white balance or potential filtration issues.

In other words, while these may not be the most theatrical hours of the day, they are certainly among the most cooperative and they are well worth exploring.

MORNING LIGHT

Once the sun has cleared the horizon and the morning mist has burned off there is a very quiet and pretty period of a few hours that, while relatively neutral in color, has a particularly pretty quality. I find this the one of the best times to work in my garden, for example, because once the warm morning glow has faded a bit the colors of the flowers are at their most accurate and yet the angle of the light is low enough to provide some interesting back- or side lighting.

It's also a nice time to explore in open field and near harbors because there is no glare yet from a high overhead sun and the colors tend toward a softer and more pastel palette. In the shot of the fishing boat heading out for the day, for instance, there is still a pinkish glow on the water, but the sun is not so high as to be wreaking havoc with exposure or causing the spectral highlights that are so common during midday.

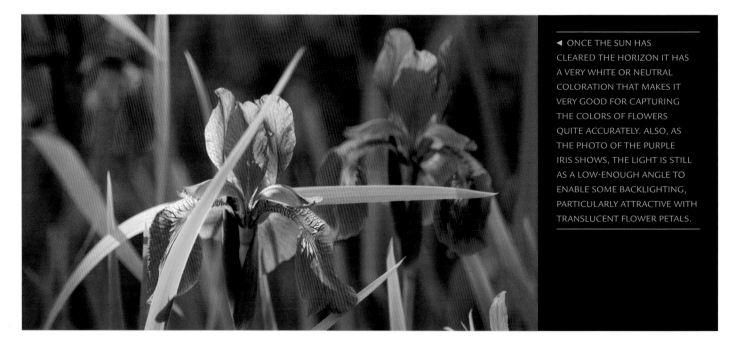

◄ ONCE THE SUN HAS CLEARED THE HORIZON IT HAS A VERY WHITE OR NEUTRAL COLORATION THAT MAKES IT VERY GOOD FOR CAPTURING THE COLORS OF FLOWERS QUITE ACCURATELY. ALSO, AS THE PHOTO OF THE PURPLE IRIS SHOWS, THE LIGHT IS STILL AS A LOW-ENOUGH ANGLE TO ENABLE SOME BACKLIGHTING, PARTICULARLY ATTRACTIVE WITH TRANSLUCENT FLOWER PETALS.

► EARLY LIGHT CAN ALSO GET QUITE HARSH, AS THIS SCENE OF SKATERS ON MONTPARNASSE BLVD IN PARIS ON A SUNDAY MORNING SHOWS. FROM THIS POINT ON, AS THE SUN CONTINUES TO CLIMB IN THE SKY, THE SHADOWS WILL GET SHORTER AND THE LIGHT EVEN MORE INTENSE.

▼ AS THE SUN RISES IN THE SKY IT PROVIDES AMPLE LIGHT FOR USING SMALL APERTURE TO GAIN GOOD DEPTH OF FIELD. DEREK DOEFFINGER USED A 16MM LENS AND AN APERTURE OF f/10 WITH A 1/100 SECOND SHUTTER SPEED TO CAPTURE THE ALL THE DETAIL OF THIS WONDERFUL SCENE OF SUNFLOWERS. © DEREK DOEFFINGER

▼ EVEN WHEN THERE IS A CLOUD COVER EARLY IN THE MORNING, AS THERE WAS WHEN I SHOT THIS FISHING BOAT HEADING OUT FOR A DAY OF FISHING, THERE IS OFTEN A WARM GLOW REMAINING FROM SUNRISE. AS LONG AS THE SUN HAS BROKEN THROUGH A FEW CLOUDS, THERE IS USUALLY A LINGERING COLORFUL GLOW, PARTICULARLY NEAR THE WATER.

Morning & Afternoon Light, continued

AFTERNOON LIGHT

The light in the mid to late afternoon is somewhat similar to that of mid-morning but because the sun has past its zenith for the day and there is often a slightly harder quality to the light—though for a few hours, at least, the light also remains fairly free of the color casts. In the reverse of the morning period, the light is starting to descend toward the horizon and is now beginning to pick up warmth and the shadows are again starting to lengthen.

This is actually my favorite time of day to begin serious shooting because I know that from this point forward the light will only get warmer and softer and colors will begin to pick up intensity. Because the light is still relatively high, however, I have an abundance of light to work with and technical considerations like using small apertures to gain depth of field are working in my favor. Also, unlike morning where the light is rising quickly and the harsh qualities of midday are looming ever closer the light will grow increasingly soft making shadows longer and more open—it's a wonderful time for landscape shooting.

▼ I SHOT THIS PHOTO OF COTTAGES ALONG LONG ISLAND SOUND SHORTLY AFTER THE HISTORY-MAKING STORM HURRICANE SANDY BATTERED THE SHORE. THE AFTERNOON LIGHTING IS AT A LOW-ENOUGH ANGLE TO ILLUMINATE THE FRONT OF THE PARTIALLY BOARDED UP COTTAGES.

◀ AFTERNOON LIGHT IS OFTEN LOST AT STREET LEVEL IN CITIES LIKE MANHATTAN, BUT TALL BUILDINGS LIKE THE CHRYSLER BUILDING SHOWN HERE ARE ABLE TO CATCH THE LIGHT NICELY.

▼ BECAUSE OF ITS NEARNESS TO THE EQUATOR THE SUN IN SOUTHERN FLORIDA IS RARELY GENTLE. EVEN THOUGH THIS LIFEGUARD STATION WAS SHOT AROUND 5:30 P.M. AT THE EDGE OF WHAT WOULD BE THE GOLDEN HOUR FURTHER NORTH, THE LIGHT REMAINS BRILLIANT AND NEUTRAL.

▲ AS THE AFTERNOON PROGRESSES TOWARD THE GOLDEN HOUR THE WARMER LIGHT IGNITES THE COLORS OF THE LIGHTSHIP OVERFALLS IN LEWES, DELAWARE—ONE OF ONLY 17 REMAINING LIGHTHOUSE SHIPS.

▲ ONE OF THE PRETTIEST TIMES OF DAY ALONG THE SHORE IS WHEN THE LATE-AFTERNOON LIGHT BEGINS TO TRANSITION TO THE MORE INTENSELY COLORED GOLDEN HOUR (WE'LL DISCUSS THE GOLDEN HOUR LATER IN THIS CHAPTER).

Midday Light

F OR SOME REASON WHENEVER I THINK ABOUT TAKING PHOTOS AT MIDDAY I RECALL THOSE OLD GUNFIGHT SCENES IN WESTERN MOVIES WHERE THE GUNFIGHTERS SET UP THE SHOWDOWN FOR HIGH NOON.

It was probably the worst possible time for a gun duel because the light is typically extremely harsh, there's an ocean of glare and the eyes of the person you're trying to outdraw are lost in the shadow of his gunslinger's hat. How are you going to see that little telltale flicker in his eyes and beat him to the draw when his angry stare is lost in the shadow of his hat brim?

For photographers, a lot of the same issues with midday light are just as objectionable. While midday is a great time to eat lunch, take a nap after a hard morning of shooting or scout new picture locations that are best explored later in the day, it's generally an awful time to be taking photographs. One reason, of course, is that the lighting during these hours, just as it must have been at the OK Corral on that fateful day, is brutally hard and directional. As a result, contrast is extreme, shadows are pitch black and highlights tend to be completely un-recordable.

▲ LIGHT IN THE MIDDLE OF THE DAY IS ALMOST ENTIRELY FREE OF COLOR TINTS THAT ARE FOUND EARLY AND LATE IN THE DAY. THE WHITE BLOSSOMS AND WHITE CLOUDS IN THIS SCENE HAVE A VERY CLEAN AND NATURAL LOOK BECAUSE OF THIS NEUTRALITY—ANOTHER POSITIVE ASPECT OF MIDDAY LIGHTING.

▶ IF THERE IS ONE THING THAT MIDDAY DOES PROVIDE ON CLEAR DAYS IT'S A LOT OF LIGHT AND BRILLIANT COLORS. FOR SOME SUBJECTS LIKE THIS RURAL IOWA SCENE, THOSE QUALITIES CAN OFTEN OUTWEIGH THE TRADITIONAL PREJUDICES AGAINST SHOOTING AT THIS TIME OF DAY.

Also, since midday light is coming almost straight down much of the year, the lack of modeling from shadows strips scenes of their depth and a lot of their texture. Often, in fact, you can look at the shadows of a scene and tell what time the picture was taken. In the shot of the Iowa farm road, for example, the shadow of the pickup truck is almost directly underneath the bed of the truck (it was shot at about 1 p.m.). In delicate subjects like close-ups or still life compositions, such overhead spotlighting obliterates subtleties in tonal gradations and, particularly in portraits, creates very unflattering shadows. Black Bart is never going to buy extra prints from you if he can't even admire his own baleful gaze.

But, at least in terms of color, midday light also has some admirable qualities. For one, because the color of light at midday is very neutral it provides highly accurate colors, particularly with light-toned neutral subjects that easily pick up color tints from the ambient light. If you are photographing a white subject like the dogwood blossoms shown opposite, for instance, getting a pure white is far simpler under a noon sun that it is at other times of day. Whatever you lose in subtlety you gain in neutrality—it's up to you to decide if that's a fair trade-off.

Also, because the light is strongest at this time of day, color contrasts are often at their most brilliant and if extreme contrasts or saturation are what you're after, then you it may be worth accepting (even enjoying) the higher contrast. And, as you can see in the shot of the trapeze artists, blue skies can be radiant in the middle of the day and with certain subjects that can be a blessing. Photographically speaking, there are few things (gunfights aside) that I try to avoid photographing more than outdoors scenes with a blah gray or white sky.

Finally, because of its intensity, midday light can also create glare, particularly on painted surfaces that can obliterate color completely.

▲ ONE OF THE OBVIOUS DOWNSIDES OF MIDDAY LIGHT IS THAT OFTEN YOU ARE CONFRONTED WITH LARGE AND UNMANAGEABLE SHADOWS. IN THIS SCENE OF AN OLD WEATHERED BARN IN AMHERST, MASSACHUSETTS, I COUNTERBALANCED THE SHADOW BY USING AN AREA OF COLOR THAT'S ROUGHLY TWICE AS LARGE.

▶ IF THERE IS ONE THING THAT BRINGS FEELING OF HOPE AND CHEERFULNESS TO AN OUTDOOR SCENE IS A BRILLIANT BLUE SKY. BY PURE COINCIDENCE THE PRIMARY COLOR OF THESE TRAPEZE ARTISTS' COSTUMES IS A SLIGHTLY DEEPER SHADE OF BLUE.

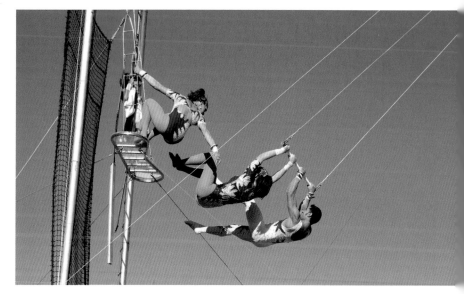

Golden Hours

IF THE MIDDLE OF THE DAY IS THE LEAST PREFERRED TIME OF DAY FOR MOST OUTDOOR PHOTOGRAPHERS, THEN CERTAINLY THE MOST FAVORED IS WHAT PHOTOGRAPHERS REFER TO AS THE GOLDEN HOURS.

This is a title—part metaphorical and part descriptive—for the first hour or so after sunrise and the hour or so just before sunset. It's in these sweet short windows of time that the land lights up with a warm golden glow that illuminates virtually everything in its path. Even relatively mundane subjects—like the concrete drawbridge shown here—take on a decidedly dramatic and rich coloration.

The actual duration of the golden lighting depends on a few factors that include the time of year, your location on the earth and also atmospheric factors like cloud cover and air pollution levels. Because of these factors the intensity of the golden hours changes from day to day and it's really impossible to predict what its golden lighting is barely noticeable. I live near a national wildlife refuge with a large marsh on the shores of Long Island Sound and some days I'll drive past it's completely ho-hum; other days it's just aglow and there are photographers and tripods lined up along the shore.

My personal observation is that light tends to be warmer at the end rather than the beginning, but that could be because I'm not a devout morning person and so I've seen a lot more late afternoons than I have golden mornings. There is, however, a kind of reversal of timing between the morning and evening golden hours. In the morning when the sun first clears the horizon the light is very warm but lightens quickly to a more neutral tone as the sun rises. At the end of the day, on the other hand, as the warm light intensifies and then suddenly shuts off, as if someone hit a switch, once the sun hits the horizon.

In either case, you can intensify the effect quite a bit with slight underexposure of about a stop. Also, I prefer to shoot in the Raw mode because then I can make non-destructive adjustments to the white balance during import—either increasing or decreasing color temperature. Often when I'm shooting in the southwest deserts, for example, the red rocks take on an intense reddish luminescence that some shots are nearly impossible to print and so I'll cool them down slightly in post-production.

▼▲ ONE OF THE GREAT THINGS ABOUT SHOOTING IN THE GOLDEN HOUR IS THAT THE LIGHT PAINTS SUBJECTS ANEW AND WITH A RICH AND UNEXPECTED SATURATION. I SHOT THIS BRIDGE A FEW MILES FROM MY HOME AND HAVE SHOWN IT TO LOCAL FRIENDS WHO DON'T RECOGNIZE IT AND ASK IF IT WAS SHOT IN ANOTHER PART OF THE WORLD. THE COMPARISON SHOT WAS MADE ONLY 20 MINUTES BEFORE THE MORE GOLD-COLORED SHOT.

◄ STILL WATERS MAKE A PERFECT REFLECTIVE SURFACE FOR THE GOLDEN LIGHT OF BOTH EARLY MORNING AND LATE AFTERNOON—JUST BE SURE TO TURN AWAY FROM THE SUN TO GET THEIR FULL EFFECT. I SHOT THIS SCENE NEAR STONINGTON, MAINE ABOUT A HALF HOUR BEFORE THE ACTUAL SUNSET.

◄ SEDONA'S RED ROCKS ARE ALREADY BRILLIANTLY COLORED, BUT DURING THE GOLDEN HOURS THEIR COLORS RADIATE WARMTH.

Sunrise & Sunset

FOR SHEER BRILLIANCE OF COLOR AND HIGH NATURAL DRAMA, FEW SUBJECTS CAN BEAT A GOOD SUNRISE OR SUNSET. WITH NATURE DOING MOST OF THE HEAVY LIFTING FOR YOU BY PROVIDING THE DRAMATIC SKIES, ALL THAT YOU REALLY HAVE TO DO IS FIND A NICE FOREGROUND TO HANG IN FRONT OF THAT PRETTY BACKDROP AND YOU'LL GET A WINNER OF A SHOT.

Some may say that shooting a lot of sunrises and sunsets if a cheap path to photographic glory, but if nature hands you beautiful gifts each and every day, don't ask questions—just load up and shoot.

Is there a difference in the colors or intensity of colors between sunrise and sunset? From my own experience (and this is partly dependent on where you live, I think) sunrises tend to have more yellow and pink while sunsets tend to be carry more red and orange colors. One reason for this is air pollution. The more particulate matter there is in the atmosphere, the more the longer blue wavelengths scatter and the stronger the warm reddish (and shorter wavelength) rays that reach the Earth—which is the reason that sunsets (see pages 68-69) are also more vivid in highly polluted areas. And since there is more pollution generated during the day from traffic and factories, sunsets tend to be more colorful. Score one for air pollution.

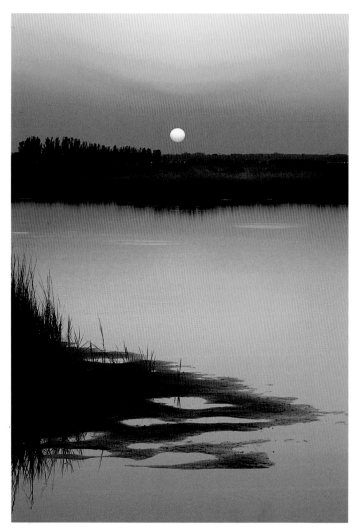

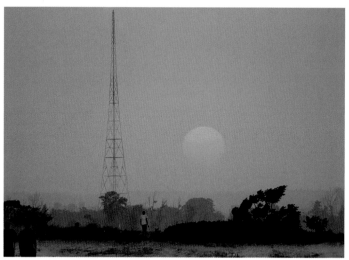

▲ ON EXTREMELY HAZY DAYS THE SUN BECOMES A GENTLE COLORFUL BALL IN THE SKY AND ON THIS DAY SEVERAL WINDSURFERS STEPPED AWAY FROM PACKING UP THEIR GEAR TO PAUSE AND WATCH.

◄ THE CALM WATER OF MARSHES AND BOGS MAKES A PARTICULARLY GOOD FOREGROUND FOR SUNRISES AND SUNSETS BECAUSE THE WATER REFLECTS THE COLOR OF THE SKY. THE MORE STILL THE WATER, THE BETTER THE REFLECTIONS.

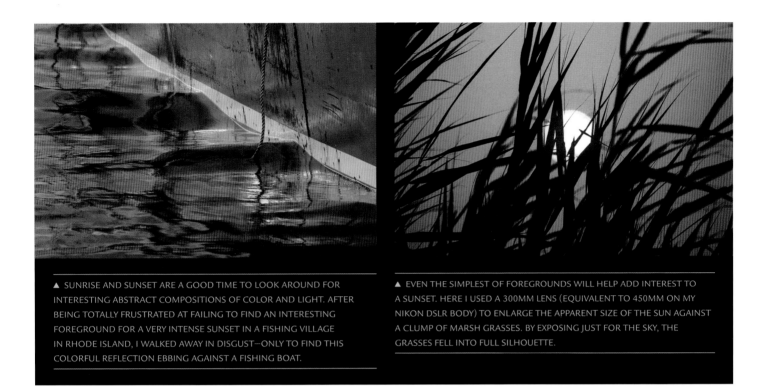

▲ SUNRISE AND SUNSET ARE A GOOD TIME TO LOOK AROUND FOR INTERESTING ABSTRACT COMPOSITIONS OF COLOR AND LIGHT. AFTER BEING TOTALLY FRUSTRATED AT FAILING TO FIND AN INTERESTING FOREGROUND FOR A VERY INTENSE SUNSET IN A FISHING VILLAGE IN RHODE ISLAND, I WALKED AWAY IN DISGUST—ONLY TO FIND THIS COLORFUL REFLECTION EBBING AGAINST A FISHING BOAT.

▲ EVEN THE SIMPLEST OF FOREGROUNDS WILL HELP ADD INTEREST TO A SUNSET. HERE I USED A 300MM LENS (EQUIVALENT TO 450MM ON MY NIKON DSLR BODY) TO ENLARGE THE APPARENT SIZE OF THE SUN AGAINST A CLUMP OF MARSH GRASSES. BY EXPOSING JUST FOR THE SKY, THE GRASSES FELL INTO FULL SILHOUETTE.

SHOOTING A LOW SUN

Here are some tips that can help you get the most from each opportunity and that will hopefully increase the number of keepers that you shoot:

METER AWAY FROM THE SUN: Be sure to exclude the sun in your meter readings or you'll end up grossly underexposing the overall scene. Many if not most sunsets end up being silhouettes anyway, but you want the colors of the sky, clouds and any well-lit foreground subjects to be true to their colors. Try to take a meter reading from just above or to the left or right of the sun and then use your exposure lock feature to hold that reading (just keeping the shutter release half pressed will lock the meter and focus). Slight underexposure from your sky reading will help to saturate colors, but an exposure that is too dark will muddy them.

HIDE THE SUN: If the sky is relatively clear and the sun is particularly intense, look for something to hide it behind—a tree, a church steeple, etc. Shooting directly into the sun, particularly on a clear day, will obliterate the foreground and create uncontrollable lens flare. By hiding the sun itself you still get the colors of the sky but your foregrounds are not overwhelmed by the brightness.

SHOOT IN RAW: I shoot in Raw almost 100% to the time now, so it's habit for me. But if you make that decision on a shot-by-shot basis, sunrises and sunset are a good time to shoot in Raw because it gives you an opportunity to revisit both color temperature and exposure.

GET THERE EARLY AND STAY UNTIL LATE: If you're shooting sunrises, try to arrive before the sun actually slips over the horizon because there is often a colorful glow—particularly on mornings after a storm when there are a lot of clouds. Similarly, at sunset there is often an afterglow once the sun has set that ignite the clouds with color. I see so many people with cell-phone cameras come to the beach and shoot the sunset only to leave before the real show has begun. Hang out for 10 minutes after the sun sets and see if you don't get a second show.

TURN AROUND AND FACE THE EAST: So often we're so intently focused on capturing the sunrise or sunset we fail to turn and look at the landscape that is being illuminated.

Pre-dawn & Twilight

COMPARED TO THE SCORCHING BURST OF FIERY COLORS THAT SUNRISE AND SUNSET UNLEASH AT THE BEGINNING AND END OF THE DAY, TWILIGHT AND THE HALF HOUR OR SO BEFORE SUNRISE BATHE THE LANDSCAPE IN A COOLER AND SUBTLER PALETTE OF BLUES, VIOLETS AND SOFT PURPLES.

These are colors that you don't see in great quantity that often and, although many photographers ignore these times of the day, I find them to be exceptionally pretty. In fact, at the end of the day, I frequently find myself completely ignoring the sunset while I search out good potential twilight scenes. Emotionally too, I like the feeling of twilight since it conveys a gentler, more reflective mood that begs quiet contemplation and a sense of closure, perhaps more than any other time of day. The emotional tide is a bit different at dawn since there is that element of hope being conferred by the promise of the soon-to-be-rising sun.

▼ WHETHER IT'S THE WARMTH OF DAYBREAK EDGING INTO THE DARKNESS OR THE DARKNESS CLOSING OFF THE SUNSET, THE BLENDS OF COLORS AT THESE TIMES OF TRANSITION IS JUST PLAIN BEAUTIFUL.

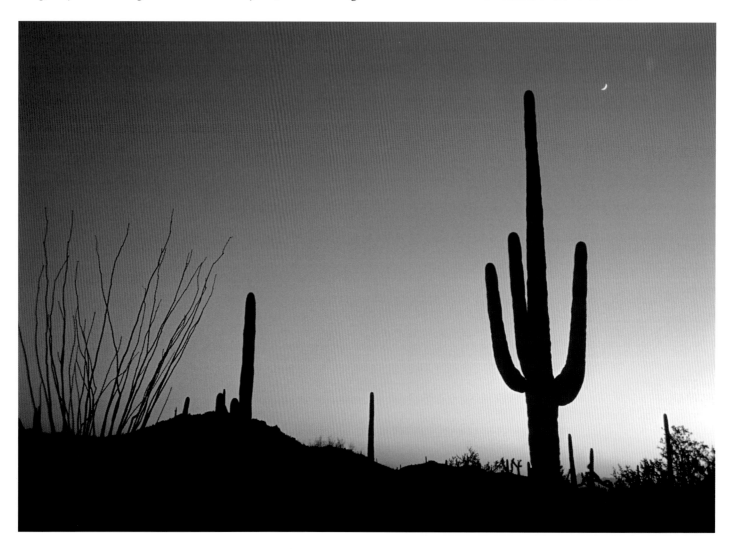

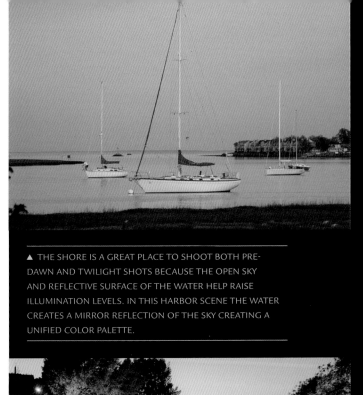

▲ THE SHORE IS A GREAT PLACE TO SHOOT BOTH PRE-DAWN AND TWILIGHT SHOTS BECAUSE THE OPEN SKY AND REFLECTIVE SURFACE OF THE WATER HELP RAISE ILLUMINATION LEVELS. IN THIS HARBOR SCENE THE WATER CREATES A MIRROR REFLECTION OF THE SKY CREATING A UNIFIED COLOR PALETTE.

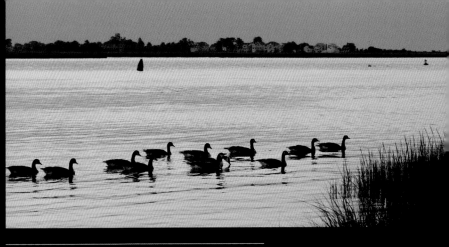

▲ DUCKS FLOAT ALONG IN SILHOUETTE AS THE REFLECTED GLOW OF TWILIGHT LINGERS IN THE WATER.

▲ THE SEINE AT TWILIGHT OFFERS A MIX OF ARTIFICIAL LIGHTS ILLUMINATING THE BANKS AND LIGHTS FROM A DINNER BOAT SET AGAINST THE FADING GLOW OF SUNSET.

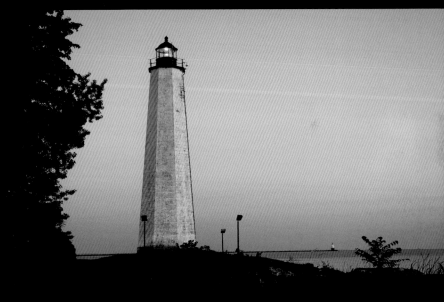

▲ BECAUSE LIGHT IS DIM AT BOTH EXTREMES OF THE DAY, A TRIPOD IS MANDATORY FOR USING THE FULL RANGE OF SHUTTER SPEED AND APERTURE COMBINATIONS. .

Often the pre-glow of dawn and the afterglow of sunset morph into the darkness and create interesting transitions in the sky. At twilight, for instance, the sky often blends from tangerine to sapphire—a very pretty effect that you can see in the twilight shot of the desert. In places where artificial lighting mixes with the colors of twilight you'll often encounter similar blends of warm and cool colors, more so at twilight then dawn. City skylines (see page 144), urban scenes and even carnivals are good examples where the warmth of the incandescent (or more typically these days, vapor lamps) mixes with the blue of twilight. While I enjoy photographing carnival rides after dark, for instance, I find that the best shots are produced when the lights of the rides have been turned on and the sky is illuminated in blue light.

In open landscapes and near the shore, the light reflecting from the sky at twilight often lingers for quite a long while (particularly during the longer days of spring and summer) and provides enough for you to experiment with both composition and exposure. In photographing the harbor scene, for example, I began shooting immediately after the sun had set and was able to continue trying different compositions and vantage points for almost a half hour before the twilight gave way to night. You get a similar opportunity at the beginning of the day but because the landscape is still emerging from darkness you're gaining in light rather than losing it and you can continue to shoot right into the golden hours (having said that I really should make an effort to get out of bed earlier—and so should you).

Color & Exposure

BECAUSE CHANGES IN EXPOSURE HAVE THE SUM EFFECT OF EITHER LIGHTENING OR DARKENING COLORS, EVEN SLIGHT CHANGES IN EXPOSURE CAN HAVE PROFOUND EFFECTS ON THE OVERALL INTENSITY OF THOSE COLORS AND THEIR RELATIONSHIPS.

As we discussed in the section on color vocabulary (page 22), colors have three distinct qualities: hue (what most people refer to as the color of an object), saturation (the purity of the color) and brightness. Exposure in photography controls the last factor in the same way that an artist can alter brightness by adding either white paint to lighten a color or black or gray paint (or a particular color's complement) to darken the color.

Is there a difference in the colors or intensity of colors between sunrise and sunset? From my own experience (and this is partly dependent on where you live, I think) sunrises tend to have more yellow and pink while sunsets tend to be carry more red and orange colors. One reason for this is air pollution. The more particulate matter there is in the atmosphere, the more the longer blue wavelengths scatter and the stronger the warm reddish (and shorter wavelength) rays that reach the Earth—which is the reason that sunsets (see pages 68–69) are also more vivid in highly polluted areas. And since there is more pollution generated during the day from traffic and factories, sunsets tend to be more colorful. Score one for air pollution.

In photography we can create the same result by simply adding or subtracting light in order to get the exposure "right." But exposure, being a highly subjective quality (at least in artistic terms) means that you get to experiment with exposure until you get the brightness levels for the colors that you think are correct. Adding or subtracting light strongly affects the apparent saturation of colors because as you add light the color brightens and the saturation gets less intense and as you subtract light it appears to be more saturated. By changing brightness you are essentially altering the apparent purity of the color. The shot of the Massachusetts barn, for instance, the red of the barn seems far more saturated on the underexposed half of the frame.

Because the LCD of a digital camera is a rather poor and inadequate way to judge exposure and color, it's often better to cover your own back with a backup exposure system. Far and away the best way to accomplish this is to take all of your photographs using the Raw exposure format (provided your camera offers that option). The Raw format allows gives you at least a four-stop range (two stops over and two under) exposure adjustment after the fact. Unlike other types of exposure correction (the curves or levels controls in Photoshop, for example), changing the exposure during the Raw conversion/import is a non-destructive method of editing. We'll talk more about this option in the last chapter of this book.

If your camera lacks the ability to capture images in Raw or if you don't want to spend the time with the extra editing chores, another simple way to capture a range of different exposures is to use your camera's auto-exposure bracketing feature. Most cameras (and certainly all DSLR cameras) will let you shoot a series of frames while varying the exposure for each individual frame—typically either in whole stops or incremental stops. The actual number of frames you can fire off in any one sequence depends on the range the camera offers, but even three frames exposed in full-stop brackets will provide a good range of exposure choices.

More importantly, by using HDRI techniques (high dynamic range imaging—see pages 112–113) and HDR imaging software, you can actually combine this series of exposures into a single final exposure providing you with a vastly expanded dynamic range—and a more accurate and enhanced color palette. By shooting a series of three exposures, for instance, you can shoot one frame that exposes for the shadows, one for the middle tones and a third for the highlight areas. In that way you can get a more accurate color rendition for colors that fall within each of these distinct dynamic areas.

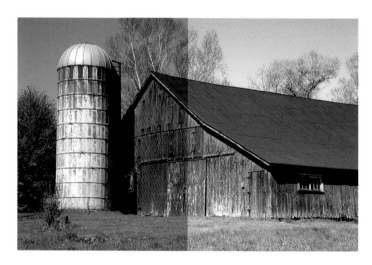

▲ EXPOSURE HAS AN OBVIOUS EFFECT ON COLOR SATURATION: THE LESS EXPOSURE YOU GIVE A SUBJECT THE MORE SATURATED THE COLORS APPEAR AND VICE VERSA.

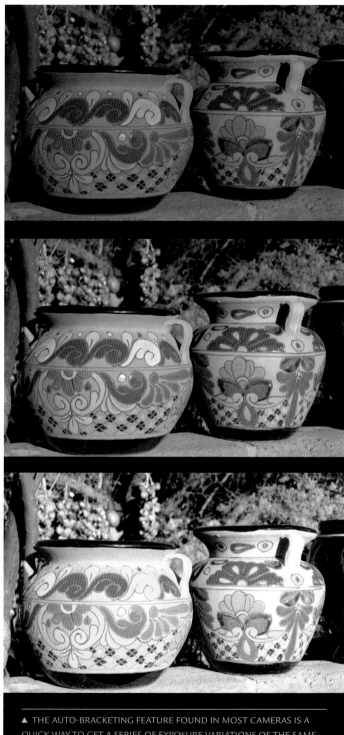

▲ THE AUTO-BRACKETING FEATURE FOUND IN MOST CAMERAS IS A QUICK WAY TO GET A SERIES OF EXPOSURE VARIATIONS OF THE SAME SHOT. YOU SELECT THE PARAMETERS AND THE NUMBER OF FRAMES YOU WANT TO EXPOSE AND THEN THE CAMERAS FIRES A RAPID SERIES OF EXPOSURES. IN THIS CASE I FIRED A SERIES OF THREE FRAMES WITH A VARIANCE OF 1.3 STOPS BETWEEN THEM.

▲ GOOD COLORS BEGIN WITH A GOOD EXPOSURE. A QUICK SHORTCUT TO AN ACCURATE EXPOSURE: METER DIRECTLY FROM A PATCH OF BLUE SKY USING YOUR CENTER-WEIGHTED METERING MODE.

▲ BACK IN THE SLIDE FILM DAYS THE TRADITIONAL ADVICE WAS, "...EXPOSE FOR THE HIGHLIGHTS AND PRINT FOR THE SHADOWS." PHOTOGRAPHERS KNEW THAT IF THE WHITES WASHED OUT, THERE WAS NO WAY TO RESURRECT THE LOST DETAILS. IT'S IMPORTANT THEN TO KEEP AN EYE ON YOUR HISTOGRAM AND MAKE SURE NO IMPORTANT HIGHLIGHTS ARE TOUCHING THE RIGHT EDGE.

Directional Light

As the earth spins on its axis and slowly rotates around the sun on its lazy year-long cycle, the direction of the light striking the world around us changes—hour to hour, morning to afternoon and even season to season.

Shadows trade places with highlights, textures are born and then evaporate and objects swell with volume and then are depleted of it. The direction of light acts as an invisible hand, quietly sculpting everything we see in form, shape, texture and, of course, color.

Though we don't often associate changes in the direction of light with changes in color, the two are inexorably linked. The brassy overhead light of a noonday sun, for example, obliterates the gentle gradation of hues in a flower blossom, while those same nuances are scooped up and embraced by the soft low-angle backlight of early morning or late afternoon light. Understanding the relationship between light direction and color is an important aspect of controlling the look of your photographs.

TOP LIGHTING

Top lighting, typical of the middle hours of the day, is like a big bright spotlight bearing down on everything we see, usually stripping scenes of any sense of depth and often (but not always) washing away surface textures. Colors can be quite radiant under this light, but downward shadows will ruin portraits with facial shadows and specular highlights are common on shiny surfaces like metal or water.

FRONT LIGHTING

Light that comes directly at your subject from the front is pretty typical of the low-angle illumination early and late in the day. The nice thing about this lighting is that it's typically on the warm side and also it tends to cast shadows behind subjects, often hiding them entirely. Front-lit colors are often rendered with good saturation and have a lot of contrast, though like top lighting, most scenes lack a sense of depth and textures are hidden. I find bright front-lit colors irresistible in a lot of situations where the subjects have a lot of inherent color, as in the shot of the bags of clams on a wharf awaiting shipping.

▲ MIDDAY LIGHT SOMETIMES GETS A BAD RAP FOR ELIMINATING TEXTURES, BUT OCCASIONALLY THE TOP-DOWN LIGHTING ACTUALLY ENHANCES THEM—AS IN THIS SHOT OF A PEELING WOODEN SCULPTURE FOUND IN AN ANTIQUE STORE COURTYARD.

◄ SOMETIMES YOU'RE STUCK WITH THE LIGHT YOU'RE GIVEN. I SHOT THIS PHOTO OF ELLIS ISLAND'S ENTRANCE FROM THE DECK OF A FERRY AND WE WERE ONLY STOPPED FOR A FEW MINUTES, SO THIS WAS THE LIGHTING I HAD TO DEAL WITH. THE COLORS ARE BRIGHT AND THE SHADOWS ARE KIND OF INTERESTING SO IN THIS PARTICULAR CASE I WASN'T TOO DISTURBED BY THE TOP LIGHTING.

▲ BRIGHT DIRECT ARIZONA SUN WAS HITTING THIS ADOBE WALL OF THIS GIFT SHOP IN THE TINY TOWN OF TUBAC SOUTH OF TUCSON ON A LATE AUTUMN AFTERNOON. THE COLORS ARE VIBRANT, BUT TEXTURES ARE ALMOST NONEXISTENT.

▲ BAGS OF CLAMS AWAITING TRUCKING SIT ON A NEW ENGLAND WHARF. THE FRONT LIGHT OF EARLY MORNING WAS PERFECT FOR ILLUMINATING THE BRIGHT COLORS. EXPOSURE IS EASY WITH FRONT-LIT SCENES BECAUSE THE LIGHTING IS VERY EVEN ACROSS THE ENTIRE SUBJECT.

Directional Light, continued

SIDE LIGHTING

Light coming from the side of your subjects can be a very dramatic and beautiful light both in the way that it models subjects and in the way that it affects colors. Because the light is scraping along the surface of your subjects (as it is in the shot of the carousel horse), shadows recede, highlights are lifted and the surface gets a highly three-dimensional appearance—a gorgeous quality for many subjects. Landscapes, in particular, can benefit from this type of modeling, so long as the shadows don't conflict with or obscure important subject lines (the shadows of trees distracting from the a field of a meadow of yellow hay, for example). Also, because most side-lit situations occur early and late in the day, there is a substantial amount of warmth that tends to romanticize colors and exaggerate their apparent saturation.

BACKLIGHTING

Whenever the light is coming from behind your subject, particularly with landscape and close-up subjects, it creates a very dramatic illumination that outlines shapes and often ignites colors in a very intense way. Backlighting has a particularly powerful effect on translucent subjects such as flower petals and autumn foliage because it's actually passing through those subjects and making them seem to glow from within. Finding backlight is easy: just work when the sun is low and position yourself so that you're shooting directly into the sun (and ignoring your father's advice never to do that).

There are some tricky aspects to working with backlight. For one, it's important to keep the sun out of the frame, otherwise the light will dominate the composition and likely obliterate much of the delicacy of that you were trying to capture. Also, exposure can be tricky with backlit scenes because the meter is going to be very affected by the brilliance of the light and, unless you compensate for that in the exposure, you'll end up with a silhouette at best (and at worst you'll end up with a black foreground with an abstract pattern of overexposed rays of light). In addition, any direct light hitting your lens is likely to create lens flare that will diminish sharpness and often creates bright reflections of the aperture in the frame. The best solution is to switch to the manual-exposure mode and meter the scene while carefully excluding the sun. Alternately the auto-bracketing mode or shooting in Raw will help.

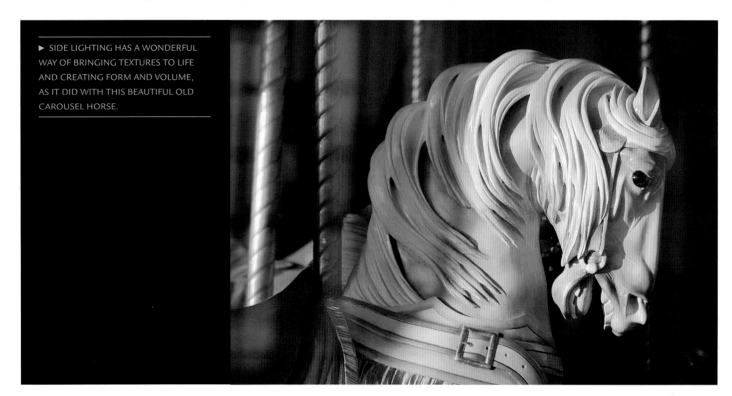

▶ SIDE LIGHTING HAS A WONDERFUL WAY OF BRINGING TEXTURES TO LIFE AND CREATING FORM AND VOLUME, AS IT DID WITH THIS BEAUTIFUL OLD CAROUSEL HORSE.

▲ WINDOW LIGHT IS OFTEN A GOOD SOURCE OF SIDE LIGHTING LATE IN THE DAY. I PHOTOGRAPHED ONE OF MY CATS SITTING IN A PUDDLE OF LIGHT WASHING HER PAW AND THE LATE AFTERNOON LIGHT BROUGHT OUT THE SOFT TEXTURE OF HER FUR.

▲ THE SUN POURING THROUGH AUTUMN FOLIAGE IS A WONDERFUL TREAT TO STUMBLE UPON, PARTICULARLY HERE IN NEW ENGLAND WHERE I LIVE. EXPOSURE IS A BIT TRICKY THOUGH AND HERE I USED THE RAW MODE SO THAT I COULD MAKE ADJUSTMENTS AFTER THE FACT. RECENTLY I'VE BEGUN EXPERIMENTING MORE WITH HDRI TECHNIQUES AND LIKELY NEXT TIME THAT IS HOW I WOULD EXPOSE THIS SCENE TO CAPTURE A BETTER DYNAMIC RANGE.

CHOOSING A BACKDROP

I shot this stem of bleeding heart flowers in the garden alongside my garage late on a spring afternoon. The first shot was made with the sun coming over my shoulder with the sun hitting the front of the flowers and the blossoms positioned with a dark shadow in the background. To make the backlight exposure, I simply walked to the other side of the plant and shot back toward the sun. The translucent quality of the blooms becomes very obvious with the sun passing through them. Which version do you prefer?

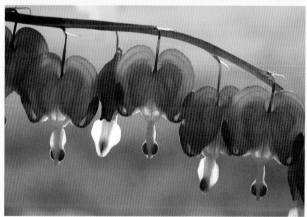

Weather: Fog, Mist, & Rain

STORM CHASERS ASIDE, THERE PROBABLY AREN'T TOO MANY PHOTOGRAPHERS THAT LOOK FORWARD TO BAD WEATHER DAYS—PARTICULARLY WHEN THEY'RE TRAVELING AND WATCHING EXPENSIVE DAYS LITERALLY GOING DOWN THE DRAIN.

In many ways, however, fog, mist and even rain can add a lot of romance and even a sense of mystery to otherwise ordinary scenes. And in many ways changes in weather like this re-invent the landscape around you, giving you an entirely new world to photograph.

Fog and mist have a particularly pretty effect on the landscape because they mute colors, often turning primary hues into gentler pastel shades and completely eliminate high contrast issues. In fact, one of the challenges that you often face on foggy days is finding a way to add small areas of contrast back into the scene to help accentuate the effects of the fog and to give scenes depth. One method is to include a bright spot of color or a dark shape somewhere in the frame as a visual counterpoint. In the shot of the fishing boat, for instance, I used the closer dark shape of the pilings in the foreground to provide some visual weight to balance out the large area of foggy sky.

In terms of color, heavy fog creates very monochromatic scenes that typically lean toward cool blue tones. You can use a white balance adjustment to warm up the colors or you can use a color balance tool in editing to reduce the blue, but I think that cool colors enhance the moodiness of the fog so I tend try not to neutralize them too much. A light morning mist, on the other hand, will often pick up the warm color of the morning sun that can be particularly pretty with woodland scenes or even empty city streets, but you have to work fast before the heat of the day burns away the mist.

Exposing for foggy or misty scenes is a bit tricky because both reflect a lot of light and that fools meters into thinking there is more light available than actually exists. Even a good matrix meter can be fooled into underexposing such scenes unless you use some means for adjusting exposure. The best solution is to add a stop or two of exposure using your exposure compensation feature.

Rain has a very similar effect to fog and mist, stealing away contrast and softening colors in wider views, but many colored surfaces become highly saturated when wet and so this can actually create more vivid colors. Autumn foliage, as we'll discuss later in this chapter, often becomes more intensely colored after a rain. One trick for capturing those saturated colors during or after a rain is to use a polarizing filter to remove surface reflections; by cutting through the reflected light of the wet surfaces, the true colors are revealed.

THE FOG EFFECT

Because fog increases the scattering of blue light, fog scenes often have a blue tint. It's easy enough to neutralize the coolness in-camera using white balance controls, or after the fact using a number of color balance tools. Here is the scene as captured (the blue version) and a less-blue version cleaned up in editing. The effects of the fog are more apparent in the cooler version, but which is better is a subjective decision.

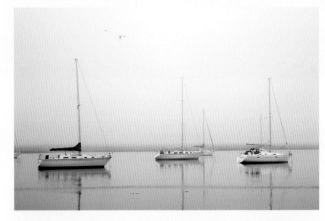

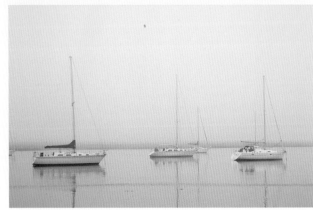

▶ TO BALANCE OUT LARGE, RELATIVELY BLANK AREAS OF FOG OR MIST, FIND A SMALL, DARK FOREGROUND SUBJECT OR A BRIGHTLY COLORED OBJECT.

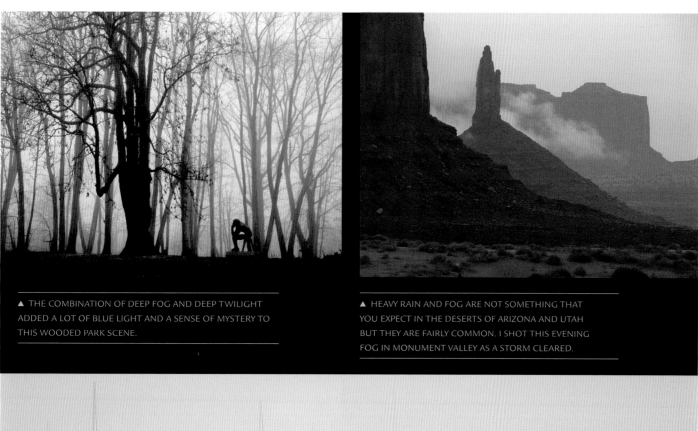

▲ THE COMBINATION OF DEEP FOG AND DEEP TWILIGHT ADDED A LOT OF BLUE LIGHT AND A SENSE OF MYSTERY TO THIS WOODED PARK SCENE.

▲ HEAVY RAIN AND FOG ARE NOT SOMETHING THAT YOU EXPECT IN THE DESERTS OF ARIZONA AND UTAH BUT THEY ARE FAIRLY COMMON. I SHOT THIS EVENING FOG IN MONUMENT VALLEY AS A STORM CLEARED.

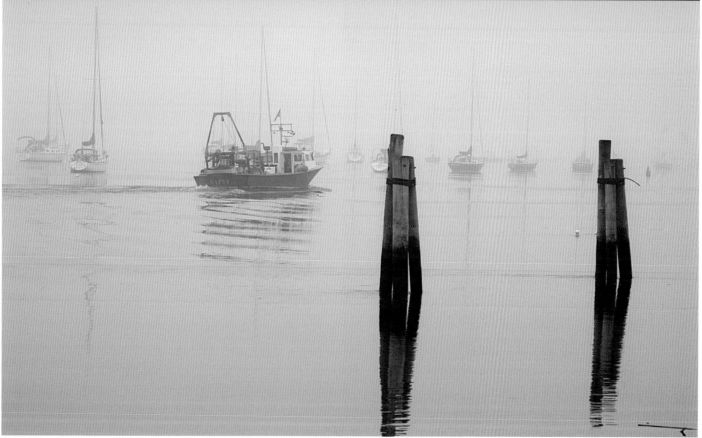

Stormy Skies

BEFORE THE ADVENT OF THINGS LIKE DIGITAL BAROMETERS, WEATHER SATELLITES AND THE WEATHER CHANNEL, AN EXPERIENCED SAILOR COULD TELL YOU ALMOST EVERYTHING ABOUT THE WEATHER JUST BY GLANCING UP AT THE SKY AND STUDYING THE CLOUD SHAPES AND PATTERNS AND THE DIRECTION IN WHICH THEY WERE MOVING.

"Red sky at night, sailor's delight, red sky at morning, sailor take warning" is more than a casual adage; for pre-digital sailors it was often life-saving advice. While that kind of shirtsleeve navigation may be a dying art, for photographers, arriving and departing storms offer a buffet of great aerial dramatics.

As the sun becomes obscured and clouds formations begin to stir, the sky and sun mingle in some incredible ways. And interestingly, often the most dramatic skies follow the worst weather days. I photographed the somewhat biblical-looking sunset sky shown here after a disappointing rainy day looking for pictures on the Connecticut shore. About a half hour before the sun began to set,

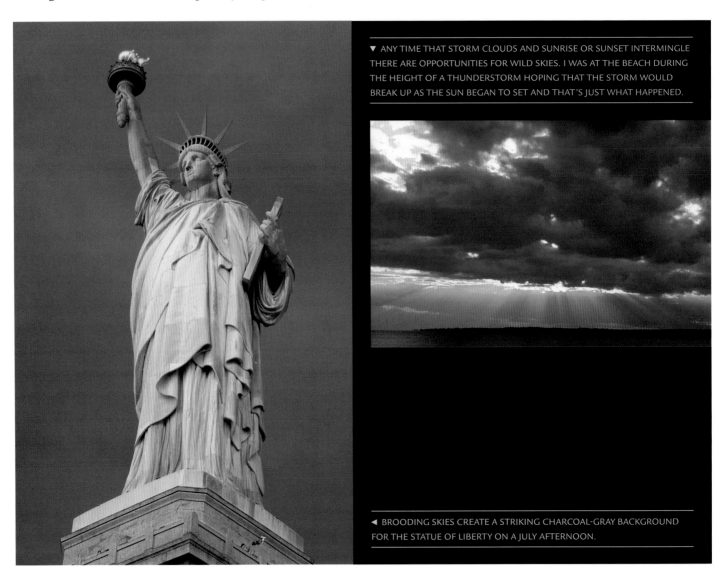

▼ ANY TIME THAT STORM CLOUDS AND SUNRISE OR SUNSET INTERMINGLE THERE ARE OPPORTUNITIES FOR WILD SKIES. I WAS AT THE BEACH DURING THE HEIGHT OF A THUNDERSTORM HOPING THAT THE STORM WOULD BREAK UP AS THE SUN BEGAN TO SET AND THAT'S JUST WHAT HAPPENED.

◄ BROODING SKIES CREATE A STRIKING CHARCOAL-GRAY BACKGROUND FOR THE STATUE OF LIBERTY ON A JULY AFTERNOON.

the sky began to churn with color and light. Any time that there's been a big overnight storm, it's a good idea to go out before dawn the next day and see if there's a "red sky at morning" in the offing.

One of the nice things about working with gray skies is that you can often meter directly from a patch of dark clouds and get a very accurate meter reading since it's very close in tone to middle gray (see page 109). To add extra drama and deepen the skies a bit, I often bracket up to two stops down from the sky reading (in full-stop increments) or just shoot in Raw and make the adjustment afterward.

▶ ONE OF THE FUN THINGS ABOUT EXPLORING IN BAD WEATHER IS THAT OCCASIONALLY NATURE OFFERS US RARE AND SPECTACULAR WEATHER EVENTS. I WAS DRIVING IN A THUNDERSTORM ONE AFTERNOON AND WHEN THE STORM STARTED TO DEPART AND THESE AMAZING MAMMATUS CLOUDS FORMED JUST AS THE SUN BEGAN TO SET. REPORTS ON THE NEWS THAT DAY SAID THAT THOUSANDS OF PEOPLE IN CONNECTICUT AND NEW YORK WERE WALKING INTO THE STREETS TO STARE UP AT THE SKY.

▲ ▶ CLOUDS ARE LIKE SNOWFLAKES AND FINGERPRINTS, YOU'RE NEVER GOING TO SEE ANY TWO THAT ARE THE SAME. I SHOT THESE CLOUDS ON TWO DIFFERENT DAYS ALONG THE EAST COAST OF FLORIDA.

Rainbows

RAINBOWS ARE SUCH A RARE TREAT THAT, EVEN IF YOU'VE SEEN QUITE A FEW OF THEM, IT'S IMPOSSIBLE NOT TO STOP AND ADMIRE THIS MIRACLE OF LIGHT AND COLOR.

Perhaps people who live in Hawaii or some other tropic environment get jaded to their beauty, but for most of us, they're still a show-stopper. You kind of have to wonder too, if scientists, artists and philosophers didn't make some connection between rainbows and the origins of color before Newton showed us all the light.

Today, of course, we know that rainbows are caused by light reflecting from, and being refracted by, millions of tiny raindrops. Light reflects off of the inner surface of the raindrop, and as it exits the raindrop it's refracted and each color emerges at a different angle, forming the bands of color that we see. You can only see a

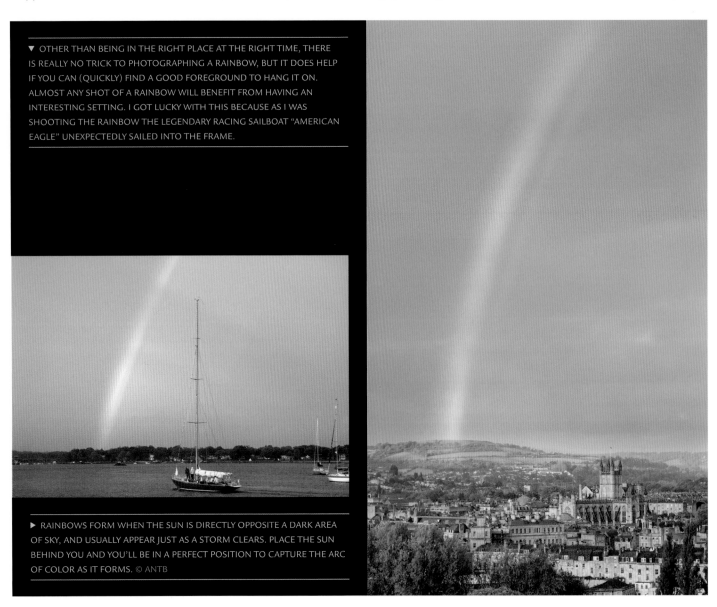

▼ OTHER THAN BEING IN THE RIGHT PLACE AT THE RIGHT TIME, THERE IS REALLY NO TRICK TO PHOTOGRAPHING A RAINBOW, BUT IT DOES HELP IF YOU CAN (QUICKLY) FIND A GOOD FOREGROUND TO HANG IT ON. ALMOST ANY SHOT OF A RAINBOW WILL BENEFIT FROM HAVING AN INTERESTING SETTING. I GOT LUCKY WITH THIS BECAUSE AS I WAS SHOOTING THE RAINBOW THE LEGENDARY RACING SAILBOAT "AMERICAN EAGLE" UNEXPECTEDLY SAILED INTO THE FRAME.

▶ RAINBOWS FORM WHEN THE SUN IS DIRECTLY OPPOSITE A DARK AREA OF SKY, AND USUALLY APPEAR JUST AS A STORM CLEARS. PLACE THE SUN BEHIND YOU AND YOU'LL BE IN A PERFECT POSITION TO CAPTURE THE ARC OF COLOR AS IT FORMS. © ANTB

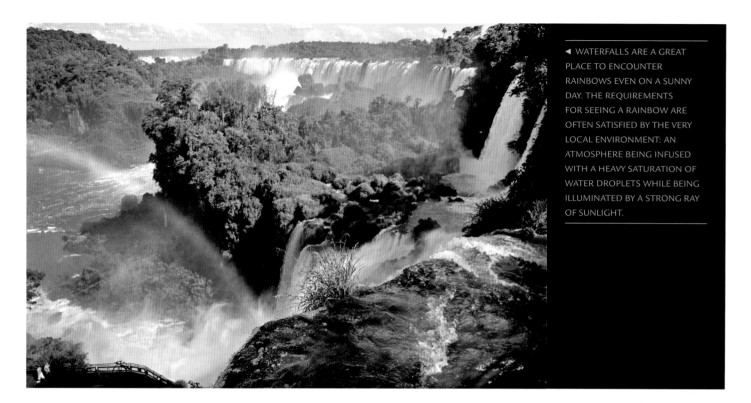

◄ WATERFALLS ARE A GREAT PLACE TO ENCOUNTER RAINBOWS EVEN ON A SUNNY DAY. THE REQUIREMENTS FOR SEEING A RAINBOW ARE OFTEN SATISFIED BY THE VERY LOCAL ENVIRONMENT: AN ATMOSPHERE BEING INFUSED WITH A HEAVY SATURATION OF WATER DROPLETS WHILE BEING ILLUMINATED BY A STRONG RAY OF SUNLIGHT.

rainbow when the sun is directly behind you and, interestingly, no two people see exactly the same rainbow—it's completely dependent on where you are standing. Even someone standing a foot away sees a slightly different display than you.

The best method for metering a rainbow is often to aim the meter directly at the rainbow because that is typically the brightest part of the scene and metering from there will underexpose the sky and the foreground enough to make the rainbow's pop. Another trick for intensifying the colors is to use a polarizing filter (see page 104). By rotating the filter you reduce the reflections in the surrounding sky and create more contrast between the sky and the rainbow. Finding the premium filter position is simply a matter of rotating it until the colors look their strongest.

► SOMETIMES WHEN IT COMES TO SHOOTING A RAINBOW YOU'RE JUST STUCK WITH THE FOREGROUND YOU GET AND IN THIS CASE I WAS STUCK WITH JUST A SLIVER OF THE ARCH HANGING OVER SOME TREES. YOU CAN MAGNIFY THE EFFECT OF THE COLORS BY ZOOMING IN AND FILLING THE FRAME. IN THIS CASE I USED AN OLYMPUS ZOOM CAMERA WITH THE EQUIVALENT OF A 900MM LENS.

Autumn Colors

IF LOOKING FOR LANDSCAPE OPPORTUNITIES WITH LOTS OF COLOR IS YOUR PASSION, THEN AUTUMN IS A TIME THAT PROBABLY KEEPS YOU AWAKE AT NIGHT.

As the nights grow cooler and summer turns to autumn, the shift in the look of the landscape is so extreme that it's impossible even to imagine the changes that are at hand. Foliage that we all but ignore as it lives its summer life in a hundred shades of green suddenly erupts into a riot of reds, golds, oranges, and yellows. Simple roadside scenes that most of us would drive by and not give a second notice hypnotize with a fiery palette so intense it's stunning no matter how often you've seen it.

Where I live in New England, autumn is a time when it seems that every photographer for a thousand miles is lining the roadside, tripods at the ready, like soldiers guarding against advancing troops, waiting to capture those brief days of autumn's magic. The colors gather slowly at first and then, a few crisp nights later, seem to reach their zenith of brilliance overnight. The peak show lasts for just a few days (though there are a lot of old New Englanders who will swear, with a wink and a nod, that they can spot not only the peak days of fall foliage, but the peak hours as well).

But while the peak of colors may be brief, autumn's colors can linger on for many weeks. Some types of trees, for instance, change much sooner than others and even once the early-changing maples have lost their brilliance, for example, the oaks retain their rich read leaves. In the scene of the edge of a small pond near my home, for instance, the maples trees in the foreground are all but bare, but the oaks are still covered in red leaves.

▼ RAIN IS A DOUBLE-EDGED SWORD IN AUTUMN: WHILE HEAVY RAINS CAN STRIP TREES OF THEIR FOLIAGE, THEY ALSO SATURATE COLORS TO A NEW LEVEL OF INTENSITY.

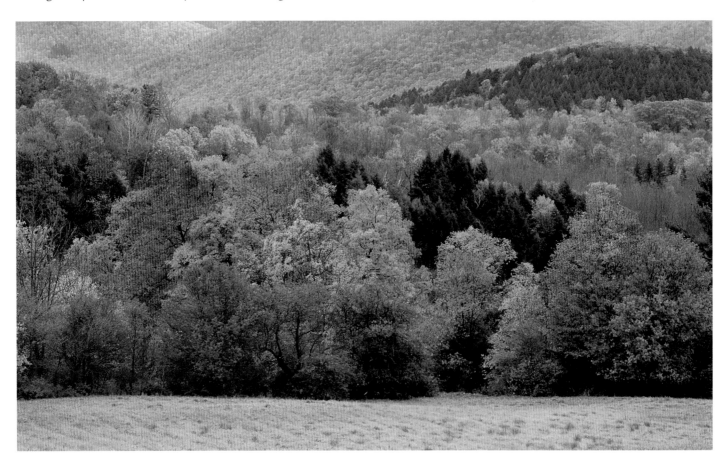

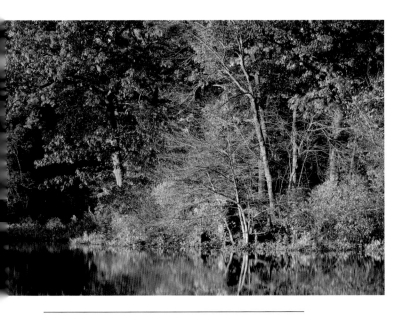

▲ ONE OF THE BEST TIMES TO LOOK FOR AUTUMN
SCENES IS LONG AFTER THE COLOR PEAK HAS PASSED.
IN THIS SCENE, BARREN TREES AT THE EDGE OF A POND,
CONTRASTED WITH OTHERS STILL IN FULL FOLIAGE, CREATE
A NICE VISUAL METAPHOR FOR THE PASSAGE OF TIME.

▲ ORANGE AND BLUE ARE OPPOSING COLORS ON THE
COLOR WHEEL—TRUE COMPLEMENTARY COLORS. BUT IN
NATURE THEY SEEM TO BE A PERFECT MATCH.

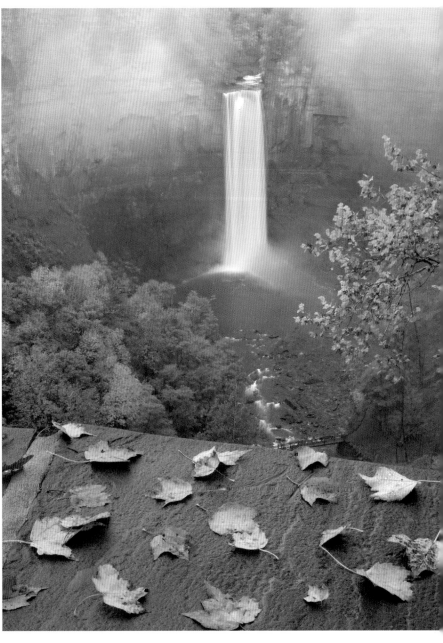

▲ AUTUMN LEAVES DO NOT ALWAYS HAVE TO BE THE STAR OF THE SHOW, THEY
CAN ALSO SERVE AS A POWERFUL THEMATIC FRAME FOR OTHER LANDSCAPE
SCENES. THIS SHOT USES A CLUSTER OF MAPLE LEAVES TO SET THE SEASONAL
MOOD FOR THE DRAMATIC SCENE BEYOND. © DEREK DOEFFINGER

Autumn Colors, continued

Because the days are growing shorter in autumn, the light is already lower in the sky for much of the day and that adds a lot of welcome warmth to the lighting throughout the daylight hours. Even so, these are great days for working in the golden hours because the warm palette of the autumn foliage responds particularly well to the warmer lighting. Lighting direction, or your position relative to the sun, is particularly important in autumn. Yellow foliage, in particular, has a translucent quality that glows beautifully with strong backlighting, so it's a good idea to scout locations where you can be shooting with the sun behind the foliage.

As you can see in a few of the shots here, autumn leaves look particularly brilliant when contrasted against a radiant blue sky but they also gather a particular depth when photographed after a rainstorm. I photographed the Vermont hillside shown here after a morning-long downpour and thought the rain pulled a lot of leaves from the trees, the remaining colors were beautifully saturated. Another very pretty time for shooting is just prior to or after a storm when the sky is slate gray and a warm sunlight pierces the clouds and aims a spotlight at the trees.

Finally, though I don't use them as often as I used to in pre-digital days, I often use a polarizing filter to remove surface reflections and saturate the colors of the leaves. Leaves are often shinier than they look and by removing the surface glare the colors come through far more intensely.

▼ THE YELLOW LEAVES ON A MAIDENHAIR TREE (GINKGO BILOBA) AT THEIR PEAK OF TRANSITION GLOW UNDER THE BACKLIGHTING OF A LATE-AFTERNOON SUN.

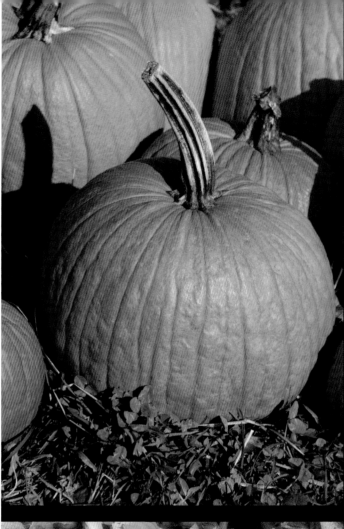

◄ PUMPKIN STANDS ARE ONE OF THE MOST ICONIC SITES ALONG NEW ENGLAND ROADS IN AUTUMN. ONE OF THE BEST WAYS TO INTENSIFY THEIR COLORS IS TO SHOOT THEM IN LATE-AFTERNOON LIGHT AND CROP THE COMPOSITION TIGHTLY SO THAT THE COLOR FILLS THE FRAME.

▼ ONE OF MY FAVORITE WAYS TO CAPTURE AUTUMN FOLIAGE IS IN REFLECTIONS IN THE MANY SMALL PONDS NEAR MY HOME. WITH THE LANDSCAPE REFERENCES REMOVED, THE COLORS BECOME ALMOST ABSTRACT, BUT THE SOURCE OF THE DESIGN IS VERY OBVIOUS.

▲ I LOVE THE COLORS AND SHAPES OF GOURDS. I WANTED TO CREATE A HOLIDAY CARD FROM THE SHOT, SO I ADDED A BIT OF SOFT FOCUS USING THE GAUSSIAN BLUR IN PHOTOSHOP. SIMPLE METHOD: DUPLICATE THE BACKGROUND LAYER, BLUR THE COPY, AND THEN ADJUST THE OPACITY TO GET THE DESIRED SOFTNESS.

▲ NOT ALL AUTUMN SHOTS HAVE TO BE GRAND OR BRIGHTLY COLORED TO WORK. OFTEN THE EARTHY LITTLE VIGNETTES THAT YOU FIND ON A MORNING WALK CREATE THE PRETTIEST SCENES.

Snow Scenes

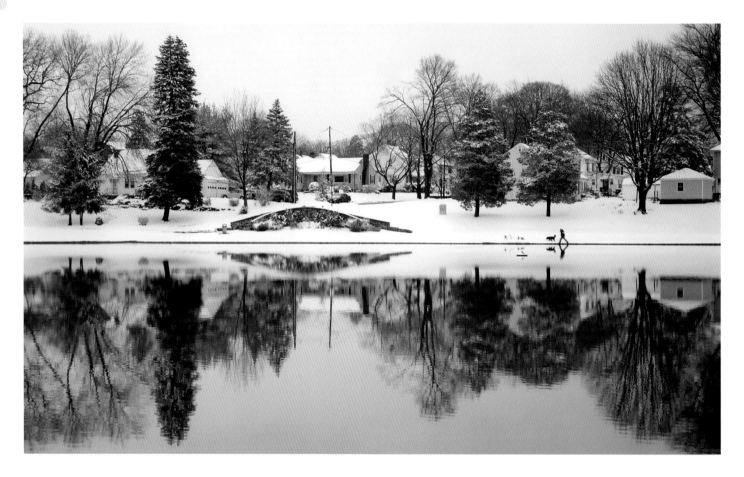

THERE ARE FEW THINGS AS PRETTY AS WAKING UP TO A FRESH COATING OF SNOW AND, FOR MANY OF US, IT'S INSPIRING ENOUGH TO YANK US OUT OF BED VERY EARLY AND GET US OUT THE DOOR QUICKLY, CAMERAS AND A FISTFUL OF MEMORY CARDS IN HAND.

The feelings of renewal and hopefulness that a new snowfall brings are hard to deny and even the most ordinary of subjects are revealed in ways that, as with autumn foliage, are hard to even imagine in another season.

The pure, bright simplicity of snow can, however, also present some real exposure challenges. The difficulty comes from the fact that while you want the snow to be as bright and clean-looking as possible you must also hold the exposure back enough to capture surface textures while also keeping the highlights from blowing off the right end of the histogram. It's a riddle that has kept many

▲ I RARELY DIVIDE THE FRAME SO CLOSE TO THE MIDDLE, BUT IN THIS CASE I LIKED THE REFLECTION OF THE HILLSIDE IN THE POND'S SURFACE. THE SCENE WAS SHOT JUST BEFORE TWILIGHT AND SNOW HAD ONLY STOPPED FALLING MOMENTS BEFORE.

photographers standing behind the tripod scratching their heads. The safest solution is to find a middle gray area to meter from, either something that is a middle tone in the composition or even just a solid blue sky. In the shot of the old New England cemetery, for example, I metered directly from one of the headstones. By metering a middle tone you set the white values approximately where they belong on the tonal scale without out burning out the highlights.

Because the photo gods are not always so kind as to supply a nice middle-toned surface to meter from, you can also solve the problem by adding extra exposure using your exposure compensation

feature. If you were to meter directly from the snow, the scene would be grossly underexposed because the meter would be fooled by the brightness of the snow. Without using compensation you'll end up with gray snow. In the shot of the cemetery, for example, because the lighting was casting the backs of the stones into shadow, I couldn't meter them. Instead I metered the overall scene but used 1.5 stops of plus exposure compensation to bring the snow back to a fairly bright white.

The direction of the lighting also plays an important role in photographing snow. As smooth as snow appears, it actually has a very crystalline and coarse surface textures and both side and backlighting will bring out that texture. Early and late in the day are the best times to find low-angle light, but these times of day often introduce a color tint to the snow that may or may not be desirable—yet another technical issue that snow presents.

In any situation, the most important thing to avoid is overexposing the snow because you can't add back detail where none was recorded—almost all other issues are negotiable in editing but that is not.

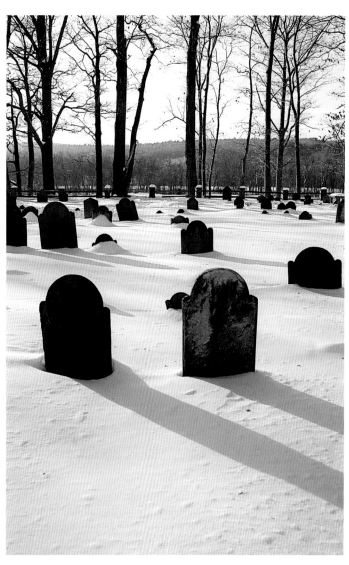

▶ SHOOTING ALMOST DIRECTLY INTO THE SETTING SUN AT THE END OF THE DAY PRODUCED LONG SHADOWS THAT GIVE THIS SCENE DEPTH, BUT ALSO LIFTED UP THE COARSE TEXTURE ON THE SURFACE OF THE SNOW. AS MENTIONED IN THE TEXT, USING EXPOSURE PLUS COMPENSATION IS NECESSARY TO KEEP THE SNOW FROM GROSSLY UNDEREXPOSING.

▲ SNOW IS A PERFECT REFLECTOR AND WILL ALWAYS TAKE ON THE COLOR OF THE SKY. IN THIS CASE I NEUTRALIZED THE BLUISH TINT OF TWILIGHT IN EDITING, BUT LEFT SOME HINT TO HELP CAPTURE THE COOL WINTER MOOD.

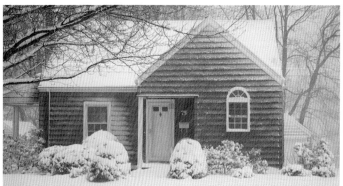

▲ TO BLUR SNOWFALL, SET THE SHUTTER SPEED LONG ENOUGH TO LET THE SNOWFLAKES STREAK AS THEY PASS THROUGH THE FRAME. IN THIS CASE I USED A SHUTTER SPEED OF 1/25 OF A SECOND TO EXAGGERATE THE BLOWING SNOW.

Chapter 4:

Technical Considerations

For a medium so heavily populated by artistic types whose ambitions are creative in nature, photography is at its core a technical and scientific pursuit. While we pursue an artistic and aesthetically inspired result, we are forced to do it using tools designed by engineers and employing principles dictated by the laws of physics. We are beauty-seeking moths relentlessly questing for the light on wings of electrical and optical design. And it's a conflict we each must resolve in our own way.

Years ago I interviewed the great travel and adventure photographer Harvey Lloyd, who described his shooting style as a very Zen-like "no mind" approach in which technical considerations were shuffled off to the back corridors of his subconscious while pure instinct drove the making of his images. Lloyd's confidence in his ability to make that leap from conscious technical diligence to pure gut reaction is, of course, based on a lifetime of training, experience, and self confidence. But it's a level of technical achievement that you can reach as well, once you understand and practice the underlying concepts.

Light, of course, is at the core of photography, and as we saw in the opening chapter, having an understanding of the nature of daylight is crucial to any photographic ambition. While our eyes and brain are capable of continuously adapting to the shifting colors of light, for instance, our cameras are not (at least not without our assistance) and so we must constantly monitor that relationship as we simultaneously keep track of its more expressive changes. Exposure, too, plays a critical role in capturing colors the way we see—or would like to—them.

Fortunately, the very technology that seems so alien to our creative goals waits nearby ready and willing to rush to our rescue. Lens filters, for instance, largely ignored by digital photographers, have a more limited but nonetheless important role in image capture. And seemingly low-tech tools like gray cards and color checkers can guide us back to the straight and narrow in those instances when even the pinnacle of electronic technology reveals its flaws. And then, too, there are software solutions like the Raw conversion and tone-mapping.

In the end, of course, it's not us against them, not artistic ambition pitted against engineering obsession, but rather the melding of the two: opposites that not only attract one another but that are wholly codependent. And it is this union of seemingly mismatched goals that leads us back to Lloyd's philosophy: that the moment one completely appreciates and absorbs the necessary technical aspects of our medium, our creative moth is set free to seek the glow of an ever brighter light.

Color Temperature

THE COLOR OF LIGHT, WHETHER IT'S DAYLIGHT OR ARTIFICIAL LIGHT IS MEASURED IN DEGREES KELVIN (OR SIMPLY, DEGREES K), A SYSTEM NAMED AFTER LORD KELVIN WHO (AS WE ALL RECALL VAGUELY FROM OUR SCHOOL DAYS) FIRST TALKED ABOUT HIS THEORY IN 1848 IN HIS PAPER "ON AN ABSOLUTE THERMOMETRIC SCALE." (AND THERE WILL NOT BE A QUIZ ON THIS INFORMATION—I ADD IT ONLY AS BACKGROUND.)

If you've ever seen a blacksmith heating up a bar of metal and watched as the bar turned from black to red to orange to yellow and eventually to white (thus the phrase "white hot"), that's a rough model of how color temperature works. Technically the scale is based on heating up an ideal black body to various temperatures and then noting the color of the black body at that temperature.

Light that has a color temperature below roughly 4,000K is considered warm lighting and light with a temperature higher than roughly 5,000K is considered cool. Colors that fall between 4,000K and 5,500K are relatively neutral (particularly as they apply to color photography). Daylight on a clear day is considered to be 5500K, for example, and falls approximately midway between the hot and cold range—it's the closest to neutral that we see during the day.

Because the color of light is in a constant state of flux, however, it changes not just from hour to hour and even moment to moment. At dawn, for instance, just before the sun rises, or at twilight, daylight has a relatively cool color temperature in the vicinity of 10,000K, but in the very early morning or again in the late afternoon, when the sun is slanting low and has a more golden color, the color temperature is considerably warmer, approximately 2–4,000K.

As we talked about in the pages on cool and warm colors (pages 36–37), light that is warm tends to excite and enhance objects on the hot end of the spectrum, but can also make neutral colors take on a warmer hue. A warm morning sun hitting a white barn, for instance, will give the barn a much warmer coloration. Conversely, cooler colors of light will add a bluer cast to neutral subjects and also bring out the saturation of cooler hues. A bride in a white wedding gown photographed in the shade (between say, 7,200K and 8,000K) will appear to be wearing a blue dress unless you do something to correct for the excessive blueness of the light—a lesson many inexperienced bridal photographers have no doubt learned.

In the days before digital all films had a particular color-temperature rating and films like color slide films were sold as either a daylight-balanced film (balanced for light of about 5,600K) or a tungsten-balanced film (balanced for lights in the 3,200K range). If you wanted to take color pictures using tungsten lighting (an indoor portrait by room lights, for instance) you had two choices: either switch from a daylight-balanced film to one balanced for tungsten lighting or use lens filters to convert the light entering the lens to match the emulsion of the film. If you were to use a daylight film indoors your pictures would have an excessively red cast because the lamps were simply far more red in tone than the light for which the film was created. And the reverse was also true: if you used a tungsten film outdoors your pictures would be excessively blue—looking almost like twilight shots (and, in fact, that is exactly how Hollywood creates the "day-for-night" look—by using tungsten film in a daylight situation). You could filter a tungsten film for use in daylight by adding warming filters.

The white-balancing feature of digital cameras, as we'll see in the coming pages, has successfully solved the issue of color temperature with one simple camera control.

◄ SUNRISE AND SUNSET ON A CLEAR DAY HAVE A VERY WARM COLOR TEMPERATURE THAT RANGES BETWEEN 2,000–4,000K.

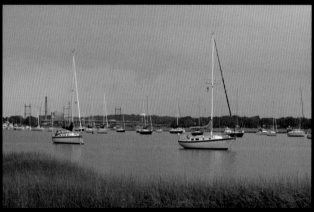

▼ HEAVILY OVERCAST DAYS HAVE A COLOR TEMPERATURE MUCH COOLER THAN MIDDAY LIGHT, OFTEN REACHING OR EXCEEDING 7,500K. THE ACTUAL TEMPERATURE OF DAYLIGHT IN ANY SITUATION DEPENDS ON MANY FACTORS IN COMBINATION WITH TIME OF DAY, INCLUDING THE SEASON, ATMOSPHERIC FACTORS AND OTHER ENVIRONMENTAL CONSIDERATIONS. ALSO, WHILE COLOR TEMPERATURE CAN BE MEASURED USING A COLOR METER, OUR INDIVIDUAL PERCEPTIONS ARE LARGELY SUBJECTIVE—WHAT LOOKS NEUTRAL TO ME MIGHT LOOK POSITIVELY WARM TO ANOTHER PERSON.

▲ MIDDAY COLOR TEMPERATURE IS TYPICALLY BETWEEN 5,000–5,500K AND IS CONSIDERED NEUTRAL IN TONE—IT HAS AN EQUAL EFFECT ON THE COLORATION OF BOTH WARM-TONE AND COOL-TONE SUBJECTS.

▼ WARM LIGHT FROM AN ALMOST-SETTING SUN IGNITES AND INTENSIFIES ANY WARM TONES THAT FALL IN ITS PATH, INCLUDING THE FAÇADE OF THIS MUSEUM TOWER.

▲ WARM LIGHT MIXED WITH A COOL SUBJECT CAN PRESENT AN INTERESTING MIX OF RESULTS. IN THIS CASE THE COOL BLUE OF THE BUILDING IS WARMED, BUT REMAINS RELATIVELY COOL COMPARED TO THE WHITE SURFACES AND THE RED TILED ROOF THAT HAVE PICKED UP THE WARMTH OF THE SETTING SUN.

White Balance

THE WHITE BALANCE CONTROL ON A DIGITAL CAMERA SOLVES THE PROBLEM OF COLOR BALANCE BY ALLOWING YOU TO PRECISELY MATCH THE RESPONSE OF THE SENSOR TO THE COLOR TEMPERATURE OF THE EXISTING LIGHT.

If you move indoors and want to shoot some photos by incandescent lamps after a day of shooting outdoors, for instance, you simply switch the white balance control from "direct sunlight" to "tungsten" and all of your photos will be color balanced to match the existing light.

If you were to move indoors and leave the camera set for daylight, all of the photos would come out with a reddish cast because the color temperature of the tungsten lights (3200K) is much more red than daylight (5500K). The opposite is also true: if you used your tungsten setting outdoors all of the photos would be overly blue because the camera would be adding blue to the photos to compensate for the over-abundance of red in the tungsten lamps.

The beauty of white balance is that, unlike the film days when you had to change film types or use filtration each time you changed light sources, with a digital camera you can change lighting an infinite number of times and get a correct white balance for every shot. It's one of the under-appreciated miracles of digital technology.

That said, in many respects shooting in the Raw format (which we'll discuss later in this chapter), particularly in complex lighting situations like a concert of other indoor event, is more reliable because you can adjust white balance after the fact. Setting the white balance yourself only works is you have a pretty good idea of the color temperature of the existing light. In daylight or shade that's simple, but as you move into unusual lighting sources (vapor lamps, for example), it's not so easy because many of these sources have a shifting color temperature or one that has an inconsistent color temperature. Even so, if you have the time to make some tests and set a correct white balance while shooting you will save yourself a lot of time and energy in editing.

▲ WHILE THE WHITE BALANCE FOR FLASH WILL PREVENT SHOTS FROM BECOMING TOO BLUE, I PREFER TO USE THE CLOUDY OR SHADE SETTING TO MAKE THINGS EVEN WARMER.

▲ I ALMOST ALWAYS USE THE CLOUDY-DAY WHITE-BALANCE SETTING FOR LANDSCAPES LIKE THIS SHOT OF A FORMAL ESTATE GARDEN BECAUSE I THINK THE ADDED WARMTH GIVE THE SHOTS A MORE APPEALING QUALITY.

WHITE BALANCE PRESETS

AUTO: In this mode the camera makes an assessment of the ambient lighting and sets the white balance for you (and I inherently distrust anything that a camera does "for me"). In very simple situations (outdoors on a sunny afternoon) or when the light source is changing quickly, the auto setting can be quite a blessing because it frees you from having to stop every few frames to reset the white balance. In most cases the camera does an adequate job of judging the existing light but there are times when manually setting the white balance to a particular light source is a more accurate option. In those situations, your camera also offers the following specific-source options (various camera manufacturers may use their own names for each):

DIRECT SUNLIGHT: This mode is intended for shooting in most daylight situations. Images will tend toward either neutral or slightly cool and this is a fairly reliable setting.

CLOUDY: A good alternative to the direct sunlight mode even on clear days because the camera will add a warm late-day look to both landscapes and portraits. This is my setting of choice for most outdoor work and I strongly recommend selecting it (or at least comparing it to) over the daylight setting. I sometimes use this mode for outdoor portraits made with fill flash (as in the portrait shown here).

SHADE OR OPEN SHADE: In most cameras this is an even warmer setting than the cloudy-day mode. It's a very good mode for warming up shots like portraits shot in deep or open shade or on overcast days. It's a good idea to shoot a comparison between this and the cloudy setting.

FLASH: This setting is designed for adding warmth for electronic flash (which is typically about 5400K) and prevents flash shots from looking too blue.

TUNGSTEN: In this mode the camera adds blue to counteract the overabundance of red in tungsten lamps (which are at 3,200K). Often I'll use this mode but add a small amount of additional warmth using the custom color picker to keep some of the atmosphere of the ambient lights. If you correct for the tungsten completely you loose some of that ambient coziness.

FLUORESCENT: In my experience this is probably the least reliable of the presets because all fluorescent lights are very unpredictable in their color temperature and often vary wildly with the brand and age of the bulb. It's often far better to run tests and use the custom color picker (if your camera has one) to adjust the white balance setting or to set a completely custom setting if your camera has that capability.

▲ IN SITUATIONS WHERE COLOR BALANCE ISN'T CRITICAL THE AUTO MODE IS FINE AND ALLOWS YOU TO SHOOT IN A VARIETY OF DIFFERENT SITUATIONS. I SHOT THIS PORTRAIT OF THE LEGENDARY HIGH-WIRE ARTIST TINO WALLENDA IN FULL CLOWN REGALIA ENTERTAINING A CROWD AND USED THE AUTO MODE SO I COULD CONCENTRATE ON HIS ANTICS RATHER THAN CAMERA SETTINGS.

Custom White Balance

THE DOWNSIDE OF USING AN AUTO SETTING OR A WHITE BALANCE PRESET IS THAT YOUR CAMERA IS THEN IN RELENTLESS PURSUIT OF TOTALLY NEUTRAL COLORS.

It can strip the charming warmth away from the early morning sun, it will turn the cool light of twilight to a dull gray, and it will do its best in all situations to make sure you have cleanest whites this side of a bleach commercial. The very purpose of using a specific white balance option (the tungsten setting, for instance) or for using the auto setting, in fact, is to provide you with an image that is ideally matched to the light source at hand and devoid of any overriding color cast.

The problem this presents from a creative standpoint is that there are times when you may want a slight or even an exaggerated tint to your colors. If you're shooting at twilight, for instance and you want to embellish the blue of the evening light, you certainly don't want your camera second-guessing your artistic ambitions. And what's the point of heading out to the desert in the buttery light of the golden hour if your camera is going to take a look at the light and then send you the chilling message, "Don't worry pal, we've got this

covered. We'll banish all that excess yellow!" This is no time to let technology, no matter how clever, come between you and beautiful lighting. Many times, in fact, even in relatively warm light, I'll use the cloud-day setting to get an even warmer look.

Similarly, if you happen to be shooting in a situation like a concert where the lighting is inherently saturated and where various hues of lighting are mixing and mingling, there is little point in "fixing" the white balance because you'd be removing the very boldness of color that the lighting designer worked so hard to create. If they wanted you to see the stage acts in a neutral condition, they wouldn't have spent all of that money on lighting gels.

I will say, however, that there are indeed times in concert situations when I've wanted to reduce and occasionally even eliminate excessive color saturation—particularly if I'm shooting face shots. Early in my digital days I frequently photographed concerts alongside a photographer whose images were consistently more color accurate than mine, and one night between sets he gave me a tutorial in using the camera's color picker to refine the white balance to skew the colors back toward neutral. I fell in love with knowing how to do this. Now when I shoot concerts I shoot at least

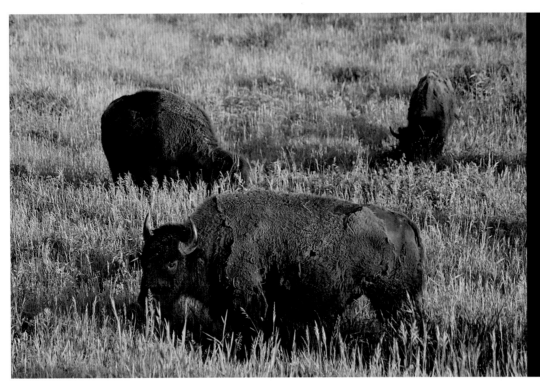

◄ EVEN THOUGH I WAS SHOOTING IN THE GOLDEN HOUR ON A CLEAR DAY, I INTENTIONALLY SET THE WHITE BALANCE TO CLOUDY FOR THIS SHOT TO INTENSIFY THE WARMTH OF THE LIGHTING. HAD I LEFT THE CONTROL IN THE AUTO OR DIRECT SUNLIGHT SETTING, THE WARMTH WOULD LIKELY HAVE BEEN STRIPPED OUT. EASY ENOUGH TO FIX IN EDITING, BUT THERE'S NO POINT IN SPENDING THE EXTRA TIME.

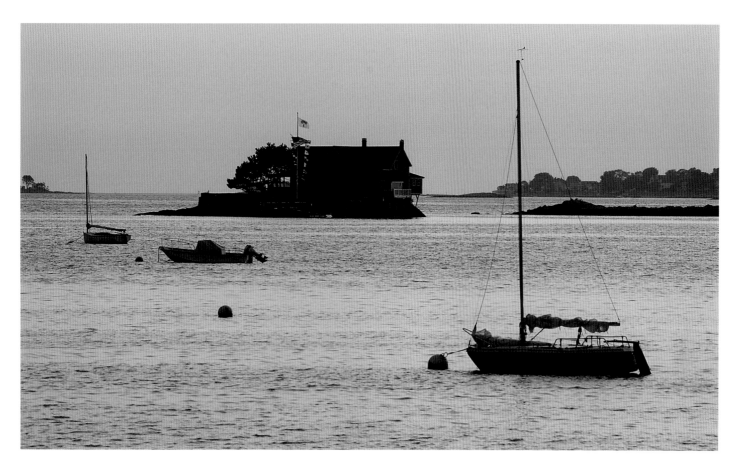

▲ TURNING A DAYLIGHT SCENE INTO A TWILIGHT SCENE IS SIMPLE: JUST SET THE WHITE BALANCE TO TUNGSTEN. THE CAMERA ADDS ADDITIONAL BLUE FILTERING TO COUNTERACT THE RED LIGHT OF TUNGSTEN, BUT SINCE YOU'RE SHOOTING IN A LIGHT THAT IS ALREADY BLUE, THE EFFECT IS JUST ONE OF AN EXAGGERATED BLUISH HUE.

▲ MOST DSLRS HAVE AN ADVANCED FEATURE THAT ENABLES YOU TO BIAS THE WHITE BALANCE ALONG AMBER-BLUE AND GREEN-MAGENTA AXES. IT'S A HIGH-LEVEL FEATURE, BUT WORTH EXPLORING IF YOU FIND THAT YOUR CAMERA'S WHITE BALANCE SETTINGS ARE CONSISTENTLY SKEWED IN ONE WAY OR THE OTHER. BESIDES, WHITE BALANCE IS OFTEN A MATTER OF PERSONAL TASTE—FOR EXAMPLE, IF YOUR IMAGES SEEM TOO WARM ALL THE TIME, FINE-TUNE THAT SETTING SO IT FALLS MORE IN THE BLUE SIDE OF THE SPECTRUM.

one song early with a variety of white balance settings until I see the one that I really want—then I can just continue to shoot and forget about it as long as the lighting director doesn't change directions on me. In most cases I still prefer to go with the bold stage lighting, but at times if I want good skin tones I like having the ability to tame the super-saturated colors in camera.

Finally, there are often times when you may want to intentionally use the wrong white balance for artistic effect. In shooting the harbor scene here, for example, I was actually shooting in a relatively warm sunset light but I wanted to see what the scene would look like at twilight. Piece of cake: I simply set the white balance menu control to tungsten and turned the scene starkly blue.

The Raw Advantage

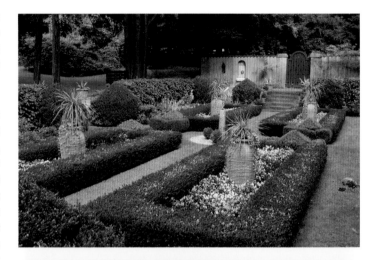

IF YOUR CAMERA OFFERS THE FACILITY TO SHOOT RAW FILES AND YOU DON'T MIND USING UP SOME ADDITIONAL MEMORY CARD AND HARD DRIVE SPACE, USING THIS FORMAT FOR MOST OF YOUR SHOOTING (OR AT LEAST MOST OF YOUR IMPORTANT SHOOTING) OFFERS A LOT OF SIGNIFICANT ADVANTAGES.

Although shooting Raw files does require an additional step in importing your image files to your editing software program (a sort of pre-edit that I'll discuss more in the final chapter of this book), I believe that it's time, energy and memory space well spent. The advantages provided by shooting in Raw will vastly improve the quality of your images and enable you to change many choices that you made while shooting. I shoot nearly 100% of my images in Raw now and (particularly with hard drive prices as inexpensive as they are these days) I am thrilled every time I open a file that I have the extra options that Raw provides. For very high-quality image work you are tying your own hands not to work in Raw.

Essentially what this format provides is a file that has not been tampered with by your camera. Whenever you shoot in the JPEG format, for instance, regardless of how careful you've been at shutting off in-camera enhancements (like built-in saturation or auto color balancing), the camera is still enhancing your image files. Even more importantly, the way that JPEG files are recorded, as each file is recorded the camera makes decisions to delete similar pixel information if it thinks that information is superfluous. In other words, if two adjacent sets of pixels are providing the very similar red color information, for instance, the camera may deem this an unnecessary use of card space and delete duplicate information.

In the end what you get is a file that has been stripped of some very important information. Not saw in the Raw format. In this format the camera creates a "clean" file that is free of any enhancements or modifications and it delivers all of the pixel information—nothing is omitted. The common analogy that is used is that Raw files are the equivalent of a digital negative and that is very true: these files deliver everything that the sensor recorded with malice and prejudice toward none.

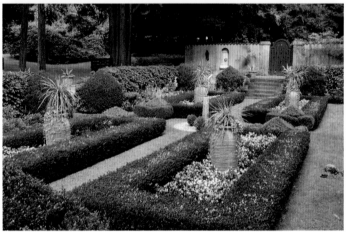

▲ ▲ I SHOT THIS FORMAL GARDEN ON A LATE AFTERNOON AND THOUGHT IT APPEARED TO BE QUITE WARM TO ME IN PERSON, THE IMAGE CAME OUT COOLER AND DARKER THAN I HAD EXPECTED. BRINGING IT BACK TO WHERE I WANTED IT WAS SIMPLY A MATTER OF BOOSTING THE EXPOSURE BY ABOUT A HALF STOP AND THEN WARMING IT FROM A CAMERA-CHOSEN COOL COLOR TEMPERATURE OF 5900 (IN THE AUTO MODE) TO A MUCH WARMER 4250.

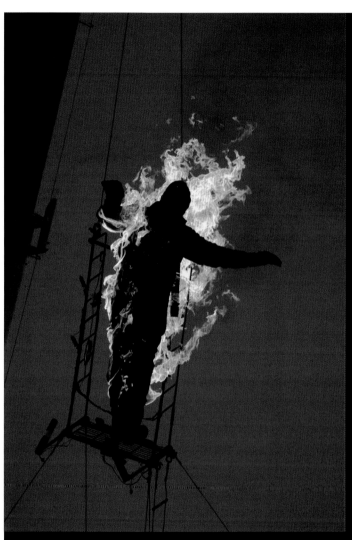
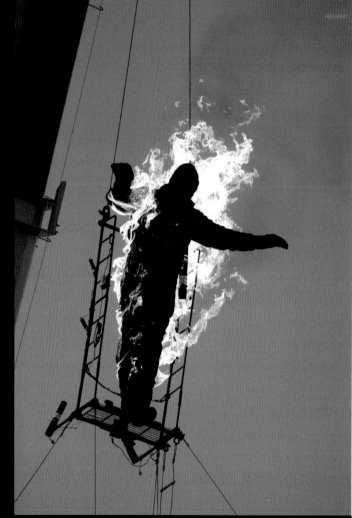

▲ ▲ MY CAMERA'S METER WAS TOTALLY BAFFLED BY THE SUDDEN BURST OF BRIGHT FLAMES AS THIS STUNT MAN'S COSTUME CAUGHT FIRE AND THE RESULTING SHOTS WERE GROSSLY UNDEREXPOSED. IN THE RAW IMPORT SOFTWARE I WAS ABLE TO BOOST THE EXPOSURE BY ABOUT 1.5 STOPS AND THEN USED THE COLOR TEMPERATURE ADJUSTMENT TO COOL THE SKY TO ITS CORRECT TWILIGHT BLUE COLOR. IN FAST-BREAKING SITUATIONS LIKE THIS SHOOTING IN RAW CAN SAVE YOU A LOT OF TIME IN POST-PRODUCTION BY ALLOWING YOU TO MAKE CORRECTIONS ALMOST ON THE FLY—IN THIS CASE, UNDER 30 SECONDS FROM BAD FILE TO GOOD.

The Raw Advantage, continued

HIGH BIT DEPTH

Another extremely important issue with format choice is bit depth. Most digital SLR cameras are capable of recording images in 12, 14 and even 16-bit depth and the Raw format supports those bit depths (as do most image-editing programs such as Lightroom and Photoshop). JPEG files are recorded as 8-bit files and can only contain or recognize 256 tonal values per color channel (red, green or blue). This means that, with all channels combined, an 8-bit image can only contain a maximum of 16.7 million tonal values (256 x 256 x 256). A 12-bit file, on the other hand, can contain 4,096 distinct tonal values per channel and that multiplies out (trust me here, the math will just melt your calculator) to 68.7 billion tonal values.

▼ THIS SUNSET WAS ORIGINALLY RECORDED AS A JPEG, WHICH IS ALWAYS GOING TO BE 8-BIT. IT WAS ALSO SHOT WITH AN OLDER CAMERA, WITH A LESS-THAN-STATE-OF-THE-ART SENSOR, SO THE DYNAMIC RANGE WAS CLEARLY WELL PAST THE LIMITS OF THE CAMERA'S EXPOSURE RANGE. IN SHORT: A PERFECT RECIPE FOR BANDING. YOU CAN SEE IN THE CORONA SURROUNDING THE OVEREXPOSED SUN HOW THE TONE SHIFTS ABRUPTLY FROM WHITE, TO YELLOW, TO ORANGE (THE CROP BENEATH HAS ALSO HAD THE HIGHLIGHTS PULLED BACK TO AMPLIFY THE EFFECT). HAD THIS BEEN RECORDED IN RAW AND DELICATELY EDITED IN 16- OR EVEN 32-BIT, THAT TRANSITION FROM WHITE TO ORANGE COULD BE MUCH SMOOTHER. © FRANK GALLAUGHER

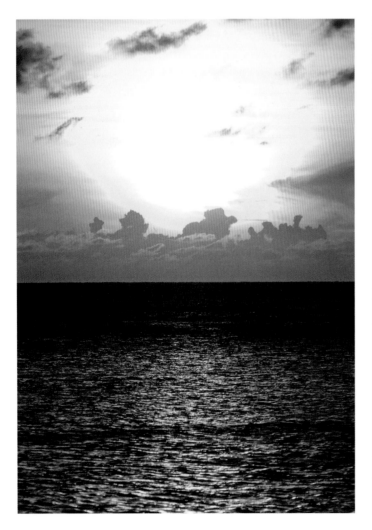

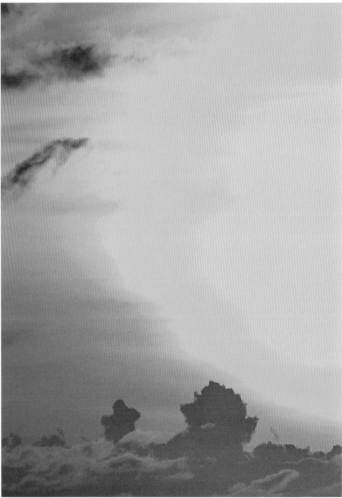

Even though our eyes can only distinguish in the area of seven to 10 million colors, and even though (currently) most output devices only support 8-bit data, Raw files can be imported and worked in Photoshop at 32-bit depth. Why is this of great consequence? Because as you edit having a higher bit depth you eliminate common flaws such as banding—a rough separation of tones that often shows up in smooth continuous tonal areas (light-tone skies, for example).

WHITE BALANCE CHANGES

On a very practical level, one supremely useful option that is available to you with Raw images is the ability to change the white balance after the fact—regardless of what white balance setting you had set on your camera when you were shooting. If, for instance, you happen to have the white balance set for tungsten lighting and you're working in daylight (oops!), you can correct that area during the importing process and with no degradation in image quality. Or, if you are unsure about what white balance to use (in a tricky situation like an indoor sporting event), you can also make that decision post-camera. And you can fine-tune white balance to your heart's content.

EXPOSURE CHANGES

Working in Raw also enables you to make exposure alterations during the conversion process. You can darken or lighten an exposure four stops or more by simply moving a slider. And you are not "correcting" an exposure error as you would with an exposure-adjustment tool in editing (the curves tool, for example), but you are actually resetting the original exposure. This can be particularly helpful when detail is lost in a shadow due to slight underexposure. I can't tell you how refreshing it is to be able to tweak exposure in a nondestructive way before I even begin editing my photos—it has uncooked my goose on many occasions.

▶ THE GREATEST GIFT THAT RAW FILES OFFER IS THAT, BECAUSE THIS IS A NON-DESTRUCTIVE FORM OF EDITING, THEY PROVIDE AN ABILITY TO RE-INTERPRET YOUR FILES OVER AND OVER AGAIN WITHOUT DOING ANY DAMAGE TO THE ORIGINAL FILE. IN THIS CASE I THOUGHT THAT THE "AS SHOT" FRAME (IN THE MIDDLE) WAS SOMEWHAT BORING SO I ALSO EXPERIMENTED WITH A COOL BLUE INTERPRETATION (AS IF THE SENSOR HAD BEEN BALANCED FOR 3200K LIGHTING, THUS ADDING EXTRA COOLNESS TO COMPENSATE FOR SUCH WARM LIGHT) AND A VERY WARM INTERPRETATION (AS IF THE SENSOR HAD BEEN BALANCED FOR 9000K LIGHTING, THAT IN TURNED ADDED SIGNIFICANT WARMTH TO COMPENSATE FOR SUCH BLUE LIGHT). WHICH IS BEST? MY IDEAS WOULD CHANGE FROM DAY TO DAY, WHICH IS WHY I ENJOY SHOOTING IN RAW SO MUCH.

Interior Spaces

MOVING INDOORS WITH YOUR CAMERA PRESENTS A VARIETY OF LIGHTING-RELATED CHALLENGES, NOT THE LEAST OF WHICH IS THE FACT THAT ALMOST ALL INTERIOR SPACES ARE LIT BY A MIXTURE OF DIFFERENT LIGHTING SOURCES—OFTEN INCLUDING DAYLIGHT AS WELL AS ARTIFICIAL LIGHTS.

In the room I'm sitting in now, for example, I have two compact fluorescent lights, a full-spectrum proofing light that I used to judge print quality and two big windows spilling in late-afternoon light. Even to try and photograph this small room and reach an agreeable lighting balance would be a challenge.

As spaces grow in size and complexity the job of balancing the various lighting sources gets even more difficult. Such complex lighting combinations play havoc with white balance and how much time you spend trying to solve those issues really depends on how critically you want to control the color balance. Professional architectural photographers go to great lengths to create such balances, including using large rolls of filter material to filters the daylight in one exposure and then photographing the interior on a separate frame using only the interior lights. Most of us are stuck with seeking more mundane solutions.

Because balancing the color of several light sources in any reasonable way is virtually impossible, the only practical solution is to set a white balance for the primary light source and simply ignore the remaining lights. The problem them becomes identifying the primary light source and if it's an artificial light source, deciding on its color temperature. In my shot of the interior of Notre Dame in Paris, for example, there are at least three lighting sources: a small amount of artificial light in the very high ceilings (a secondary light source in terms of room illumination), the candles (a prominent but yet minor consideration) and the daylight that is pouring into the small side chapels. I chose to leave the white balance set on

▲ I HAD TO RUN THE ISO UP TO 1600 TO SHOOT THIS SCENE WITH A HANDHELD CAMERA SINCE NO TRIPODS ARE ALLOWED INSIDE NOTRE DAME CATHEDRAL.

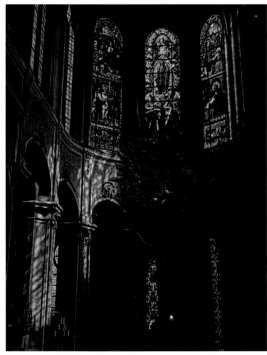

▲ WHEN THE SUN IS AT A LOW ANGLE, LOOK FOR HOW IT 'S SHINING THROUGH ANY NEARBY WINDOWS. THERE CAN BE AN ENGAGING PATTERN OR SHADOW BEING CAST AGAINST PART OF YOUR INTERIOR. © FRANK GALLAUGHER

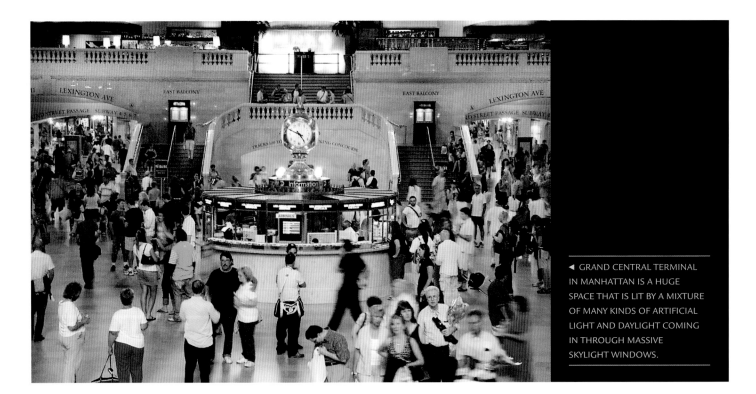

◄ GRAND CENTRAL TERMINAL IN MANHATTAN IS A HUGE SPACE THAT IS LIT BY A MIXTURE OF MANY KINDS OF ARTIFICIAL LIGHT AND DAYLIGHT COMING IN THROUGH MASSIVE SKYLIGHT WINDOWS.

automatic and assume that the camera would balance for the most abundant light source: daylight. You can see some splash of red on the sidewalls from the ceiling lights and the candles, of course, glow with warmth. Because I always shoot in Raw, where source overlapped I was able to tweak the final result quite a lot in editing.

In some huge spaces like Grand Central Terminal (shown above) there are so many light sources happening that the only practical alternative is to shoot a few test shots and see if you can pick a balance that you like, or simply leave the white balance in the auto mode and make adjustments in editing. Bear in mind, that even if your color balance is completely wrong from a technical standpoint it may still capture the atmosphere of the space that you're photographing. Since all light looks pleasantly neutral to your eyes once our brains have had a few moments to adjust, almost all photos of artificial light tend to look different that the way we remember anyway. In most interior shots those with a slight reddish tint almost always looks and feels more genuine regardless of how authentic they might be.

One larger issue with interior spaces is contrast, particularly if there is a bright daylight source mixing with dim artificial lighting. Unless there is a way to either boost the interior lights or dim the daylight, the best option is to try and expand the dynamic range of your camera's response using a multi-shot technique like HDRI (discussed on pages 112–113).

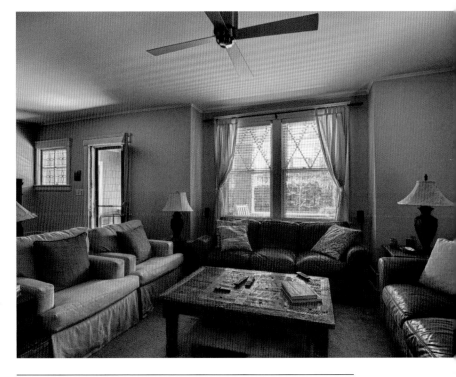

▲ WITH HOME INTERIORS, YOU WANT IT TO FEEL INVITING AND COZY—BUT YOU'LL HAVE TO STRIKE A BALANCE WITH THE MUCH COOLER EXTERIOR SUNLIGHT, OR EVERYTHING OUTSIDE WILL HAVE A HEAVY BLUE CAST.
© FRANK GALLAUGHER

Lens Filters

IN THE DAYS BEFORE DIGITAL CAMERAS, MOST PHOTOGRAPHERS—PARTICULARLY PROFESSIONALS WHOSE WORK HAD TO BE TECHNICALLY PERFECT AND EXTREMELY ACCURATE IN TERMS OF COLOR—HAD AN ALMOST OBSESSIVE RELATIONSHIP WITH LENS FILTERS.

This was particularly true for slide films because color transparencies are a finished product as soon as they're processed. Photographers carried filters to warm or cool pictures, and painstakingly match their film's color response to the existing light source. Unfortunately, filters were expensive, delicate and if you carried enough of them they got darn heavy. Also, unless you were spending a fortune on optically pure filters, they also slightly degraded image sharpness.

The good news is that most lens filters that were used by photographers have been made obsolete by image-editing software. Most color corrections like cooling, warming, or white balancing are far simpler and more precise when made after the fact. More importantly, by making the corrections in editing, fewer decisions have to be made at the time of shooting and that great speeds and simplifies the picture-taking process. There are, however, a few filters that still remain extremely useful and that deserve a spot in your camera bag and whose effects cannot be recreated in editing:

POLARIZING FILTERS

Polarizing filters solve a lot of shooting problems that really can't be solved during editing including darkening blue skies, removing surface reflections from any non-metallic surface (foliage, water, glass surfaces) and helping to saturate colors. These filter work by blocking non-polarized light from entering your camera and in turn they are able to block a lot of superfluous light that creates unwanted reflections and de-saturates colors. Polarizing filters are mounted in a rotating base and the degree of polarization intensifies (or decreases) as you rotate the filter. With a DSLR this means that you can see the effect of the filter in the viewfinder or on the LCD.

Polarizing filters work best when the sun is at your left or right and have almost no effect when the sun is behind your or in front of you. In landscape situations polarizing filters have a powerful ability to both saturate the foreground colors and darken the sky simultaneously. I used a polarizing filter to do exactly that in the shot of Monument Valley and simply rotated the filter until I saw the effect that I wanted. These filters absorb about 1.3 stops of light, so you have to compensate for that by either lowering the shutter speed, opening up the lens, or raising the ISO.

◄ SATURATING THE BOLD COLORS OF THE LAWN, GARDENS AND THE BLUE SKY SURROUNDING CHATEAU CHENONCEAU IN FRANCE'S LOIRE VALLEY WAS A SIMPLE MATTER OF ROTATING MY CIRCULAR POLARIZING FILTER UNTIL I SAW MAXIMUM SATURATION IN THE VIEWFINDER.

▶ ONE OF THE MOST PRACTICAL USES IS THE ABILITY OF A POLARIZING FILTER TO VIRTUALLY ELIMINATE ALL REFLECTIONS FROM GLASS WINDOWS. THIS CAPABILITY COMES IN VERY HANDY WHEN WALKING AROUND CITIES AND SHOOTING INTERESTING WINDOWS LIKE THIS SHOT OF THE P. T. BARNUM MUSEUM IN BRIDGEPORT, CONNECTICUT.

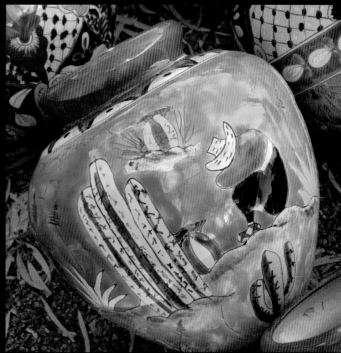

▲ POLARIZING FILTERS ARE ABLE TO DARKEN BLUE SKIES BECAUSE THEY ONLY ALLOW LIGHT VIBRATING IN A SINGLE DIRECTION TO ENTER THE LENS. LIGHT VIBRATING IN OTHER DIRECTIONS IS UNABLE TO PASS THROUGH THE FILTER AND SO MUCH OF THE DAYLIGHT THAT IS SCATTERED BY THE ATMOSPHERE, AND THAT DESATURATES COLORS, NEVER REACHES THE SENSOR.

▲ ONE OF THE MOST PRACTICAL USES OF A POLARIZING FILTER IS TO REMOVE SURFACE GLARE AND REFLECTIONS FROM NONMETALLIC SURFACES. HERE I USED THE FILTER TO HELP SATURATE THE RICH COLORS OF A PIECE OF MEXICAN POTTERY.

Lens Filters, continued

NEUTRAL-DENSITY FILTERS

Neutral Density (ND) filters do exactly what their name implies: the put a layer of density in front of the lens to reduce the amount of light reaching your sensor but without affecting the color of the light in any way. These filters can be extremely useful when you want to create long time exposures and there is simply too much ambient light to accomplish this without using a filter. The filters come in a variety of densities that can block anywhere from one stop to as many as 10 stops of light (and you can combine filters if necessary though you have trouble autofocusing through multiple filters or very dense filters). Probably the most practical filters are those that decrease the light by two to four stops. Photographer Derek Doeffinger used a 10-stop ND filter to create the eight-second exposure of an upstate New York waterfall shown below. Because these filters enable you to use longer exposures, you can create many creative-motion effects that you simply can't create in any other way.

▼ THE ABILITY TO MAKE EXTENDED TIME EXPOSURES IS ONE OF THE PRIMARY USES OF NEUTRAL DENSITY FILTERS. PHOTOGRAPHER DEREK DOEFFINGER USED A 10-STOP FILTER TO CREATE THIS EIGHT-SECOND EXPOSURE IN ORDER TO GET A SILKY BLUR IN THE FLOWING WATER.
© DEREK DOEFFINGER

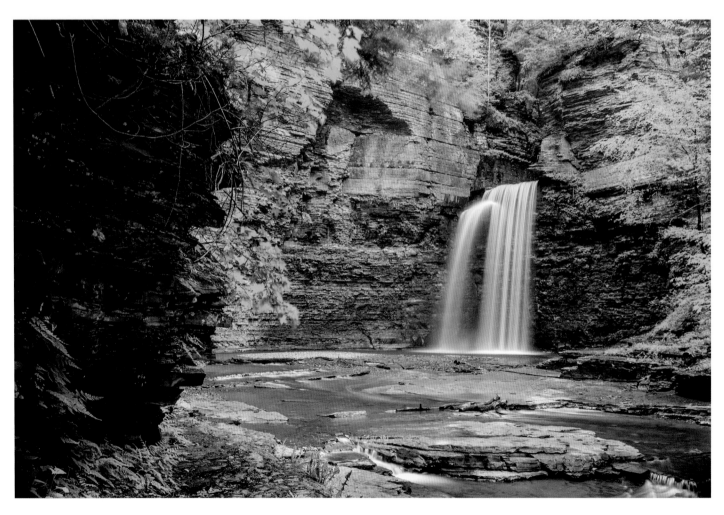

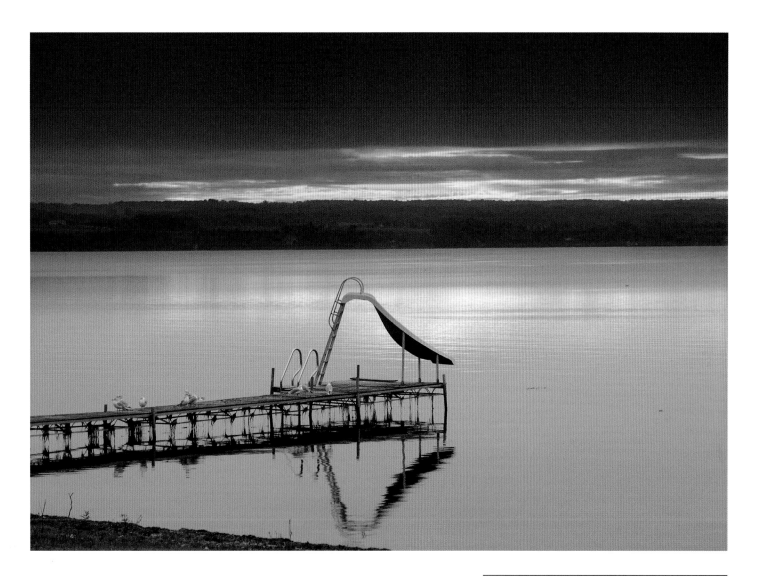

GRADUATED NEUTRAL-DENSITY FILTERS

Graduated neutral density filters work in exactly the same way as a full neutral density filter but the density is graduated and it limited to roughly half of the filter while the remainder of the filter is clear. The purpose of these filters is to hold back the light from just a portion of the frame so that you can create a more balanced exposure across the entire scene. If you are photographing a landscape with a dark foreground and a much brighter sky, for example, by placing the density area of the filter of the top half of the scene, you can use a longer exposure to record shadow detail in the darker foreground areas of the frame without the sky washing out.

▲ BALANCING A DARK FOREGROUND WITH A MUCH BRIGHTER SKY AREA IS ALWAYS AN EXPOSURE CHALLENGE. IN THIS INSTANCE THE PHOTOGRAPHER BALANCED A BRILLIANT SUNSET SKY WITH THE DARKER WATER OF A LAKE BY PLACING A COLOR-GRADUATED DENSITY FILTER OVER THE TOP HALF OF THE FRAME. THE FILTER HAD A SLIGHT REDDISH COLORING IN THE DENSITY AREA THAT ADDED TO THE COLOR SATURATION OF THE SKY.
© DEREK DOEFFINGER

Exposure Tools for Accuracy

A S WE DISCUSSED BRIEFLY IN THE EARLIER SECTION ON BASIC EXPOSURE, GETTING A PRECISE EXPOSURE IS ONE OF THE MOST IMPORTANT ASPECTS IN CAPTURING COLORS AND TONAL VALUES IN THE WAY THAT YOU ENVISION THEM. HUE, SATURATION AND BRIGHTNESS, THE THREE QUALITIES OF COLOR, ARE ALL DEPENDENT ON EXPOSURE.

If you are constantly battling to bring poor exposures back to where they should be you are also in a continuous battle to hold onto the accuracy of the colors at hand. While many exposure-related flaws can indeed be fixed in editing, to set up a workflow routine that relies on editing to fix flaws is kind of like relying on ketchup to fix bad cooking. It might cover up mistakes, but there are surely better and more reliable recipes for success.

LIGHT METERS

The sophistication of light meters in both simple and advanced cameras has by and large made getting the right amount of light into the camera an almost forgone conclusion—at least in most common daylight situations. Color accuracy is also quite good in most digital cameras although not all cameras see color the same way and even two different cameras of the same brand and model can record colors differently. Also, because many cameras employ in-camera processing tools—like exaggerated saturation—colors are being altered even when you don't make exposure mistakes (which is why it's a good idea to shut them off and also to shoot in Raw most of the time).

▼ YOUR CAMERA'S METER AND SENSOR ARE DESIGNED TO RECORD SCENES OF AVERAGE BRIGHTNESS WITH ACCURACY AND GOOD COLOR FIDELITY. ALMOST ANY DIGITAL CAMERA WILL CREATE GOOD EXPOSURES FROM SUCH SCENES.

The matrix meters that are found in all digital cameras work by measuring dozens (and potentially hundreds) of separate zones in your composition, comparing them to an on-board database of past exposure examples programmed into the camera's computer, and then spitting out just the right combination of aperture and shutter speed for a "correct" exposures. These meters not only compare various parts of a scene for brightness and tonal relationships, but they can also make a very good educated guess about what your subject might be. For example, if a matrix meter sees tall vertical subject in front of a bright background area, it might make an educated guess that what you're photographing is a person in front of an area of blue sky. It them compares its notes for that type of subject to its database and provides what it thinks is the best solution (in this case, giving priority to the person and not the sky). For a lot of old school shooters (like myself) who grew up carrying a handheld meter around their necks and taking a multitude of separate readings to calculate just the right exposure, these meters are really wonders to behold.

Many cameras also offer more selective types of metering, including center-weighted (a system that measures the entire frame by gives priority to the center of the frame) and spot metering (where as little as three percent of the frame is metered) that will also vastly improve metering accuracy in many situations. In the shot of the seagulls on the beach, for instance, I was able to use the spot-metering mode of my DSLR to take a reading of a tiny spot of middle gray on the seagull closest to the camera.

Regardless of the type of camera or meter, all light meters are designed to create a perfect reading for subjects that are middle gray in tone, or exactly halfway between pure black and pure white. And it's the meter's deepest desire to reproduce all subjects—on average—as this middle level of tonality. For subjects of average color in average brightness, this strategy works quite well. Problems arise, however, when your subjects fall out of those parameters. If you aim your camera at a white swan, for example, and make no adjustments to the meter's reading, you will end up with a middle gray swan. Similarly, if you were to photograph a black cat without exposure correction, you'd end up with a gray cat. Gray cats are nice (I own two) but the result is still not ideal. The range of tones is not as evident with color subjects since you're looking at color images, not black and white, but the same principle does apply: the camera will do its best to make a dark-red barn a middle-red barn. And it will do its darndest to make everything a middle-level tone, regardless of color. This is not a flaw in the metering system, rather, it's the meter doing what it was designed to do: render all subjects as a middle gray tone.

▲ SPOT METERING IS AN IDEAL SOLUTION WHEN IT COMES TO METERING VERY PRECISE SMALL AREAS OF A PHOTO. IN THIS CASE I WAS ABLE TO METER DIRECTLY FROM A GRAY PATCH ON THE SEAGULL'S WING AND IGNORE THE BRIGHT SAND THAT SURROUNDED THE GULLS AND THE DARK WATER IN THE BACKGROUND.

▲ EXPOSURES GET TRICKY WHEN A BRIGHT SUBJECT IS PLACE IN FRONT OF A DARK BACKGROUND OR VICE VERSA. IF YOU EXPOSE FOR THE LIGHTER SUBJECT, IT WILL REPRODUCE AS A MIDDLE-TONED GRAY; IF YOU EXPOSE FOR THE DARK BACKGROUND THE LIGHTER SUBJECT WILL WASH OUT. UNDERSTANDING THIS INHERENT PROBLEM WILL HELP YOU MAKE THE RIGHT EXPOSURE DECISIONS. IN THIS CASE I METERED THE SWAN WITH A CENTER-WEIGHTED METER AND THEN USED PLUS ONE-AND-A-HALF STOPS OF EXPOSURE COMPENSATION TO LIGHTEN THE SWAN. THE CONTRAST WAS GREAT ENOUGH SO THAT THE BLACK BACKGROUND WAS EASY TO DARKEN IN EDITING.

Exposure Tools for Accuracy, continued

There are, however, two tools that can help you beat the camera at its own game and create more accurate exposures and more precise color renditions. I think that owning both is a very good idea.

18% GRAY CARDS

The best way to create a more accurate meter reading with demanding or complex subjects is to meter from an 18% gray card—a piece of cardboard (available at most photo-supply shops) that is calibrated to reflect back exactly 18% of the light striking it. By placing the card in the same light as your subject and then metering from just the card, the meter will establish an exposure that is correct for the card—and in turn, subjects darker than middle gray (i.e., those that reflect back less light than the gray card) will naturally go darker and those lighter (those that reflect back more light) will record lighter. Bear in mind that the meter and your camera's sensor both see the world as a realm of gray values—not as a palette of dazzling colors.

In photographing the card it's important to keep the card in the same light as your primary subject (a trick that's often more complicated than it sounds, particularly if you're shooting a broad landscape) and to fill the frame with just the card. Gray cards are

▼ WHAT YOU SEE AND WHAT YOUR CAMERA SEES ARE TWO DIFFERENT THINGS: YOUR CAMERA SEES THIS FISH SCULPTURE AS A PATTERNS OF GRAY VALUES WHILE YOUR BRAIN SEES ONLY THE COLORS.

particularly useful when your primary subject (a flower blossom, for example) is surrounded by a particularly dark or bright background or when the scene has a lot of inherent contrast. Once you've metered the card you can either lock that meter reading using your camera's exposure-lock feature or simply switch to manual exposure and set that meter reading. A shot of a gray card should provide a brightness level of 50% in your editing software and each of the three channels (R,G,B) should read at 128 (halfway between 0–255, the tonal range of an 8-bit file).

COLOR CHECKER

While a gray card will go a long way toward assuring improved exposures in terms of tonality, it can't guarantee correct colors. You can, however, substantially improve color accuracy by using a tool known as a color checker or color target to establish a color profile for your camera. These checkers consist of a grid containing anywhere from 24 (for a basic GretagMacbeth ColorChecker) to 48 or more different color swatches (such as the Datacolor SpyderCheckr SCK100). Other even more complex cards are available, as well. Each of the color patches on these cards is engineered and printed to scientifically match the precise color of common subjects like different skin tones, blue sky and various types of common vegetation. By comparing these known colors to the colors in your files you can correct colors with more precision.

Using a color checker adds a few layers to your normal shooting and editing procedure but these steps become second nature after awhile and vastly improve color results. Basically the process involves photographing the checker in the same light as your subject, then importing that shot into your editing software and creating a color profile. There are various software products available for creating profiles (the SpyderCheckr, for instance, comes with its own software). Once you've created a profile for your camera and for a particular lighting situation you can match colors either visually or numerically to the checker's known color values. The software profiling procedure is relatively simple and involves aligning your shot of the target with a grid that measures and compares each of the color swatches to known colors.

Is such extreme color accuracy necessary for day-to-day shooting? Probably not, but there may be times when you will be photographing art works for a friend or perhaps shooting fashion where precision does matter. And having a perfect loop from camera to a calibrated monitor to a color-matched printer (and scanner) will give you utmost confidence in your photo abilities.

▼ ▶ IF A GRAY CARD IS NOT AVAILABLE, THERE ARE NATURALLY OCCURRING SUBJECTS THAT REFLECT APPROXIMATELY THE SAME AMOUNT OF LIGHT. A RICH BLUE SKY (PARTICULARLY IN THE NORTHERN SKY) IS A GOOD METERING TARGET AND YOU CAN SHOOT AT WHATEVER READING THE SKY PRODUCES. BRIGHT GREEN FOLIAGE OR GRASS WORKS ALSO BUT YOU WILL NEED TO SUBTRACT ABOUT 2/3 OF A STOP OF LIGHT. WEATHERED WOOD SUCH AS AN OLD BARN IS ANOTHER GOOD MIDDLE-TONE METERING TARGET THAT CAN TYPICALLY BE USED TO PROVIDE VERY ACCURATE EXPOSURES.

High Dynamic Range Imaging

BUT WAIT, DIDN'T I JUST SAY THAT YOUR EYES HAVE A BETTER DYNAMIC RANGE? THEY DO—AND DECIDEDLY SO.

The estimated ratio of 6.5 stops for the human eye is misleading because it's only accurate for a fixed gaze under constant lighting. In reality your eyes are continually scanning and reexamining every detail in front of them—opening a shadow here, closing down a highlight there—and then compositing these views into a single mental image. That fact that your eyes are in constant motion and instantly adjust to the prevailing lighting conditions produces a more accurate potential dynamic range of about 1,000,000:1—or about 20 or more stops. So, while the range of a DSLR would at first seem to exceed that of our eyes, when you factor in the human visual system's ability to adjust, there is simply no comparison.

Your eyes, in fact, can pick out and retain details in complex situations that would make your camera toss up its digital hands in surrender. If you were walking on the beach on a bright sunny afternoon, for example, your eyes would be able to easily pick out details in a bed of brilliant white sand. Then, as you bend to look down at the sea life at your feet, you might spot a cluster of dark muscle shells

in the shadow of a rock and within an instant your eyes would begin to pick out surface colors and textures in those shells. By comparison your camera would be able to record one view or the other, not both. If you expose for the shells, the white sand will wash out and if you expose for the sand, the shells will fall into complete blackness.

Any tonal information that falls outside of your camera's dynamic range is simply not recorded. In the case of shadow detail, some lost information can sometimes be rescued in editing but highlight information that is not recorded by the sensor can never be reclaimed. What this means in terms of gathering color information is that, if the scene that you are photographing exceeds the dynamic range of your sensor, you have to make (and live with) decisions about which information is protected and which is thrown to the wolves. And in very contrast-filled situations, that can be a painful sacrifice.

There is, however, a technique called High Dynamic Range Imagining (HDRI) that you can use to broaden the dynamic range of your captured images and send those wolves howling empty bellied into the sunset. This is a multi-shot technique that works by shooting several separate exposures of the same scene and then combining them in editing using special software such as Photomatix, HDR Efex Pro, or the Merge to HDR function in Photoshop. You can,

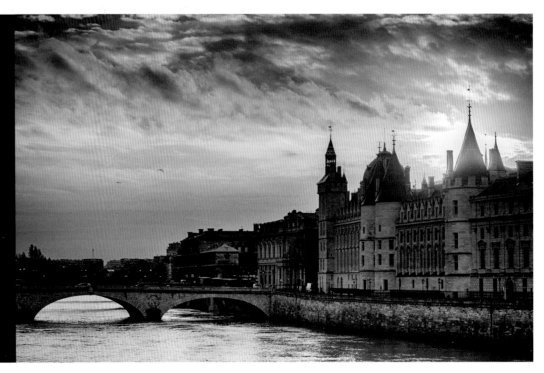

▶ BACKLIGHTING IS THE CLASSIC SCENARIO OF A SCENE WITH TOO WIDE A DYNAMIC RANGE TO FIT INTO A SINGLE EXPOSURE. THIS VIEW OF THE SEINE RIVER WAS SHOT DIRECTLY FACING THE MORNING SUN, AND CAPTURING DETAIL IN THE SKY MEANT A TOTALLY BLACK FOREGROUND, WHILE THE SECOND EXPOSURE FOR THE FOREGROUND HAD A TOTALLY WHITE SKY. MERGING THE EXPOSURES WAS SIMPLE ENOUGH, BUT THE PRELIMINARY RESULTS LOOKED ARTIFICIAL. DELICATE TONE-MAPPING AND COLOR ADJUSTMENTS (WARMING THE FOREGROUND) WERE REQUIRED TO ACHIEVE A NATURAL RESULT.
© FRANK GALLAUGHER

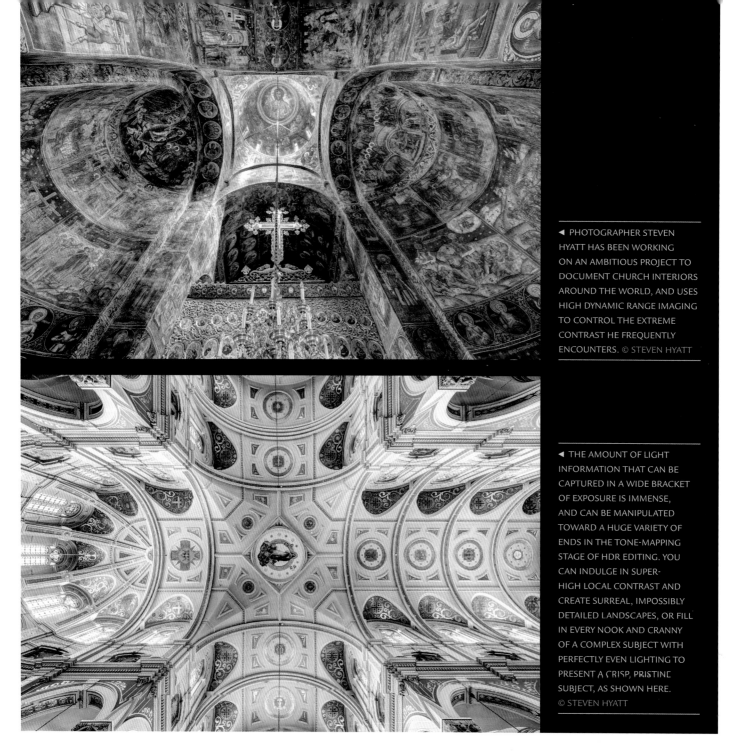

for example, take three different exposures of the same scene: one to record the shadow information of those mussell shells, one to record the mid-tones of a row of palm trees and another to capture the highlights of the sand. When these three images are combined in editing, you significantly extend the dynamic range to include everything from the darkest shadows to the brightest highlights. You can, of course, make more than three exposures, and experienced HDRI shooters often do. The creative doors opened by using HDRI are truly astounding. The images above, for example, are by Charleston, South Carolina-based photographer Steven Hyatt, for his Churches of America fine-art project (www.thechurchesofamerica.com), and all were created using the HDRI method. Because most of the interiors that he photographs have an inherently high range of tonal values created by a broad mix of ambient artificial light and sunlight pouring in through windows, using normal exposure techniques would result in sacrificing either highlight or shadow detail. By making a series of exposures, Hyatt is able to capture detail in all areas of his compositions.

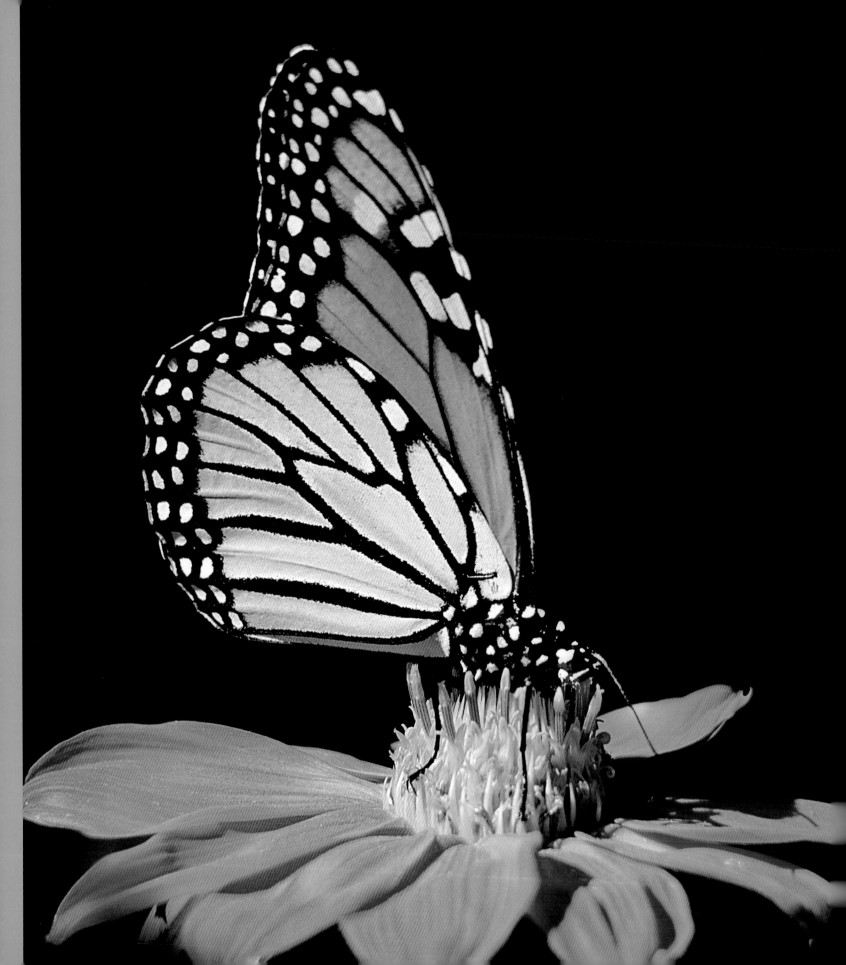

Chapter 5:

Creative Color

"It is only after years of preparation that the young artist should touch color—not color used descriptively, that is, but as a means of personal expression." So wrote the great artist Henri Matisse about making the leap from color as a literal tool to one of artistic ambition. And the point is quite valid for photographers: until you have mastered the basics of recognizing and recording the colors of the world around you with confidence and accuracy, it's impossible to progress into exploring the more imaginative possibilities of color. (Matisse, incidentally, speaks from his own history: as exotically colorful as his famous are, his early paintings were very dark and have been described as "gloomy" by art historians.)

Creative use of color can come in many forms and serve many purposes. Using a spot of bright color in an otherwise muted composition, for example, is not only an attention-grabbing design tool, but it's a powerful way to direct the viewer's attention to a specific detail or to showcase a particular area of a larger scene. A woman in a brightly colored dress moving through the gray concrete corridors of a dull city block is almost impossible not to acknowledge.

Color can also be used to draw attention in other ways: a bright red wall cries out for examination from the sheer boldness of its hue. Why was this wall painted with such audacity? What message am I being called to examine? The colors of close-up and macro subjects pique our curiosity in a more intimate world: Are the dragonfly's eyes really such a vibrant green? Do all insects have colorful eyes? Often the simple act of aiming a macro lens a single flower blossom or a seashell reveals patterns and ranges of color unseen in our broader view of the world.

Then too, there is the power of pure abstraction: color does not have to describe in a factual or even understandable language. It can be exploited for the purely visual reasons: colors tossed together in unexpected and unexplained ways, colorful shapes colliding together without rhyme or reason or just simply to entertain the eye. And in digital editing, the reality of color is, shall we say, flexible.

Along the path of color discovery one also begins to appreciate the depth, strength and versatility of individual colors: the pomposity of red, the brilliance of yellow, the natural wonder of a thousand shades of green. And each new unearthing leads to another and eventually you begin to develop a personal color vision and eventually you arrive at the threshold that Matisse foretold: you shed the garment of color as a means to describe and step bravely into the colors of your own imagination.

A Splash of Color

AS TEMPTING AS IT IS TO FILL THE FRAME FROM EDGE TO EDGE WITH A BOLD OR EVEN A SUBTLE BLEND OF COLORS (AFTER ALL, COLOR IS FREE, WHY NOT GET GREEDY WITH IT?), OFTEN PRESENTING THE VIEWER WITH A SCENE THAT CONTAINS A DECIDEDLY MORE STINGY SPLASH OF COLOR IS MORE EFFECTIVE.

Small but significant patches of color can perform many useful tasks in a photographic composition ranging from drawing attention to physically diminutive but emotionally meaningful areas to acting as a counterbalance to large areas of muted or dark negative space.

Isolated pockets of color are particularly dramatic when they call upon naturally complementary colors, as in the shot of a single yellow dandelion that, while it takes up a substantially smaller portion of the frame, seems to dominate the surrounding area

▲ WITH THE EXCEPTION OF THE GIRL'S BRIGHT PINK DRESS, VIRTUALLY EVERYTHING IN THIS SCENE IS DRAB FROM THE MUDDY WATER TO THE LEADEN SKY. IN LOOKING AT THE SCENE QUICKLY YOU BARELY NOTICE THE MANHATTAN SKYLINE IN THE DISTANCE.

◄ THE PLACEMENT OF THE BRIGHT BLOSSOM IS IMPORTANT IN THIS COMPOSITION BECAUSE OUR ATTENTION IS INITIALLY DRAWN THERE AT THE EXPENSE OF EVERYTHING ELSE IN THE FRAME.

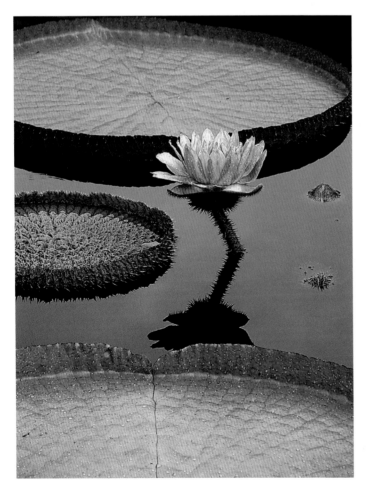

of purple flowers (see page 46). The effect is even more pronounced because the warmer and lighter color seems to advance while the cooler colors are perceived as retreating. In fact, this contrasting of a brighter area against a darker and heavier background is one of the most powerful methods for establishing a feeling of balance and unity in the composition.

Bright patches of color are also useful at bringing a bit of life to otherwise drab or monotonous parts of a scene. I included the little girl in the magenta dress to counteract what was otherwise a completely dreary view of the Manhattan skyline looking back from Liberty Island. The sky was deeply overcast and I'd been trying for an hour to find some way to liven up the gray concrete monoliths and then she walked into the frame—problem solved.

Very often a scene may contain more than one isolated pocket of color that, while seemingly in conflict with one another, can also act as a unifying force against a large area of darkness if the colors are well matched. In such cases analogous colors tend to draw one another out and each helps to reinforce the other. Incidentally,

this type of scene isn't really something you can set out to find ("Honey I'm going out to find small analogous patches of color on a neutral background to photograph…"), but you are far more likely to recognize and take advantage of them if you are aware of their importance.

One thing to keep in mind any time that you use a restricted area of color is that placement becomes exceedingly important because whether you intend it to or not, the eye will be drawn to those spots of color as surely as they will to a spot of mustard on your clean white shirt. (At which point, your clever better half may suggest you just photograph your shirt.) In the shot of the water lily shown opposite, for example, even though the blossom has a moderate amount of color competition from the red edging around the green lily pads, the eye lands immediately on the flower. The human brain simply cannot resist such unexpected pockets of bright color.

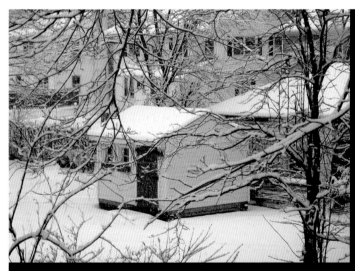

▲ WHILE MORE INTENSE COLORS CAN DRAW ATTENTION EVEN IF THEY OCCUPY ONLY A TINY PORTION OF THE FRAME, WHEN THE COLORS BECOME LESS INTENSE IT HELPS IF THEY ARE PHYSICALLY LARGER—AS IS THE CASE WITH THIS PALE YELLOW GARDEN SHED. NOTE THAT THE SHED AND ITS RED DOOR ARE THE ONLY COLORS IN SCENE OTHERWISE COMPRISED ALMOST ENTIRELY OF BLACK, WHITE, AND GRAY.

▲ A SPOT OF COLOR CAN GO A LONG WAY TOWARD BALANCING THE PERCEIVED VISUAL WEIGHTS IN A SCENE. WHILE THE SUN IS JUST A TINY SPOT ON THE HORIZON IN THIS ARIZONA LANDSCAPE, ITS INTENSE BRIGHTNESS IS ABLE TO HOLD ITS OWN AGAINST THE MUCH HEAVIER MASSES OF A DARK MOUNTAIN IN THE FOREGROUND AND DARK SKY ABOVE.

Colorful Backgrounds

A BROAD SOLID EXPANSE OF COLOR CAN MAKE AN INTERESTING BACKGROUND FOR CERTAIN TYPES OF PHOTOGRAPHS BECAUSE IT NOT ONLY RAMPS UP THE COLOR INTEREST OF THE SHOT, BUT IF WELL CHOSEN IT WILL ALSO HELP TO UNIFY THE SCENE.

Colorful backgrounds are also great attention grabbers and can often help establish the emotional climate of a scene. Stage set designers, for example, spend a lot of time on lighting and painting their backgrounds because they know that a large area of color can help to set the mood and establish things like time of day or locale—using a cool blue backdrop to create the feeling of twilight, for instance, or to set a melancholy mood.

Brightly colored man-made backgrounds are often painted that way for a reason—usually to draw people's attention or to help enhance a certain kind of mood or even just to liven up a setting. The blue wall shown opposite looks lively and exotic, but it's just the bathhouse at a local town beach near my home in Connecticut. The color was obviously chosen by a freethinking town employee to add a kind of fun flair and perhaps even add a hint of the Caribbean to an otherwise purely functional structure. Similarly, the brilliant red wall of a large antiques store was no doubt created to help peak the curiosity of passersby enough to lure them into the business.

Nature is a plentiful source of interesting colored backgrounds though you often have to employ a bit of creative technique to exploit them. In the shot of the red-wing blackbird that I shot in Iowa, for instance, I watched as the bird returned to the same twig several times and liked the yellow prairie grass behind it, but wasn't seeing the shot that I wanted because the grass, while a nice color, had too much detail and was distracting. By switching to a 400mm lens (equivalent of 600mm on my Nikon body) and using a wide-open aperture, I was able to turn the grass into a blur of yellow.

The danger of using a vibrantly colored background is that it can easily overwhelm whatever is in front of it, so it helps if you have a subject that is bold enough to hold its own, visually. Again, while exploring the red wall of the antiques shop I spotted the Greek head and started experimenting with compositions using the red as a backdrop. The size, brightness, and powerful gaze of the subject were enough to do battle with the vibrant red.

▶ WHITE SKY CAN MAKE AN INTERESTING BACKGROUND IF YOU'RE CAREFUL TO EXPOSE FOR YOUR SUBJECT AND NOT THE BACKGROUND. FOR THIS SHOT OF THE FLYING WALLENDAS PERFORMING OUTDOORS ON A CLOUDY DAY, I TOOK A GROUND-LEVEL READING OF A NEUTRAL TONE AND THEN LOCKED THAT EXPOSURE.

▲ COLORFUL BACKGROUNDS TEND TO WORK BEST IF THEY ARE FREE OF DETAIL AND TEXTURE. ONE WAY TO SOFTEN DETAILS IS TO USE A COMBINATION OF A LONG LENS AND A WIDE APERTURE TO LIMIT DEPTH OF FIELD. FOR THIS SHOT OF A RED-WINGED BLACKBIRD IN AN IOWA MEADOW, I USED THE EQUIVALENT OF A 600MM LENS AND AN APERTURE OF $f/5.6$.

▲ A SOLID COLORED BACKGROUND GIVES YOU A GREAT CANVAS FOR CREATING SIMPLE COMPOSITIONS. THE ONLY DIFFICULTY IS THAT YOU USUALLY HAVE TO SETTLE FOR WHATEVER FOREGROUND MATERIAL YOU HAVE AT HAND—IN THIS CASE, AN EMERGENCY PHONE BOX.

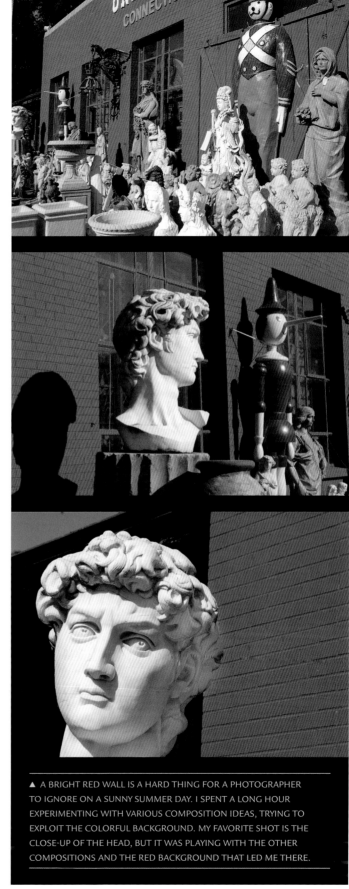

▲ A BRIGHT RED WALL IS A HARD THING FOR A PHOTOGRAPHER TO IGNORE ON A SUNNY SUMMER DAY. I SPENT A LONG HOUR EXPERIMENTING WITH VARIOUS COMPOSITION IDEAS, TRYING TO EXPLOIT THE COLORFUL BACKGROUND. MY FAVORITE SHOT IS THE CLOSE-UP OF THE HEAD, BUT IT WAS PLAYING WITH THE OTHER COMPOSITIONS AND THE RED BACKGROUND THAT LED ME THERE.

Colorful Close-ups

CLOSE-UP PHOTOS ARE A SURPRISINGLY RICH SOURCE OF INTERESTING COLORS AND COLOR COMBINATIONS AND MUCH OF THE COLOR FOUND IN THE MACRO WORLD COMES AS A COMPLETE SURPRISE WHEN WE CAPTURE IT IN PHOTOGRAPHS BECAUSE SO FEW OF US TAKE TIME TO GO LOOKING FOR IT.

Other than young kids, not many of us take the time to pause and examine insects, for instance, yet they possess some of the most beautiful and complex color combinations in nature. And the beauty of many common objects is often completely lost in the chaos that makes up our visual world. It's not until we slow down and isolate small subjects, whether natural or man-made, that we begin to see their true beauty.

Perhaps the toughest part of capturing and exploiting the color found in small subjects is just getting close enough so that the intended subject dominates the frame. There isn't room to go into detail here, but there are a number of ways to accomplish this and macro lenses, close-up extension tube and bellows (for extreme close-up work, larger than life-size or 1:1) area all good options.

Whatever tool you choose, just remember that it's important to check the LCD after you've shot to be sure your subject is filling the frame. Often we get so focused on small subjects that they seem to grow in our mind's eye and then when we see the finished photo they appear much smaller than we remember.

▲ TO PHOTOGRAPH THIS MONARCH BUTTERFLY AGAINST A BLACK BACKGROUND ALL THAT I HAD TO DO WAS FIND A BLOSSOM THAT WAS BRIGHTLY LIT BY THE SUN AND HAD A DEEP SHADOW BEHIND IT—A RELATIVELY EASY-TO-FIND SETTING ON A BRIGHT SUMMER DAY. THE CONTRAST BETWEEN THE BUTTERFLY AND THE SHADOW WAS SO EXTREME THAT ALL I HAD TO DO TO GET THE BACKGROUND TOTALLY BLACK WAS TO CAREFULLY EXPOSE FOR THE BUTTERFLY USING THE CENTER-WEIGHTED METERING MODE. I USED A CLOSE-UP EXTENSION TUBE ON A 70–300MM LENS TO GET CLOSE TO THE BUTTERFLY.

▲ I CAME ACROSS THESE ORCHIDS IN A PUBLIC GREENHOUSE IN CORPUS CHRISTI, TEXAS AND WHILE THE LIGHTING WAS SOFT AND BROUGHT OUT THE COLORS OF THE FLOWERS, THE BACKGROUND WHILE IN SHADOW WAS STILL A BIT CLUTTERED. SINCE I COULDN'T MOVE THE PLANT, I SHOT IT AS IT WAS AND DARKENED THE BACKGROUND IN EDITING.

TIPS FOR PUMPING UP CLOSE-UP COLORS

USE A BLACK BACKGROUND: Using a black background with close-up subjects has a lot of significant benefits and the most obvious is that color saturation tends to grow exponentially when they contrasted with a black setting. There are a number of ways to get a rich black background and the simplest is just to try and find a naturally occurring shadow that you can position behind your subject. That's exactly the trick I used to photograph both the orchids and the butterfly that are shown opposite.

USE A SHALLOW DEPTH OF FIELD: If you can't find a black background another option to subduing a busy background is just to toss it out of focus using either a wide aperture or a long-focal-length lens, or both. I often work with a 200mm macro lens for just that reason: because longer focal lengths have inherently shallow depth of field it's easier to knock the background down with a longer lens (the longer lens also allows me to work farther from the subject because the close-focusing distance is longer).

LOOK FOR COLORFUL BACKGROUNDS: In situations where the subject itself is more neutral in tone you can still make a colorful image by contrasting it against a brightly colored background. Legendary automotive photographer Jill Reger is a master of this technique and often uses the bright colors of one antique car as a bright backdrop for close-ups of another car's details. Again, working with a relatively long lens and restricting depth of field helps create a distinct separation between subject and background.

LOOK FOR DRAMATIC LIGHTING: Photographing close-up subjects in flat light is unquestionably simpler than using more directional lighting because there are fewer contrast and dynamic-range issues to deal with. But dull light produces dull photos. I much prefer to look for close-up subjects that have some inherent drama because I think they present a more realistic vision. Lighting that comes from the side or behind the subject can be particularly dramatic with subjects like flowers or insects that are partially translucent— the wings of a dragonfly, for example—because they will make the translucent areas seem to glow.

▲ ▼ AUTOMOTIVE PHOTOGRAPHER JILL REGER HAS SHOT THOUSANDS OF CLASSIC AND ANTIQUE CARS AND AMONG HER TRADEMARK SHOTS ARE CLOSE-UPS OF AUTOMOTIVE DETAILS LIKE THESE STYLISH HOOD ORNAMENTS. BOTH OF THESE PHOTOS WERE SHOT WITH A 70–200MM ZOOM LENS AT WIDE APERTURES TO TOSS NEARBY CARS INTO A COLORFUL BACKGROUND BLUR.
© JILL REGER

Silhouettes

WHEN I WAS A YOUNG KID (AND I'M DATING MYSELF AGAIN) MY PARENTS USED TO TAKE US TO THE STATE FAIR EACH FALL AND ONE OF OUR TRADITIONAL STOPS WAS A VISIT TO THE SILHOUETTE ARTIST.

This person (and he always had a line, so I have to assume he had a pretty lucrative business) would sit people down in front of him and in a matter of just a few minutes create a beautiful likeness of that person's profile using just scissors and black construction paper. And though as I grew older there weren't many photos of me as a kid hanging around my parents' house, those silhouettes were never taken down—they'd become a bit of my family's folk art collection.

Creating silhouettes with a camera is fun and very simple: all that you have to do is to place an opaque object—anything from an apple to a castle will do—in front of a bright background and expose for the background. Silhouettes are interesting because they remove most of the familiar telltale information about a subject, such as texture, form and volume, that most of us rely on to identify objects. The power of these shots comes entirely from two things: the shape of the object itself and the color of the background.

While recognizable shapes probably have a more immediate impact, it's perfectly legitimate to use this technique to create interesting abstract images. If you are hoping that your silhouettes will create familiar shapes, however, it's important that you choose a shooting angle that presents all of the necessary visual information. A silhouette that falls halfway between an identifiable shape and an abstract is probably more confusing than revealing. You have to be particularly careful that the shape you're silhouetting doesn't merge into other unrelated shapes.

While the sky is a pretty common background for silhouettes, you can use almost any bright surface—water, light-colored walls, or even the glass wall of an aquarium. Sunrise and sunset are particularly nice times to shoot colorful silhouettes because nature will provide a lot of intense color. You can even shoot silhouettes at night if you happen to be in a place like Times Square where you can kneel down low and pose a friend in front of a brilliant wall of lights.

▲ BLUE SKY IS A GOOD COLORFUL BACKGROUND FOR A SILHOUETTE, PROVIDED THERE IS ENOUGH CONTRAST BETWEEN THE SUBJECT AND THE SKY. IN THIS CASE I TOOK A METER READING FROM THE SKY IN THE MANUAL MODE AND THEN COMPOSED THE STEEPLE OF THIS GREEK ORTHODOX CHURCH WITH THE SUN BEHIND THE STEEPLE.

► THE WARM-TONED WATER OF A RIVER AT SUNRISE MADE AN IDEAL BRIGHT BACKGROUND FOR SILHOUETTING THESE DUCKS.

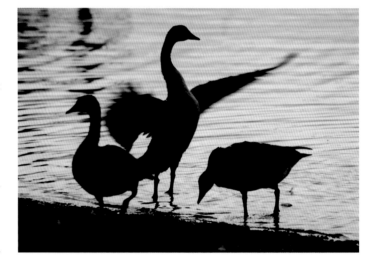

▲ THIS SILHOUETTE IS A BIT OF A POST-PRODUCTION CREATION. I SHOT THE ROCK FORMATION NEAR THE VALLEY OF THE GODS STATE PARK IN SOUTHERN UTAH, BUT I SHOT THE SUNSET SKY IN FLORIDA. I MERGED THE TWO TOGETHER IN PHOTOSHOP TO ADD A LITTLE MORE INTEREST TO WHAT WAS OTHERWISE A BLANK SKY.

▲ NOTHING BEATS A COLORFUL SUNSET AS A BACKDROP FOR A SILHOUETTE. IN THIS CASE I TIMED THE SHOT SO THAT THE SUN WOULD BE BEHIND THE DECK RAILINGS TO HELP ADD DEFINITION TO THE STRUCTURE OF THE COTTAGE.

◄ THE THING I PARTICULARLY LIKE ABOUT THIS SHOT IS THAT THERE ARE SEVERAL LAYERS OF SHAPES INVOLVED: THE FAMILY AND THEIR DOG IN THE FOREGROUND, THE BOATS IN THE MIDDLE GROUND AND THE ISLANDS IN THE DISTANCE. THERE'S EVEN A SEAGULL IN THE LOWER LEFT CORNER IN SILHOUETTE. EVEN THOUGH THERE ARE NO SURFACE TEXTURES OR AND NO SENSE OF VOLUME, EVERYTHING IN THE SHOT IS IMMEDIATELY IDENTIFIABLE BY ITS SHAPE.

Abstracts

PABLO PICASSO, WHO PROBABLY DID MORE TO POPULARIZE AND EXPAND THE HORIZONS OF ABSTRACT ART THAN ANY OTHER PAINTER, DEFINED THE PATH TO ABSTRACTION THIS WAY: "THERE IS NO ABSTRACT ART. YOU MUST ALWAYS START WITH SOMETHING. AFTERWARD YOU CAN REMOVE ALL TRACES OF REALITY."

And indeed, regardless of how little reality you eventually want to imbue a subject with, you must start with something in front of the camera. However far from reality you take that something from that point is entirely up to you—which is part of the fun of abstraction: there are no fences, no glass ceilings and no right or wrong. Often, in fact, the farther afield you wander the more interesting your pictures become; Picasso himself being a perfect case in point.

Abstraction can have many purposes and comes from many philosophies in art, ranging from a simple graphical distortion to deconstruction solely for the sake of introducing new graphical interpretations of objects. Many artists, of course, have higher metaphorical aspirations. Alfred Steiglitz began his famous equivalents series in the early 1920s using photographs of clouds as lyrical metaphors for music (and later in the series, for even more complex emotional and psychological ideas). And the great Dada artist May Ray often combined media with photographs or distorted photographic processes in order to combine ideas from several different sources—in one famous image drawing *f*/holes on a woman's back to marry the human form to that of a violin.

Regardless of the emotional or intellectual concept being expressed, the essence of abstraction is typically to place the ideas of color, design and image structure above the practical reality of the subject itself. Familiar objects are exploited as mere stepping-off points or instigators of other visual ideas and ambitions. Cubists (including most notably Picasso) often used the freedom of abstraction to reveal a subject from multiple angles simultaneously—showing us a woman's face from many points of view at once, for example. And artist/photographer David Hockney used collages of dozens of individual photographs of an object or place to reveal those subjects through multiple viewpoints and, since no one can look at multiple viewpoints in a single instant, to show us in effect the passage of time.

Creating abstract images with a camera seems like a monumental conflict at first since the very tool that we're using has been designed to render every last iota of realistic detail and do it with merciless electronic and optical precision. It seems almost like sacrilege then to intentionally muck about with that perfection and toss reality aside. But the very act of abandoning the recognizable in favor of the impressionistic can be utterly liberating. Using a camera to completely obliterate the recognizable structure of an object is kind of like being a kid again and carefully building a dam across a stream only to stomp it into oblivion.

There are many paths to abstraction and, as my high school art teacher told me so many times: there are no mistakes in art, only new paths to explore. Very often ideas for abstract images present themselves. Other times interesting images are born from the intentional distortion or misuse of camera techniques. Derek Doeffinger's imaginative study of a Native dancer in Mexico is the result of using a relatively long 1/10 second exposure time to distort the fluidity of the motion. His image intentionally raises the patterns of color and movement above the more literal and identifiable image that would be created by a more traditional approach.

▲ THIS IMAGE BEGAN AS A SIMPLE SHOT OF AN OIL SLICK IN A PARKING LOT. WHILE THERE WERE SOME COLORS, I WAS DISAPPOINTED BY HOW DULL THEY SEEMED IN THE ORIGINAL CAPTURE SO I BEGAN TO PLAY WITH THE HUE/SATURATION TOOL IN PHOTOSHOP AND CREATED THIS HIGHLY SATURATED AND EXAGGERATED DESIGN.

▲ DEREK DOEFFINGER, WHO HAS WRITTEN EXTENSIVELY ABOUT SHUTTER SPEEDS AND THEIR EFFECT ON MOVING SUBJECTS, EXPLOITED HIS KNOWLEDGE TO TURN A NATIVE DANCE SHOW IN MEXICO INTO A SWIRLING MASS OF COLOR AND MOTION. © DEREK DOEFFINGER

◄ SIMPLE SUBJECTS LIKE PEELING PAINT ON A RUSTING METAL SIGN ONLY NEED TO BE DISCOVERED TO BECOME GREAT ABSTRACT SUBJECTS. DEREK DOEFFINGER FOUND THIS EXAMPLE IN MEXICO. © DEREK DOEFFINGER

▼► WHILE SITTING ON MY PORCH ONE DAY I NOTICED THAT A STACK OF COLORFUL OBJECTS ON A SHELF BENEATH THE TEXTURED GLASS SURFACE OF A NEARBY TABLE CREATING THESE IMPRESSIONISTIC PATTERNS IN THE GLASS. I SPENT THE NEXT HOUR REARRANGING THE OBJECTS AND PHOTOGRAPHING THE COLORFUL DESIGNS. IN THE SHOT BELOW YOU CAN SEE THE TABLE AS IT LOOKED BEFORE I BEGAN ISOLATING THE ABSTRACT DESIGNS.

Low- & High-key Images

ALTHOUGH THE GOAL IN CREATING MOST PHOTOS IS TO INCLUDE A BROAD DISTRIBUTION OF TONAL VALUES, THERE ARE TIMES WHEN RESTRICTING THE TONAL RANGE TO CREATE EITHER A VERY DARK OR A VERY LIGHT IMAGE CAN BE QUITE EFFECTIVE.

Photos that have predominantly dark tones are called low key and those that have mainly light and airy tones are considered high key.

▲ ▼ VERY OFTEN IT'S POSSIBLE TO SHIFT A MODERATELY TONED SCENE TO A LOW-KEY (OR HIGH-KEY) FEEL BY AN ADJUSTMENT IN EXPOSURE—EITHER IN CAMERA OR IN EDITING. IN THIS CASE I DEEPENED THE TONAL RANGE OF THESE RELIEF CARVINGS TO CREATE A SOMEWHAT MORE DRAMATIC MOOD.

Limiting the tonal range of an image can be powerful, both visually and emotionally. I often think of low- and high-key images as the light and dark forces of photography: High-key images bring out cheerful bright Mary-Poppins emotions, while low-key pictures bring out the Darth Vader. Yes, that's probably overdramatizing the concept a bit, but altering mood is actually the purpose of using such extreme eclipses of tonal range: to manipulate your viewers' responses at first glance. By simple selection of tonal combinations, you get to pay psychological puppet master, more or less forcing your viewers to confront your emotional interpretation of a scene.

Art directors are well aware of the power of a restricted tonal range. Greeting card companies, for example, are unabashedly blatant about exploiting the happy-and-smiley feel-good mood created by high-key images. They're well versed at using piles of white daisies blowing in the summer sunlight to tug at your heartstrings (and to tug a few bucks out of your wallet). And Hollywood filmmakers just love the film noir (literally "black film") qualities of a tonally bleak setting. Think about some of the dark settings that Hitchcock used in films like *Wait Until Dark*—what blacker setting visually or emotionally than a blind woman being stalked by a sunglasses-wearing murderer in a gasoline-soaked room illuminated much of the time only by a single match. Yikes.

Creating both low-key and high-key images is a matter of either finding subjects that fall naturally into those tonal ranges naturally, or of using somewhat radical manipulations of exposure—either in camera or after-the-fact in editing—to create them. In photographing the mechanics of a train wheel, for instance, the scene was naturally dark enough so that a correct exposure captured a low-key feel. In photographing the pink flowers in a meadow, on the other hand, I made a series of shots with a correct exposure settings, but when I looked at them on the computer they lacked the bright and airy feeling that I had experienced standing in the field. By adding roughly two stops during the Raw conversion, I created an image where the exposure is technically overexposed but the mood is much closer to what I was actually experiencing at the time.

It's not critical in either low- or high-key images that everything in the frame be within the restricted tonal range, only that those tonalities predominate. It's perfectly fine to have a small patch of bright tonality in a low-key image, for instance, and often that contrasting are helps to balance the visual weight of the larger dark areas. Similarly it's fine to include a small dark patch in a high-key image provided it's small enough to not compete with or upset the balance of lighter areas. Do a Google image search sometime on either "high key" or "low key" and you'll get some great photo ideas.

◄ WHITE SUBJECTS LIKE THIS MISSION CHURCH IN SOUTHERN ARIZONA ARE BY NATURE HIGH KEY, BUT IT TAKES CARE IN SETTING EXPOSURE TO RETAIN BRIGHT TONAL RANGE. IN THIS CASE I USED A GRAY CARD READING TO PREVENT THE METER FROM BEING BIASED BY BRIGHT SUBJECT.

▲ APPROXIMATELY TWO STOPS OF EXPOSURE WERE ADDED TO THIS SHOT OF PHLOX IN A MEADOW TO CREATE A LIGHTER, MORE AIRY ATMOSPHERE.

▲ SPRING IS AN ABUNDANT SOURCE OF HIGH-KEY SUBJECTS. WHITE FLOWERS, LIKE THE BLOSSOMS OF THIS DOGWOOD TREE, ARE A NATURAL FOR A HIGH-KEY APPROACH.

Color in Portraits

THROUGHOUT THE CENTURIES PAINTERS HAVE APPLIED RADICALLY DIFFERENT APPROACHES TO UTILIZING COLOR IN PORTRAITURE, THOUGH THEIR GOAL IS ALMOST ALWAYS EXACTLY THE SAME: TO PRESENT THEIR SUBJECTS AND THEIR SETTINGS IN AN INTERESTING WAY WHILE AT THE SAME TIME OFFERING SOULFUL INSIGHTS INTO THEIR SUBJECTS' PERSONALITIES.

Rembrandt, for example, often worked with a rich palette of dark earth tones, typically contrasting with golden highlights, while Van Gogh on the other hand often used bright primary hues pitted against one another in experimental fashion in what now seem like almost pre-psychedelic combinations.

While Rembrandt's color choices were often aimed at extolling the strength of dignity of his subjects, Van Gogh's were often as much about his own offbeat vision of the world as they were of his subjects' physical characteristics. Interestingly, both of these painters often used themselves as subjects for their portrait explorations—a thought to keep in mind if you can't find subjects of your own to shoot.

The colors that you include in your portraits, in setting and wardrobe and in your choice of lighting situations, are extremely important and often they say as much about your vision of the world as they do about your subjects. Color's most important role in portrait photos is, as with many other subjects, to establish an overall mood. Using color (and light) to create mood in a portrait is very similar to the way that you create mood in a landscape: when the dominant colors are warm and the lighting is soft and flattering, your images will have an engaging and welcoming feel. Crank up the saturation and punch up the contrast of the lighting and you create an entirely different emotional dynamic.

Because of this, it's important that you choose a color scheme that reinforces the mood that you're trying to establish. In Jennica Reis' delightful portrait of her daughter carrying a fistful of brightly colored helium balloons, the brilliant hues of the balloons and her pink dress add to the cheerful excitement of the moment. By contrast, Iancu Cristian's portrait, shot in a softly lit wooded setting with a more limited and earthy palette sets a happy, yet more tranquil and reflective mood. By choosing more natural tones and carefully avoiding any bright colors or hard contrasts that might have distracted her subject's face, she has made the face the hero of her shot. The only hint of bold color in the frame is the sash and trim of the dress, which contrasts nicely with the surrounding green.

Travel is a great time to use local color to enhance your portraits. In photographer Stephanie Albanese's street portrait of an old Mexican woman, she has used the extremely vibrant indigenous hues of the locale to help reveal a story of her subject's culture and heritage. To make the image even more colorful she draped the woman in a vividly colored blanket and posed her in a pocket of warm morning sunlight—a few thoughtful touches that transformed the situation into a classic travel portrait.

Finally, one of the nice things about shooting portraits is that, unlike a lot of other subjects, you can make changes to setting and wardrobe and radically transform the color combinations. Moving your subject from sunlight to shade and substituting a blue-toned outfit for a red one, for example, can transform a hot and passionate composition into a more quiet, perhaps more introspective interpretation.

◄ PORTRAITURE CAN ALSO BE AN EXERCISE IN RESTRAINT. HERE, A MUTED COLOR PALETTE LETS THE PERSONALITY OF THE SUBJECT SHINE THROUGH WITHOUT DISTRACTION.
© ACCORD

▲ NOTHING BEATS A HANDFUL OF COLORFUL HELIUM BALLOONS TO SET A CHEERFUL, UPBEAT MOOD IN A PORTRAIT. SUCH BRIGHT BACKGROUND COLORS CAN SOMETIMES DRAW ATTENTION AWAY FROM YOUR MAIN SUBJECT, BUT IN THIS CASE THEY'RE NO MATCH FOR THE GIRL'S EXCITED EXPRESSION. © JENNICA REIS

▲ THE MUTED EARTHY TONES OF THIS INFORMAL OUTDOOR PORTRAIT NICELY HIGHLIGHT THE YOUNG WOMAN'S SOFT PINK COMPLEXION. ALSO, THE HARMONY OF THE OUT-OF-FOCUS AREAS AND THE SMOOTHNESS OF HER SKIN HELP TO EMPHASIZE THE DELICATE QUALITY OF HER FACIAL FEATURES. © IANCU CRISTIAN

◄ THOUGH HER FACE IS BARELY VISIBLE, STEPHANIE ALABANESE'S CHARMING STREET PORTRAIT SHOT IN SAN MIGUEL DE ALLENDE, MEXICO PAINTS A FASCINATING PORTRAIT OF THIS NATIVE WOMAN. AND EVEN IF YOU'VE NEVER BEEN THERE, THE BRILLIANT COLORS OF THE WALL AND THE BLANKET AND THE STRAW HAT ON THE BICYCLE ALL COMBINE TO CREATE A VIVID DEPICTION OF MEXICO. © STEPHANIE ALBANESE

Colors of a Place

IN THE SAME WAY THAT A PARTICULAR PART OF THE WORLD CAN HAVE A DISTINCTIVE LANDSCAPE, READILY IDENTIFIABLE ARCHITECTURE (THE SHOTS OF GREECE ON THESE PAGES ARE PERFECT EXAMPLES), OR EVEN RECOGNIZABLE SCENTS AND SOUNDS, MANY DESTINATIONS POSSESS AN IDENTIFIABLE SET OF COLORS.

Often, in fact, the colors of a region are one of the first things that come to mind when we create a mental image of a particular destination—the hillsides of Vermont in October or the colorful fishing boats that line Caribbean beaches, for example. Color and places are inexorably linked in our imaginations and in our memories—a fact not lost on those who design travel brochures or edit travel magazines. You don't see photos of hotel rooms in ads for Bora Bora; you see photos of the turquoise sea. When it comes to travel: color sells.

There are many reasons why a particular geographic area has its own identifiable color scheme. In terms of homes and other structures, often it's because of the abundance of a particular building material. The earthen-colored adobe structures of the American southwest, for example, exist because for centuries, that was the only material available to construct homes. Often an area's colors are related to its agriculture—the lavender fields and sunflower farms of France are instantly recognizable examples. Then, too, there is the simple matter

▲ EVEN IF YOU'VE NEVER BEEN THERE, IT PROBABLY WOULDN'T TAKE MORE THAN A FEW GUESSES TO IDENTIFY THE LOCATION OF THIS SHOT AS MEXICO. THESE HOT-COLORED WALLS SEEM VERY SYMBOLIC OF BOTH THE CULTURE AND THE CLIMATE OF THAT COUNTRY. © STEPHANIE ALBANESE

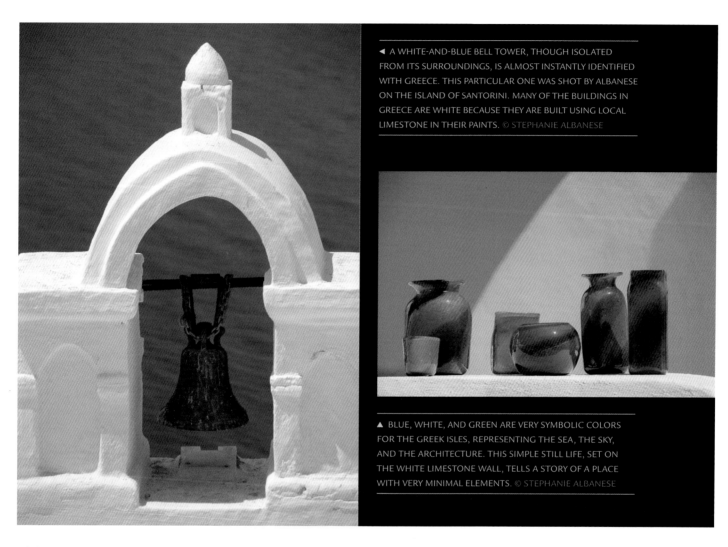

◄ A WHITE-AND-BLUE BELL TOWER, THOUGH ISOLATED FROM ITS SURROUNDINGS, IS ALMOST INSTANTLY IDENTIFIED WITH GREECE. THIS PARTICULAR ONE WAS SHOT BY ALBANESE ON THE ISLAND OF SANTORINI. MANY OF THE BUILDINGS IN GREECE ARE WHITE BECAUSE THEY ARE BUILT USING LOCAL LIMESTONE IN THEIR PAINTS. © STEPHANIE ALBANESE

▲ BLUE, WHITE, AND GREEN ARE VERY SYMBOLIC COLORS FOR THE GREEK ISLES, REPRESENTING THE SEA, THE SKY, AND THE ARCHITECTURE. THIS SIMPLE STILL LIFE, SET ON THE WHITE LIMESTONE WALL, TELLS A STORY OF A PLACE WITH VERY MINIMAL ELEMENTS. © STEPHANIE ALBANESE

of climate: the Pacific Northwest and Hawaii are both lushly green because there is a lot of moisture to nourish plant growth.

The colors of a region are also born from and interwoven with the culture and are reflected in every part of their lives and their environments, from their wardrobes to their homes to their foods. The intensely colored red and yellow walls in Stephanie Albanese's travel photo almost instantly identify the locale as Mexico. Even if you've never been to Mexico, the colors are simply too distinctive to exist anywhere else.

The distinct look of a particularly colorful region usually comes as a delightful revelation for traveling photographers because, being the visual souls that we are, the colors just shout out—particularly if we happen to come from rather mundane places. "Our environment here in upstate New York is fairly monochromatic, especially during the long winter months," says Albanese who frequently travels with her husband Gary Whelpley, both professional photographers (www.whelpleyandalbanese.com). "So, when visiting new places, we especially enjoy environments and cultures which embrace vibrant color in all aspects of life. The simple fact of being immersed in a new culture absolutely delights me."

The images on these pages, of San Miguel de Allende, Mexico and Santorini, Greece were all shot by Albanese and are wonderful examples of just how identifiable—and fun—the colors of a place can be.

Red

OF ALL THE PRIMARY HUES, RED IS THE MOST AGGRESSIVE AND EYE-CATCHING COLOR AND BECAUSE OF THAT IT OWNS A PROMINENT PLACE IN OUR DAILY COLOR EXPERIENCE.

Red is the color of warnings and alerts and is used universally to signal impending danger on signs, flags, and even medicine packaging. Fire engines, stops signs, fire hydrants, traffic lights—all signal for our attention with a beacon of red. Forest fire danger is signaled by a "red flag" warning and on most weather maps, the most severe storm warnings are indicated by red. And that is red's forte: it pierces the veil of distracting visual clutter and demands we acknowledge it.

Perhaps part of the reason that red elicits such a primal reaction is because of its subconscious associations with blood and mortality. Red is often used as a symbolic color of war and revolution. Dickens used the symbolism of red wine flowing in the streets of the French Revolution in *A Tale of Two Cities* (and how I hated having to recognize all of that symbolism in my high-school English class). In politics, the United States has been divided into camps of red and blue states—our allegiance is to a color. And red is also a mainstay in colors on political flags and on shields of heraldry.

Red is also the color of explosive passion. We get red with anger; see red when in a rage; and bulls charge at a matador's red flag (interesting that bulls are actually quite color blind). Red is also the color of romance, desire, and passion: ruby red lips call to us from the Hollywood screen, lovers send red roses, red is easily the most common color of nail polish and lovers sip from red wine and make love on the beach in front of a red sunset (if only on the big screen). And, of course, the symbol of love is a red heart: where would St. Valentine's day be without red heart-shaped boxes of chocolate? Red is also associated in some contexts with wholesomeness and generosity: a shiny red apple for the teacher almost guarantees a passing grade.

Mixed with a bit of white, red becomes pink and is the color of innocence, femininity, and flirtatious romance. In darker shades, deep and rusty reds are the colors of autumn harvest and fall foliage, and earthy reds are often associated with the red rock regions of the American west. Mixed with yellow, red becomes orange and with a bit of blue, it leans toward purple, even magenta.

But user beware: as powerful as it is, even a small red object can compete with other objects in the frame, and pitted against weaker colors can distract from other important subjects. A single red tulip in a bed of yellow buds will immediately distract the eyes.

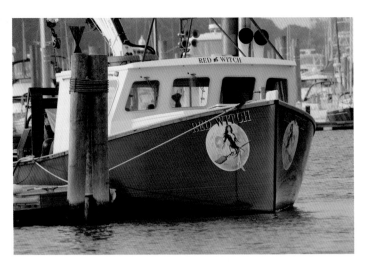

▲ VISUALLY, RED ADVANCES MORE THAN MOST OTHER COLORS, PARTICULARLY AGAINST WEAKER COLORS LIKE YELLOWS AND CREAM COLORS AND ITS OPPOSITES ON THE COLOR WHEEL—BLUES AND GREENS. SET AGAINST THESE COLORS, RED SEEMS TO RISE UP, CREATING A THREE-DIMENSIONAL EFFECT.

▲ RED IS GOOD AT ATTRACTING MANY TYPES OF ATTENTION—INCLUDING THE EYE OF PHOTOGRAPHERS. I'VE PHOTOGRAPHED THIS FISHING BOAT WHARFED BY MY HOME MANY TIMES BECAUSE I JUST CAN'T RESIST THE BOAT'S BEAUTIFUL PAINT JOB AND THE WHIMSICAL BOW PAINTING.

◄ THOUGH THEY ARE DISAPPEARING AT AN ALARMING RATE, RED BARNS ONCE DOTTED THE NEW ENGLAND COUNTRYSIDE. THIS ONE WAS SHOT ON A NATURE PRESERVE NEAR AMHERST, MASSACHUSETTS.

◄ ALL OF THE COMMON PSYCHOLOGICAL ASSOCIATIONS OF RED: POWER, DANGER, PASSION AND AGGRESSION SEEM TO PERFECTLY MATCH THE REPUTATION OF THE FERRARI. AUTOMOTIVE PHOTOGRAPHER JILL REGER MULTIPLIED THE EFFECT BY STACKING UP A ROW OF IDENTICALLY PAINTED EXAMPLES. © JILL REGER

Orange

ORANGE IS CREATED BY MIXING RED AND YELLOW AND IT'S ONE OF THE FIRST "NEW" COLORS THAT WE LEARN TO CREATE AS KIDS.

In fact, you can pretty much tell when one of your kids has learned to mix orange in school because they come home with a fistful of orange paintings: orange houses, orange dogs, orange trees and orange people. And interestingly, one of the psychological attributes of orange is that it's considered a fun color and is often associated with creativity and intelligence.

Psychological studies have also shown that orange increases the feelings of hunger and a desire to socialize and linger, which is why you may notice that restaurants use it in their color schemes. (In the 1970s you could hardly drive to a town in America and not see one of the famous Howard Johnson restaurants with its bright orange tile roof.) Though the color of other juices is often altered with dyes to make them more appealing in grocery stores, the color of orange juice is its own best advertising.

Because it's a derivation of red, orange also carries a mix or emotional responses from those two colors: while not as passionate or alarming as red, for example, it's still has implications of warning. Because it's a highly visible color, orange is frequently used for runner's vests, highway cones, construction hard hats and life vests. As with red, orange is regarded as a hot color and it has significant associations with fire, flames, sunrise and sunset.

Orange is also seen as a color of determination, enthusiasm and physical activity and is often used in the colors of collegiate and professional sports uniforms. Orange even has its own sport identity: basketballs have traditionally been colored orange. Because it also contains a significant amount of yellow, orange is also regarded as a cheerful, warm, inviting and is also associated with passion and compassion. Orange also has deep seasonal associations with autumn and harvest and is the color most associated with Halloween.

Nature is a bountiful source of orange and its relationship with nature makes is a color that is often associated with health and wholesomeness. It is the color of sunsets and sunrises, flowers, butterflies and insects, as well as numerous fruits and vegetables: oranges, tangerines, carrots, peppers and, of course, pumpkins.

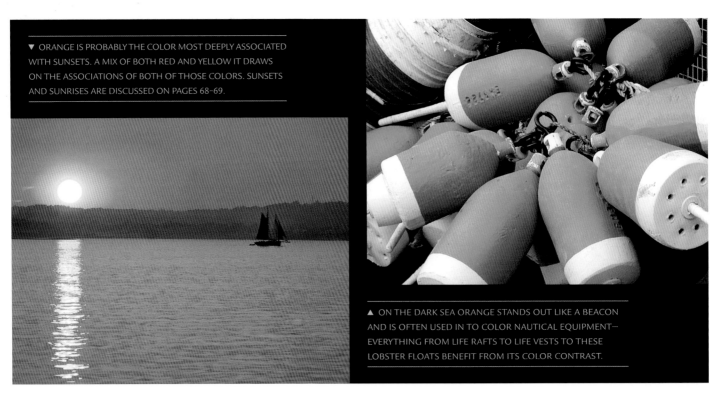

▼ ORANGE IS PROBABLY THE COLOR MOST DEEPLY ASSOCIATED WITH SUNSETS. A MIX OF BOTH RED AND YELLOW IT DRAWS ON THE ASSOCIATIONS OF BOTH OF THOSE COLORS. SUNSETS AND SUNRISES ARE DISCUSSED ON PAGES 68-69.

▲ ON THE DARK SEA ORANGE STANDS OUT LIKE A BEACON AND IS OFTEN USED IN TO COLOR NAUTICAL EQUIPMENT— EVERYTHING FROM LIFE RAFTS TO LIFE VESTS TO THESE LOBSTER FLOATS BENEFIT FROM ITS COLOR CONTRAST.

◀ NO DOUBT BECAUSE OF ITS BRILLIANT AND ATTENTION-GETTING QUALITIES, ARTIST CHRISTO CHOSE ORANGE AS THE COLOR FOR HIS GATES PROJECT THAT WOUND THROUGH MILES OF PATHS IN MANHATTAN'S CENTRAL PARK. IT BECAME THE MOST TALKED ABOUT AND VISITED ART INSTALLATION IN THE CITY'S HISTORY.

▼ BECAUSE OF ITS BRIGHTNESS, ORANGE CONTRASTS NICELY WITH BLACK IN SILHOUETTE SHOTS. I PHOTOGRAPHED THIS ORANGE SUNSET OVER THE MOUNTAINS WEST OF TUCSON, ARIZONA.

▼ NATURE IS A BOUNTIFUL SOURCE OF ORANGE, PARTICULARLY AMONG CULTIVATED FLOWERS. ORANGE IS OFTEN USED IN FORMAL GARDENS AS AN ACCENT-COLOR AND IS FREQUENTLY PLACED NEAR IT'S COLOR OPPOSITES GREEN AND BLUE TO CREATE COLOR CONTRAST.

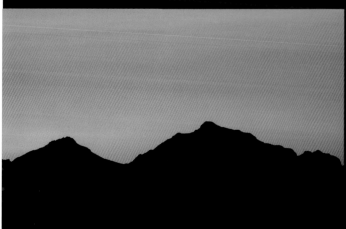

Blue

B LUE IS ONE OF THE THREE PRIMARY COLORS AND, ALONG WITH GREEN, IS ONE OF THE MOST PREVALENT COLORS IN NATURE.

In fact, the largest source of pure color that we see on a daily basis is the blue sky. While we sometimes think of blue as a light color because the sky is often a pale shade, in fact it is the darkest of the colors on the color wheel. Blue is also the coolest of the colors and most blue subjects have the sensation of coolness: icy winter scenes, twilight, moonlight landscapes and the sea. Glaciers and icebergs are blue. Blue stage lighting is usually used to set a cool mood and when an artist wants to add coolness to a white snow scene they will mix blue into the white.

Because of its deep color, blue has mental associations with depth and infinity: we look into the deep blue see and planes disappear into the wild blue yonder. Blue is also the color of calmness and tranquility largely because staring at the sea and the sky has a soothing effect on most people. Schools and doctors offices often use shades of blue to provide an environment of calmness and reassurance. All things blue also have strong associations with masculinity: blue is for boys, pink is for girls. You don't see a lot of pink football uniforms.

Blue is also used to describe sad moods: people get in a blue funk, if things aren't going well we're "feeling blue," and B. B. King not only sings the blues, he's the King of the Blues. Interestingly though, blue is also used to describe happy moods and optimism: people in a great mood see nothing but blue skies ahead. The greatest symbol of joy is the bluebird of happiness. Blue is also often the color of money and the Irish singer Van Morrison wrote a popular song called "Blue Money." Blue eyes are considered sexy and Frank Sinatra was known as "Ol' Blue Eyes."

Because of its rich color, it is often regarded as the color of strength, power and wealth and you often see it used in both business and sports to connote those qualities. Both IBM and the New York Giants football team are often referred to as "Big Blue." Blue is also considered a color that represents authority, order, and conservatism: blue business suits are very formal, blue is often used in corporate logos and, because it also symbolizes trust, is probably the most widely used color in corporate advertising. Blue also implies power and authority: most police uniforms are blue. In the military blue is typically reserved for the most formal and dignified of uniforms. It is also the color of loyalty and is often found in school colors schemes. Superheroes often drape themselves in blue capes.

In nature blue mixes easily with the colors of its neighbors to create variations: a touch of red aims it toward purple and in

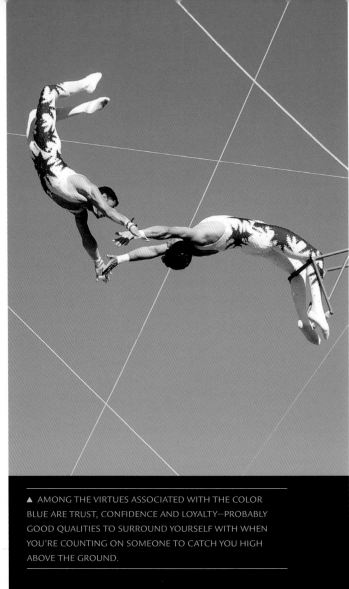

▲ AMONG THE VIRTUES ASSOCIATED WITH THE COLOR BLUE ARE TRUST, CONFIDENCE AND LOYALTY—PROBABLY GOOD QUALITIES TO SURROUND YOURSELF WITH WHEN YOU'RE COUNTING ON SOMEONE TO CATCH YOU HIGH ABOVE THE GROUND.

▲ A BLUE BOTTLE AND BLUE WINE GLASS ABSORB ALL THE OTHER COLORS FROM WHITE LIGHT AND TRANSMIT ONLY THE BLUE.

shades it seems to contain a certain amount of green. Lakes, rivers, and shallow areas of the ocean (especially where there is abundant underwater plant life) have a greenish-blue cast. Blue also shows up in nature in unusual and unexpected forms: in the Pacific Ocean, firefly squid (Watasenia scintillans, do a Google image search if you want to see some very cool pictures) are able to generate a blue light source via bioluminescence—a chemical reaction—and this blue glow attracts their prey.

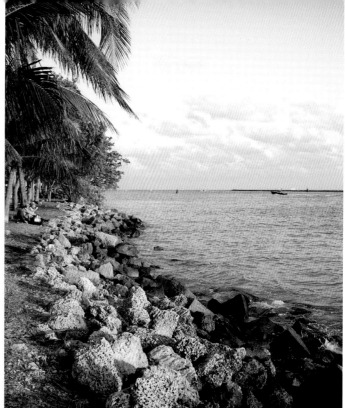

▲ A LARGE PART OF THE REASON THAT WE SEE THE SEA AS BLUE IS THAT IT REFLECTS THE COLOR OF THE SKY. THE SEA ALSO ABSORBS OTHER COLORS FROM WHITE LIGHT AND BECAUSE THE WAVELENGTHS OF BLUE LIGHT ARE SHORTER THEY SCATTER MORE IN THE WATER. BELOW ABOUT 200 METERS ALL LIGHT, AND THEREFORE ALL COLOR, IS ABSORBED.

▲ AS ENGULFED AS WE ARE BY THE COLOR BLUE IN THE SEA AND THE SKY, NATURE IS ACTUALLY KIND OF STINGY WHEN IT COME TO OFFERING TRUE BLUE AS A COLOR IN OTHER LIFE FORMS. SEARCHING OUT THE COLOR IN NATURE IS A FUN AND CHALLENGING ASSIGNMENT.

▲ THE COLOR OF BLUEBERRIES IS CLOSEST TO THE COLOR OF BLUE YOU'LL SEE ON COLOR WHEELS AND, IN FACT, LEANS QUITE A BIT TOWARD PURPLE—A FACT YOU'RE WELL AWARE OF IF YOU'VE EVER GOTTEN FRESH BLUEBERRIES ON A WHITE SHIRT. © MATIN

Green

GREEN IS THE COLOR OF JUNGLES AND FORESTS AND FIELDS OF CORN AND, ON A MORE MUNDANE LEVEL, FRONT LAWNS WAITING TO BE MOWED.

In short, green is nature's color of choice for plant life here on Spaceship Earth and as such, symbolically represents the renewal of life. Although green in nature is often dramatically punctuated by outbursts of red, yellow, blue, purple and a crayon-box full of other colors, it remains the dominant color of the botanical world. Green, which is a blend of blue and yellow, emotionally encompasses the hope and positive qualities of blue and the warmth and good feelings of yellow.

Green is also the color of spring and summer and because of this it has deep associations with fertility, rebirth, hope and growth. Our eyes are able to discern more shades of green than any other color and it's not surprising then that there are so many names for green. Go to a paint store sometime and you'll see a rainbow of green hue options with a poetic list of colorful names: Shamrock green, India green, avocado, olive green, army green, lime, Cadmium green, sea green, emerald, moss green and Kelly green—just to name a dozen. Ask a paint salesperson to help you pick a shade of green and their eyes will spin.

Being able to discern so many greens can make a walk in the forest a very stimulating experience but it also makes it a challenge both to find and to capture a pure green accurately. Pure green in Photoshop will register as 0 red, 255 green and 0 blue. Take a photo of something you think is pure green sometime and then use the information tool to check its purity. You'll discover that what we think of as a pure green often contains considerable red and blue. As you use the hue control to adjust the color you can shift it toward a pure green, but that is not to say it will be the actual green of the object or the exact hue that you remember. The memory of colors often varies considerably from their reality.

The color green is also part of many common phrases in the English language. Good gardeners are said to have a green thumb. And anything that's certain is "...as sure as God made little green apples." Perhaps because green is associated with freshness, someone who is new to something is referred to as a greenhorn. And when we're far from home, we long to see the green, green grass of home. Celebrated around the world, the Irish holiday of St. Patrick's Day is celebrated by the "wearing o' the green."

Green is considered a very restful color and is a favorite of interior decorators. It is also considered a lucky color: it's the color of a four-leaf clover, and greeting card and calendar publishers often depict young children (and young foals) laying in a field of clover to symbolize innocence and newness.

For all of its positive connotations in nature, green also has some negative connotations: jealousy is referred to as the "green-eyed monster." And people who get seasick look green around the gills. Monsters (Frankenstein chief among them) are often depicted as green, and green has less-than-cozy associations to all things slimy— perhaps because so many molds are green and blue-green in color. And as we all know, the grass is always greener on the other side. Green is also the signal to go forward—traffic lights are green and when Hollywood approves a new script, they give it the green light.

▲ WHERE MOISTURE IS EXCESSIVE, GREEN LIFE FOLLOWS. JAPANESE GARDENS LIKE THIS ONE HAVE VAST AMOUNTS OF RAIN AND MOISTURE, AND ARE GREEN YEAR-ROUND.
© ROBERT CRUM

▼ HOW DOES A BISON ON THE GREAT PLAINS KNOW WHAT TO EAT? ESSENTIALLY THEY EAT ANYTHING THAT IS GREEN—THEY KNOW WHAT HEALTH-FOOD ADVOCATES KNOW, THAT GREEN IS THE COLOR OF LIFE AND HEALTH.

▲ THE FIRST GROWTH OF MANY PLANTS IS USUALLY A RICH, VIBRANT GREEN. IN TEMPERATE AREAS WHERE ENDLESS EXPANSES OF NEW GROWTH REPLACE THE DULL WINTER LANDSCAPE, THE COLOR GREEN IS SO PROLIFIC IT IS OFTEN REFERRED TO AS THE CHLOROPHYLL CURTAIN. © JANET LOUGHREY

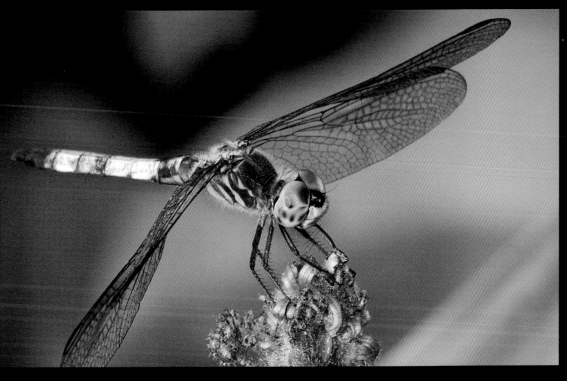

◄ BECAUSE NATURE IS A PLAYGROUND OF GREENS, MANY INSECTS AND OTHER CREATURES HAVE ADOPTED THE COLOR AS A MEANS OF CAMOUFLAGE. HERE THE EYES OF A DRAGONFLY MATCH THE COLORS OF THE PLANT LIFE ON WHICH IT RESTS. I'VE COME WITHIN INCHES OF PRAYING MANTES AND GRASSHOPPERS IN MY GARDEN AND NOT SPOTTED THEM UNTIL THEY'VE FLOWN UP IN MY FACE.

Yellow

YELLOW IS THE MOST LUMINOUS OF ALL COLORS. ALTHOUGH WE KNOW THAT THE SUN'S LIGHT IS ACTUALLY WHITE, MOST PEOPLE THINK OF SUNLIGHT AS BEING YELLOW LARGELY BECAUSE THE ONLY TIME THAT WE REALLY NOTICE THAT DAYLIGHT HAS COLOR IS WHEN IT IS LOW IN THE SKY AND THE LIGHT IS WARMER.

As was discussed in the pages on time of day (pages 66-67), the sun actually is more yellow at these times because as the sun gets lower in the sky it travels a greater distance through the atmosphere and the light is filtered so that more yellow (and red) light reaches our eyes.

Because of its affiliation with sunshine and its inherent brightness, yellow is often regarded as the most cheerful of colors. It has associations with happiness, fun and hope. It's tough to think of sitting in a bright yellow room while feeling somber or depressed for very long and you might actually find yourself being annoyed by the color because it is at conflict with your feelings and mood.

Yellow, along with red is one of the two the warmest colors of the spectrum and often produces feelings of safety, quiet and often inspires deep reflection or intellectual thought. Because it's such an intensely bright color, it's rarely used alone for residential interiors, but is often combined with white, particularly in kitchens and kids' rooms. Hotels, interestingly enough, tend to use more beige and tans—created from blends of white, brown, and a small amount of yellow—which are more restful and quieting. As nice as it might be to wake up in a room painted bright yellow, it could be a tough place to fall asleep.

Yellow is not particularly prevalent in the natural landscape, but where it occurs it brings feelings of happiness, fun and good nature. Spring gardens often overflow with yellow tulips and daffodils and brilliant yellow hedges of forsythia are a sure harbinger of summer. Yellow is the color of blonde hair (and blondes always have more fun, right?), flowers, baby chicks, canaries singing sweetly and a surprising number of tasty foods—summer corn, butter, lemons, bananas, summer squash, egg yolks, cheese, mangoes, and mustard to name just a handful.

Because of its brightness yellow is often used as the color of caution: school buses, fowl weather gear and yield signs and all manner of warning signs (including those millions of "Baby on Board" sings we all grew to loathe) and a gazillion happy face stickers. Taxi cabs, buses and boats are often painted yellow because they stand out in the chaos of big city traffic. Police crime-scene tape is always a bright yellow color because of its immediate visibility and implied authority. Because of these mental associations some people get anxious around too much yellow, rather than feeling comforted by its warmth, they go on high alert waiting for the source of all the caution warnings.

The dark side of yellow has associations with cowardice, humiliation and fear: "He's nothing but a yeller dog!" as they say in the old Westerns. It's also the color of certain forms of illness (jaundice) and it's the color of urine ("Don't eat the yellow snow!"). During both medieval times and during the years of Nazi-occupied Europe Jews were forced to wear yellow badges with the Star of David outlined in black to identify them.

Photographically yellow can be a tough color to expose for because if you underexpose it even a little it gets a bit grubby looking and if you overexpose it even a tad details are quickly lost. In editing for hue yellow often controls the colors most of us think of as green—grass, foliage and green paint. You'll notice when you try to shift the hue of a green lawn, for instance, that the green channel has little effect compared to the yellow channel. This is because green is created by the mixture of blue and yellow and yellow dominates most green hues.

▲ YELLOW AND GREEN ARE CALLED ANALOGOUS COLORS BECAUSE THEY FALL NEXT TO ONE ANOTHER ON THE COLOR WHEEL. IN MOST CASES ADJACENT COLORS GO TOGETHER NICELY AND ARE REGARDED AS A PLEASING COLOR ARRANGEMENT.

▲ ONE OF THE MOST OBVIOUS USES OF YELLOW IS SIMPLY TO GET ATTENTION. IT WOULD BE PRETTY DIFFICULT FOR FRIENDS TO MISS THIS HOUSE, JUST TELL THEM TO LOOK FOR THE BRIGHTEST HOUSE ON THE STREET.

▲ SUNFLOWERS ARE APTLY NAMED—THEY ARE THE COLOR THAT MOST OF US THINK OF AS THE COLOR OF SUNLIGHT. ANYONE THAT HAS GROWN SUNFLOWERS ALSO KNOWS THAT THE HEADS TURN THROUGHOUT THE DAY TO FOLLOW THE SUN ACROSS THE SKY.

▲ SPRING AND SUMMER RAINS ARE OFTEN FOLLOWED BY A SUDDEN AND UNEXPECTED BURST OF YELLOW IN SOME DESERT REGIONS. I SHOT THESE WILDFLOWERS IN THE VALLEY OF THE GODS STATE PARK IN UTAH.

▲ THOUGH YOU MIGHT THINK THAT OPPOSITES WOULD COMPETE WITH ONE ANOTHER TO CREATE DISCORD, THE COMBINATION OF COMPLEMENTARY COLORS IS OFTEN CONSIDERED ATTRACTIVE.

Chapter 6:

Color
After Dark

In his essay *Night Walks*, Charles Dickens elegantly describes his bouts with insomnia and his decision to take to the streets wandering until dawn rather than tossing and turning the nights away. He writes: "The disorder might have taken a long time to conquer, if it had been faintly experimented on in bed; but, it was soon defeated by the brisk treatment of getting up directly after lying down, and going out, and coming home tired at sunrise." It was during his night walks that Dickens discovered a personal fascination for, and a kinship with, the sights and experiences of London after dark. The night became his muse.

The world that Dickens experienced after dark bore little resemblance to the city that most of London's residents saw by day—a character that he personified so often in his books. ("The wild moon and clouds were as restless as an evil conscience in a tumbled bed, and the very shadow of the immensity of London seemed to lie oppressively upon the river.") And for those photographers ambitious enough (or sleepless enough), photographic expeditions into the world of the night often lead to equally unpredicted visual rewards. Hidden in the night are treasures of color and light that could never be imagined by the light of day.

From a distance the cities of the night shimmer like imaginary empires glowing on a distant horizon, their shapes described by countless thousands of lighted windows. From street level, urban sidewalks become seething, slinking dragons of life, breathing fire of neon and transforming a sea of concrete into pulsing arteries of light and shadow and color. Even a simple beer sign in a barroom window becomes a radiant spark for the imagination, unseen and unimagined by daylight. And some places, like Times Square or the Las Vegas Strip, are transformed into wild wildernesses of illuminated wattage no less impressive in their spectacle than the most magnificent of natural wonders.

Beyond the city's electric hum, the night offers fiery fodder for the imagination even in the most unexpected and ordinary of venues: the whirls of color found in the Ferris Wheels of roaming carnivals that pass through small towns, monuments and buildings dramatically spotlighted and, of course, even nature's own punctuations to the night: the eternal glow of the moon and stars.

With so many subjects to choose from, with so much color and magic burnishing and banishing the darkness, photographers have no excuse not to explore and, like Dickens, come home "tired at sunrise."

City Skylines

WHEN IT COMES TO NIGHT PHOTOGRAPHY, FEW SUBJECTS ARE AS PRETTY OR AS FUN TO PHOTOGRAPH AS A CITY SKYLINE.

Once the sun goes down the glittering glass facades and tall spires give the urban landscape a fairy-tale appearance and, for all of the grit, grime, and grubbiness that cities can force-feed us by day, at night they become the Palace of Oz shimmering on the far horizon. And capturing all that magic with almost any camera is actually quite easy and straightforward.

One of the most crucial aspects of photographing skylines is timing. While it might seem that nighttime skyline shots are made after dark, in fact, the best shots are made around twilight when there is still enough light in the sky to help illuminate building shapes and some provide detail to the architecture. The timing is somewhat critical, however, because while you want there to be some light on the buildings, you also want it dark enough to look like night. My favorite time to shoot is at the end of twilight when there is a nice sapphire blue, and there are enough lights on in the buildings to create a nighttime look.

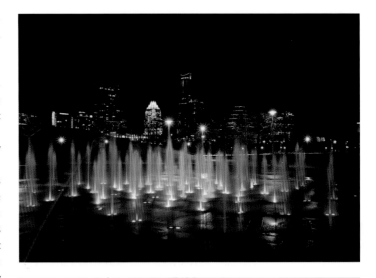

▲ ANYTIME THAT YOU CAN FIND A COLORFUL FOREGROUND YOU ADD A LOT OF DRAMA TO AFTER-DARK SKYLINES. HERE, A COLORFUL FOUNTAIN DISPLAY FRAMES THE AUSTIN, TEXAS SKYLINE. © ROB GREEBON

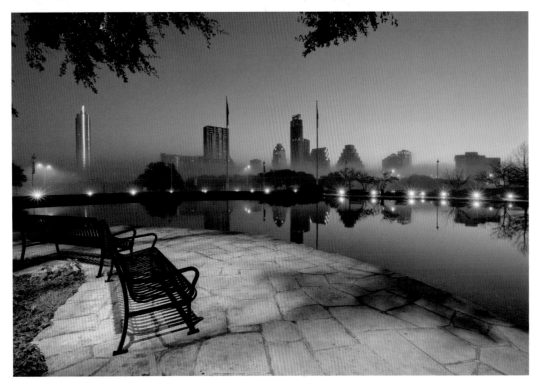

◄ NIGHT IS NOT THE ONLY TIME TO CAPTURE DRAMATIC SKYLINE VIEWS. OFTEN THE MOMENTS JUST BEFORE DAWN PROVIDE A PARTICULARLY PRETTY COMBINATION OF ELEMENTS. IN THIS SHOT OF THE AUSTIN SKYLINE, ROB GREEBON USE A PERFECTLY STILL REFLECTION COMBINED WITH MORNING MIST AND LINGERING CITY LIGHTS TO CAPTURE A UNIQUE CITY VIEW. THE WARM COLOR OF THE PATH IN THE FOREGROUND CONTRASTS NICELY WITH THE COOL COLORS OF THE SKY AND REFLECTION.
© ROB GREEBON

Timers control the lighting in most major urban buildings, so you will probably need to study a scene for a few days to figure out exactly when the buildings are fully lit. Or you can just set up in late afternoon and take a progression of shots as the daylight fades and the buildings begin to light up. In my shot of the Manhattan skyline (shot from Jersey City, New Jersey, by the way—there is a great pedestrian walkway with beautiful views of the financial district), for example, I set up about an hour before sunset and waited for just the right balance between daylight and artificial lights.

The actual geographic direction that you shoot from is important, too. This will depend largely on your access to clear views of the skyline, but whenever possible I prefer to work with west-facing views (shooting from west to east) so that I'm shooting with the sunset illumination. Sunsets and the afterglow that follows can add a great deal of reflected color to skyline scenes. Also, fortunately, many cities are built around waterways and if you can use a river or bay as a foreground you will get extra light bouncing back into the buildings. Austin, Texas-based photographer Rob Greebon, went out before dawn to shoot this very pretty shot of the Austin skyline using Lady Bird Lake in the foreground to capture a mirror reflection of the sleeping city.

I always shoot skylines in Raw because that format provides tremendous flexibility in fine-tuning exposure and white balance. It's pointless to try and white balance the lights of the buildings or the streets because there are just too many different light sources, but it is worthwhile to tweak the overall white balance.

Because skylines often require exposures of several seconds, sharpness can be a serious issue. Here are a few more technical tips that will help you get the best skyline shots:

- Always use a tripod. Even though the skyline will technically be at infinity in most cases, I prefer to work at a medium aperture (f/8 or so) for maximum sharpness and this requires very long exposures.
- Use the self-timer mode to prevent camera shake even when you're using a tripod.
- Use your mirror lock-up feature. Locking up the mirror will greatly reduce internal vibration during long exposures. (This is one great advantage that mirrorless cameras have over SLRs—no mirror vibration.)
- Use a prime lens. I find prime lenses substantially sharper and prefer to use them to shoot skylines.

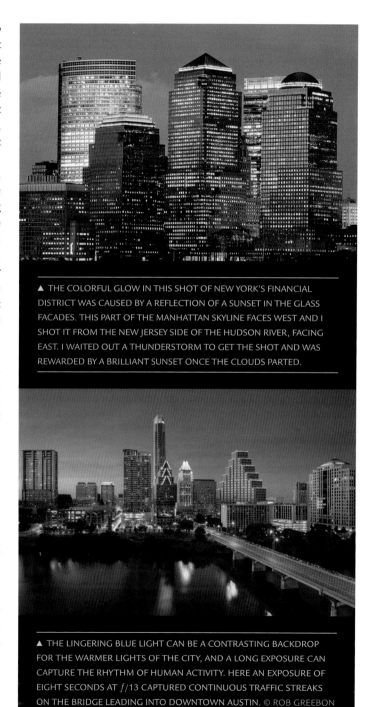

▲ THE COLORFUL GLOW IN THIS SHOT OF NEW YORK'S FINANCIAL DISTRICT WAS CAUSED BY A REFLECTION OF A SUNSET IN THE GLASS FACADES. THIS PART OF THE MANHATTAN SKYLINE FACES WEST AND I SHOT IT FROM THE NEW JERSEY SIDE OF THE HUDSON RIVER, FACING EAST. I WAITED OUT A THUNDERSTORM TO GET THE SHOT AND WAS REWARDED BY A BRILLIANT SUNSET ONCE THE CLOUDS PARTED.

▲ THE LINGERING BLUE LIGHT CAN BE A CONTRASTING BACKDROP FOR THE WARMER LIGHTS OF THE CITY, AND A LONG EXPOSURE CAN CAPTURE THE RHYTHM OF HUMAN ACTIVITY. HERE AN EXPOSURE OF EIGHT SECONDS AT f/13 CAPTURED CONTINUOUS TRAFFIC STREAKS ON THE BRIDGE LEADING INTO DOWNTOWN AUSTIN. © ROB GREEBON

City Street Scenes

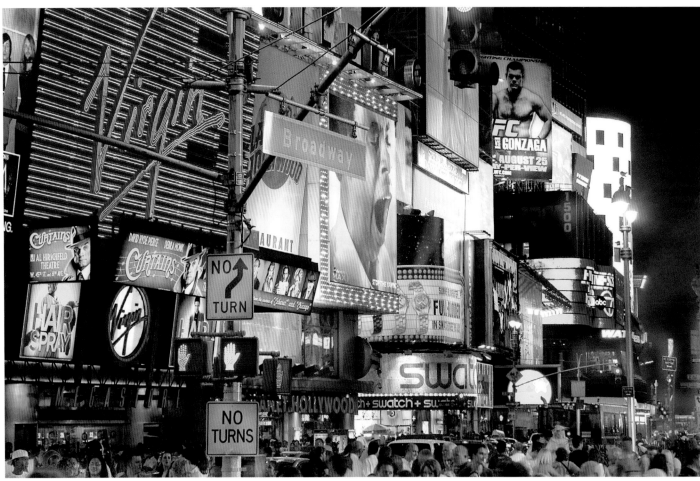

▲ IT'S HARD TO IMAGINE ANY PLACE THIS BRIGHT AND THIS CROWDED AT MIDNIGHT, BUT THAT EXACTLY WHEN I SHOT THIS PHOTO. BECAUSE TRIPODS AREN'T ALLOWED IN TIMES SQUARE WITHOUT A PERMIT, I BRACED THE CAMERA ON A GARBAGE CAN FOR AN EXPOSURE OF 1/20 SECOND AT *f*/4.5.

UNLIKE SHOOTING DISTANT SKYLINE VIEWS, SHOOTING CITY SCENES AT SIDEWALK LEVEL IMMERSES YOU IN THE GOOD, THE BAD, THE UGLY AND, IF YOU'RE IN THE RIGHT CITY, THE ABSOLUTELY SPECTACULAR OF THE URBAN WORLD.

Unlike the daytime world where the theme is mainly one of masses of people and endless blocks of gray granite and concrete, the after-dark world of the city is resplendent with color and light. In some cities, Manhattan and Las Vegas high on that list, they don't hit their visual stride until the sun has gone down.

Even after dark most cities are relatively well illuminated by light from traffic, neon signs, storefronts, theater marquis and other sources of artificial light, much of it quite brilliant. The more vexing problem is one of contrast: there can be an extreme divide between the brightly lit areas and the dark corners not receiving any light. The key to photographing at night is to try and pack the frame with light from edge to edge. In my shot of the wall of infinite signs on Broadway in Times Square, for example, I filled the frame with illuminated signs from top to bottom. Filling the frame also gives compositions a more infinite quality, making the signs seem to go on forever (which is actually the way it feels when you're standing in Times Square).

Getting an accurate white balance at night is somewhat complex because, as with skyline shots, there are far too many different types

of light all burning at different color temperatures. Also, most cities now use vapor lights for basic street illumination and they have very unpredictable color temperatures and even lights of the exact same type will often change color differently as they age. While I do make an attempt to find a pleasing white balance as a starting point, I always shoot in Raw knowing that I'll make the final determinations about color balance during the editing phase.

If you are able to use a tripod (impossible and actually illegal in places like Times Square, but useful in less crowded areas) and are shooting relatively static city street scenes at night, it's worth experimenting with HDRI techniques (see pages 112–113). The ability to shoot multiple exposures vastly expands the dynamic range of your photos and lets you add detail to dark shadow areas. Even if there is motion in your HDRI shots—moving traffic, for example—the effect of the moving lights will be somewhat abstract anyway so the fact that you're capturing it on separate exposures isn't typically a major concern.

Working during or after a rain is a great time to shoot in the night city because the wetness adds a seen to pavement and other surfaces and reflects light beautifully. Often shooting after a rain will also greatly decrease contrast issues, as well, because of the reflected lights.

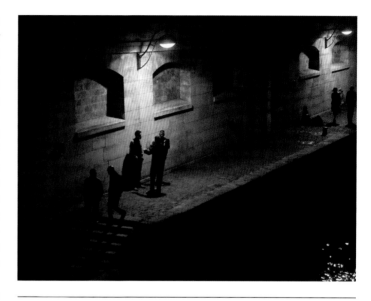

▲ SINGLE-POINT LAMPS LIKE THE SODIUM-VAPOR STREETLIGHTS THAT ARE UBIQUITOUS AROUND THE WORLD HELP FRAME THE SCENE, LETTING THE EDGES OF THE FRAME FALL OFF INTO SHADOW. © FRANK GALLAUGHER

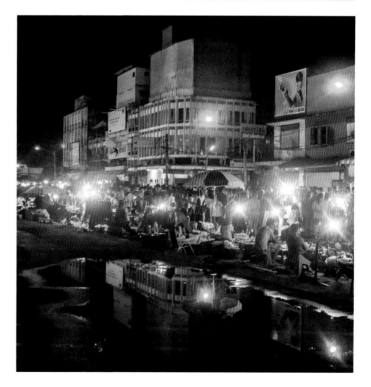

► MARKETS MAKE DYNAMIC STREET SUBJECTS IN ANY CASE, BUT AT NIGHT, THE LIGHTS COME OUT (OFTEN AT A VARIETY OF DIFFERENT COLOR TEMPERATURES) AND THE COLORS AND ACTION PICKS UP. SHOOTING RAW WILL, AS ALWAYS, GIVE YOU THE MOST LEEWAY IN CORRECTING AND TWEAKING THE VARIOUS RESULTING COLOR CASTS—THOUGH THEY DO TEND TO ADD TO THE ATMOSPHERE IF YOU LEAVE THEM IN. © FRANK GALLAUGHER

Lights in Motion

BECAUSE THE NIGHT PROVIDES US WITH A RICH BLACK CANVAS UPON WHICH TO DRAW, IT CAN BE A LOT OF FUN TO PAINT WITH BRIGHT STREAKS OF COLORED LIGHT IN MOTION.

In some respects the techniques used to capture lights in motion are similar to using an artist's scratchboard that is painted with black and hides layers of colors underneath. With a scratchboard you use a nib to scratch away at the black surface to reveal unexpected and often abstract patterns of color beneath and with a camera you simply leave the shutter open long enough to scratch away at the darkness and reveal the tracings of light unseen by the human eye.

You can create interesting patterns of colored light using moving lights with a stationary camera or use stationary lights with a moving camera—or you can combine the two in some very inventive ways. The one constant among all the techniques is using a shutter speed that is long enough to capture the effects that you're after and so, depending on the brightness of the lights, its often best to use a low rather than a high ISO speed so that you can keep the shutter open longer. Also, using a smaller aperture will help increase the depth of field if you're shooting scenes (like a city block at night) that have inherent depth.

Here are three common techniques use for capturing lights in motion:

STILL CAMERA, MOVING LIGHTS

There are a lot of sources of moving lights that will create interesting color patterns if you simply mount your camera on a tripod and use a time exposure. The quintessential example of this is traffic shot from an overpass or moving along a city street. But there are several other common sources of moving lights including carnival rides (see the next section), fireworks, laser light shows, fountain displays and even the stars. You can also create your own source of moving lights using sparklers (see the peace sign shot), laser pens or penlight flashlights.

The length of the shutter speed that you use will depend both on the effect that you're after and the speed of the motion of the light.

Traffic that is moving over a long stretch of highway might take an exposure of 10 or 20 seconds to pass through the frame while you might get an interesting pattern of lights from a fast-moving carnival ride in just a second or two. In most cases it's best to let the lights create a smooth, continuous pattern—letting traffic move from one corner of the frame to the opposite corner, for example, rather than closing the shutter while the lights are somewhere in the frame.

MOVING CAMERA, STATIONARY LIGHTS

You can also create interesting light patterns by using stationary lights and then jiggling or moving the camera—as I did in the shots of Times Square shown opposite. This is a very experimental technique and there's no predicting the results. I've used every conceivable method of moving the camera from just a quick jiggle up and down to spinning it in concentric circles. One of the joys of doing this kind of work with a digital camera is that you can see your results instantly on the LCD so that you know which ideas are working better than others. You can never duplicate your results from frame-to-frame but you can eliminate certain ideas and experiments and delve further into others.

ZOOM EFFECT

This effect, also known as "racking" was wildly popular for about 15 minutes in the mid 1970s when zoom lenses first started to proliferate. But as dated as the results can sometimes look, you can still us it to create some really fun and colorful images. The technique is very simple: just rack the zoom from one extreme of focal length to the other while the shutter is open. Several factors will contribute to the final look including the length of the zoom range, the speed at which you change the zoom and the motion of the lights themselves (if any) during the exposure.

If you want straight rays of light aimed at a single focal point, it's best to use a tripod so that you're not inadvertently compounding the zoom with motion—though you can certainly do that intentionally and I frequently use both zooming and camera motion in concert.

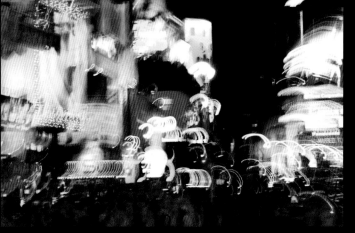

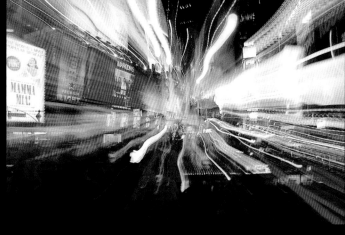

▲ OVER THE YEARS I'VE TRIED MANY TECHNIQUES TO CAPTURE THE COLOR AND THE CHAOS OF TIMES SQUARE, AND THIS IS ONE OF MY FAVORITE SHOTS—CREATED JUST BY JIGGLING THE CAMERA DURING A HALF-SECOND EXPOSURE. YOU CAN'T USE A TRIPOD THERE WITHOUT A PERMIT ANYWAY, SO YOU MAY AS WELL JUST GO WITH THE FLOW AND LET MOTION BECOME A PART OF THE PICTURE.

▲ FOR THIS SHOT OF TIMES SQUARE, I KEPT THE SHUTTER OPEN FOR A HALF SECOND AND VERY QUICKLY RACKED THROUGH THE ENTIRE FOCAL-LENGTH RANGE OF THE ZOOM FROM 18MM TO 70MM.

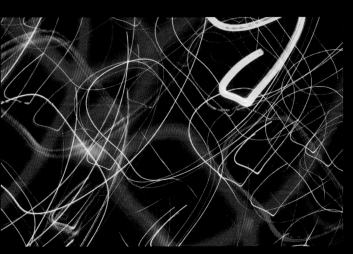

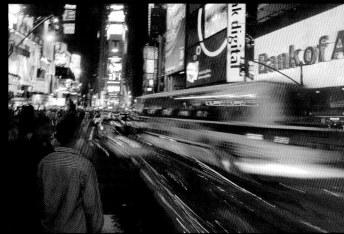

▲ I CREATED THIS ABSTRACT PATTERN OF LIGHTS SITTING IN MY LIVING ROOM ONE NIGHT USING AN EXPOSURE OF 1/8 SECOND AT ƒ/7. THE DIFFERENCE IN THE WIDTH OF THE LIGHT STREAKS IS DUE TO TWO DIFFERENT SIZES OF LIGHTS ON THE CHRISTMAS TREE.

▲ SOMETIMES IT'S FUN TO EXPERIMENT WITH LONG HANDHELD SHUTTER SPEEDS JUST TO SEE WHAT YOU GET. THIS 1.6-SECOND EXPOSURE TURNED THE TRAFFIC IN TIMES SQUARE INTO A LONG BLUR OF COLOR.

Neon Signs

OF ALL THE NIGHTTIME SUBJECTS WAITING TO BE DISCOVERED AND PHOTOGRAPHED, FEW ARE AS COLORFUL AND INTERESTING AS AN ARTFUL NEON SIGN.

Though the peak of neon's popularity was in the 1950s and 1960s and then went through a few decades of decline, in recent years there seems to be a resurgence of interest in it. Exposing for neon is a little bit tricky because you have a very bright subject and, usually, a dark background. The brightness of the neon tubes can fool the camera into underexposing the scene (particularly if there are other elements in the shot that you want properly exposed) but, on the other hand, including a large area of dark background can fool the meter into overexposing the sign. I almost always bracket exposures and I check both the LCD and the histogram continuously so that I'm certain I'm not blowing out the highlights because that is always the biggest danger.

Once the highlights are overexposed with neon you lose that rich color glow and it's almost impossible to get it back even if you're shooting in Raw. Instead, bracket anywhere from three to five frames and check your LCD to see which settings are providing the best results. In photographing this classic motel sign, for example, I set up the tripod and shot a series of bracketed exposures by setting a specific aperture and altering the shutter speeds. Also, overexposing neon causes a phenomenon called halation where the tubes create an exaggerated glow that softens the sharpness of the neon tubes. Also, you want the exposure to be dark enough to hide any shiny pieces in the sign fixture or hardware that might be reflecting colored light or revealing distracting details of the structure of the lamp.

Background considerations are particularly important when shooting neon and pure black always works best. If you are photographing a sign in the window of an open business, you must be very careful not to include any distracting interior lights (fluorescent lamps are the worst since they'll often glow a sickly green) or lighted areas in side the business or they'll compete with the sign. If possible, wait until the business is closed so that you have a dark background but this can be a bit tricky because many businesses shut down the neon when they close up for the night (though I've been bold enough to ask a few small businesses to leave the signs on for a few minutes so I can shoot them). Also, it's best to wait until true darkness rather than shooting at twilight so that you're not fighting exterior reflections in the glass. In summer this is tough because the business may close and shut off their signs before it's completely dark outside—which is why I tend to shoot neon in winter when the days are shorter.

Setting an exact white balance isn't crucial since you can use editing tools to adjust colors later. I almost always shoot neon in the Raw format so that I can adjust the exposure and white balance after the fact. Also, because a different gas is used to produce each different color of neon, it's almost impossible to set one correct white balance. Experimenting is the best way to get accurate colors.

Lastly, if you're using a tripod (and you should when possible), always use the lowest ISO you have available (or the default ISO) so that you can reduce the possibility of digital noise that is caused by using higher ISO speeds. Since very long exposures also encourage noise, I usually try to keep the exposure times as brief as possible.

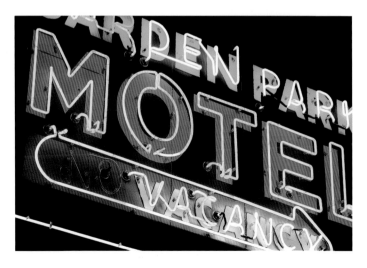

◄ CLASSIC NEON SIGNS LIKE THIS 1950S MOTEL SIGN ARE GETTING HARDER AND HARDER TO FIND (THIS ONE WAS DESTROYED BY A WINTER STORM SHORTLY AFTER I SHOT IT) BUT SUCH SIGNS MAKE A FABULOUS NIGHT SUBJECT. IF YOU'RE LUCKY ENOUGH TO FIND A CLASSIC SIGN, TAKE TIME TO EXPERIMENT WITH VARIOUS COMPOSITIONS AND FROM A VARIETY OF DIFFERENT ANGLES. OFTEN IF YOU WORK THE SUBJECT YOU'LL FIND A VARIETY OF COMPOSITIONS IN A SINGLE SIGN.

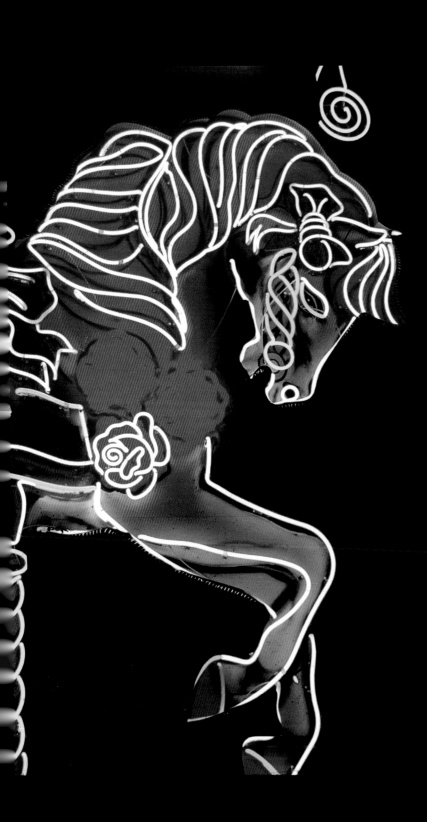

▲ BARS AND PUBS ARE USUALLY A GOOD SOURCE OF NEON BUT OFTEN YOU'RE FORCED TO SHOOT THROUGH GLASS WINDOWS AND THAT CAN CREATE A REFLECTION PROBLEM BETWEEN THE SIGN AND THE INNER SURFACE OF THE GLASS. DIRTY WINDOWS ARE A CONSTANT PROBLEM AND AT TIMES YOU SIMPLY HAVE TO WALK WAY FROM A SHOT BECAUSE OF FLAWS IN THE SITUATION.

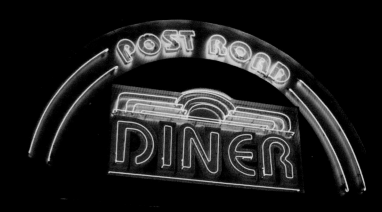

▲ WHENEVER POSSIBLE, CHOOSE AN ANGLE THAT POSITIONS THE SIGN AGAINST AN AREA OF BLACK SKY. THE CONTRAST OF THE NEON DESIGNS AGAINST BLACK ENHANCES THE SATURATION AND PROVIDES A CLUTTER-FREE BACKGROUND.

◄ WHENEVER I'M TRAVELING AT NIGHT ALONG LOCAL ROADS I KEEP AN EYE OUT FOR INTERESTING NEON, BUT SOMETIMES IT'S HARD TO MISS. I NEARLY DROVE OFF THE ROAD WHEN I SPOTTED THIS SPECTACULAR SIGN ON ROUTE 1 JUST NORTH OF MIAMI, FLORIDA. HUNGRY AND TIRED AS I WAS AFTER A LONG DAY OF SHOOTING, I SPENT A HALF HOUR PHOTOGRAPHING IT.

Architecture at Night

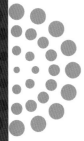

ONE OF THE NICE ASPECTS OF PHOTOGRAPHING FLOODLIT BUILDINGS AT NIGHT IS THAT A LIGHTING DESIGNER HAS DONE MUCH OF THE CREATIVE HEAVY LIFTING FOR YOU.

Most public buildings, for instance, are illuminated for maximum beauty and drama by someone whose business is making the architecture look great at night. Very often the lighting is designed to reveal details and patterns in the architecture that aren't necessarily obvious in daylight. Also, because the direction, quality, and intensity of natural light are continually shifting, even if you stumble upon good interesting or dramatic lighting, it doesn't last for long.

Also, since a building isn't going anywhere and is lit the same way night after night, season after season, you'll have plenty of opportunities to experiment with different angles, lenses and exposure settings. All that you really need are a nicely lit building and a steady tripod to come away with some very handsome shots regardless of the time of night or the time of year. It's for this reason, in fact, that when I teach a basic digital class my students' very first homework assignment is to photograph a building at night. If they don't like their results one night, they can just return another night.

One of the downsides of photographing buildings at night is that they are almost universally lit by vapor lamps of some type (usually a mercury- or sodium-vapor light) and while the color may be accepting or even pleasing to the naked eye, the camera will record it quite differently. Typically these lamps photograph much warmer than they appear to our eyes and it can be surprising just how drastically the color we see differ from what we capture in photographs. To further complicate the matter, vapor lamps are often missing some wavelengths and so there simply is no correct white balance. Also, as different lamps may age differently, the color may not be consistent across the surface of a building. These color issues are most obvious when the building is made of a light-toned material such as light granite or marble. One solution is to shoot in Raw and try to make a good adjustment in editing or, as a last-ditch solution, tone down the saturation to try and remove the offending color as much as possible.

Another issue that you will encounter is that it's often possible to include an entire building without taking in other light sources that have nothing to do with the building you're shooting. Your compositions may include street lamps or traffic patterns that are

◄ IT'S HARD TO IMAGINE ANY DAYLIGHT SITUATION THAT WOULD BE AS DRAMATICALLY LIT AS THIS NIGHTTIME VIEW OF THE TEXAS STATE CAPITOL BUILDING IN AUSTIN. THE LIGHTING DESIGNERS HAVE DONE AN AMAZING JOB OF LIGHTING THE FRONT, SIDES AND DOME OF THIS MONUMENTAL STRUCTURE WITH BEAUTIFULLY EVEN LIGHT. THE SHOT WAS MADE WITH A RELATIVELY SHORT EXPOSURE OF 1/6 SECOND AT ƒ/2.8. © ROB GREEBON

impossible to crop out. In most cases the best option is simply to ignore these extraneous light sources because our brain accepts these distractions in real life and simply turns a blind eye toward them in a photograph. It's also possible in editing to selectively de-saturate these distractions or to darken them substantially with a burning-in tool or a paintbrush.

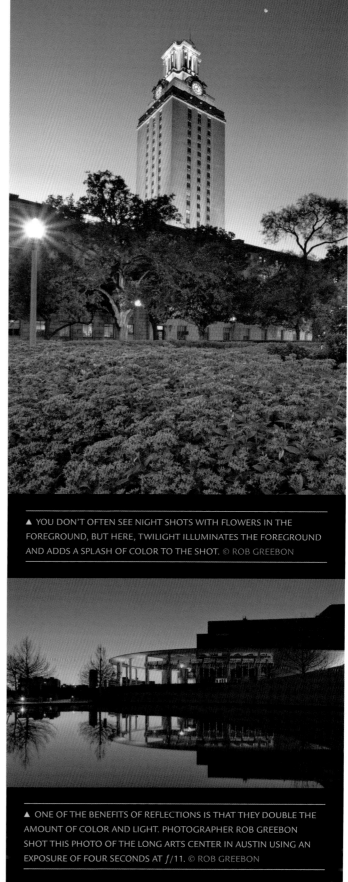

▲ YOU DON'T OFTEN SEE NIGHT SHOTS WITH FLOWERS IN THE FOREGROUND, BUT HERE, TWILIGHT ILLUMINATES THE FOREGROUND AND ADDS A SPLASH OF COLOR TO THE SHOT. © ROB GREEBON

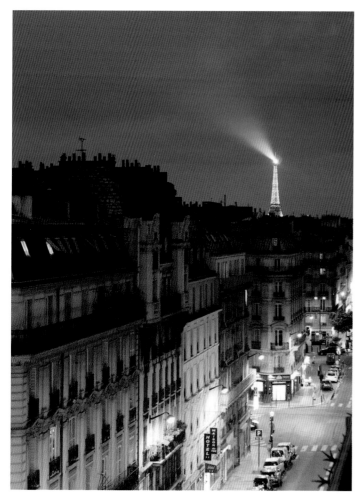

▲ THE EIFFEL TOWER IS ONE OF THE MOST-PHOTOGRAPHED ARCHITECTURAL SUBJECTS IN THE WORLD, AND GETTING AN ORIGINAL SHOT WITH IT FRONT AND CENTER IS NEXT TO IMPOSSIBLE. BUT PLACING IT WITHIN THE CONTEXT OF A TYPICAL PARISIAN STREET SCENE ADDS INTERESTING CONTEXT, AND WHILE THE TOWER ITSELF IS OBVIOUSLY QUITE SMALL, IT'S NO LESS ICONIC. © FRANK GALLAUGHER

▲ ONE OF THE BENEFITS OF REFLECTIONS IS THAT THEY DOUBLE THE AMOUNT OF COLOR AND LIGHT. PHOTOGRAPHER ROB GREEBON SHOT THIS PHOTO OF THE LONG ARTS CENTER IN AUSTIN USING AN EXPOSURE OF FOUR SECONDS AT ƒ/11. © ROB GREEBON

Carnival Nights

FEW EVENTS OFFER BETTER OPPORTUNITIES FOR FUN EXPERIMENTS WITH COLOR AND LIGHT THAN CARNIVALS AND FAIRS.

From the midways to the vertigo-inducing rides to the circus acts, carnivals are a visual funhouse of light, color and motion. Large events like state fairs provide the biggest variety of rides and shooting opportunities, but even the smallest of traveling parking-lot carnivals is packed with a brilliant array of rides and they typically stay in one place for a week or two, offering you a lot of chances to play. I started shooting carnivals when I was a teenager and the colorful swirl of a Ferris wheel still lures me out on summer nights.

Because there are really no right or wrong results, pretty much everything you shoot at a carnival is a creative surprise waiting to happen and the results are often so pretty and unexpected that shooting carnivals becomes downright addictive. Also, in the past few years most carnival rides have switched over to LED lighting and so there is a bigger palette of colors on most rides, the colors are far more intense and the lights are quite a bit brighter.

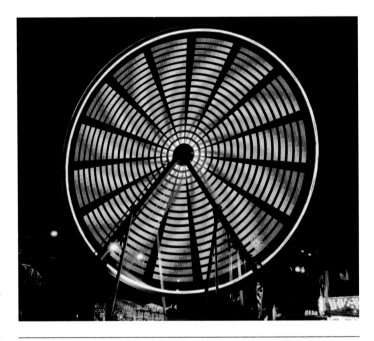

▼ ▼ THE STRANGE CGI-LIKE EFFECTS IN THESE TWO SHOTS ARE THE RESULT OF THE FERRIS WHEEL ROTATING WHILE I RACKED THROUGH THE FOCAL LENGTHS OF A ZOOM LENS. THE TECHNIQUE, AS DESCRIBED EARLIER IN THIS CHAPTER, INVOLVES STARTING WITH YOUR ZOOM LENS AT ONE EXTREME OF ITS FOCAL LENGTH RANGE AND THEN ZOOMING THE LENS DURING THE EXPOSURE. THE ODD VARIATIONS ARE THE RESULT OF MULTIPLE FACTORS INCLUDING THE SPEED OF THE RIDE'S ROTATION, THE SPEED OF MY ZOOMING AND THE LENGTH OF THE SHUTTER SPEED.

▲ ONE THING I DISCOVERED RECENTLY ABOUT FERRIS WHEELS IS THAT AS YOU CHANGE THE SHUTTER SPEED AND AS THE SPEED OF THE ROTATION OF CHANGES, THE PATTERN OF THE LIGHTS CHANGES. THIS IS HAPPENING PARTLY BECAUSE YOU'RE CAPTURING DIFFERENT REGIONS OF THE COLOR WHEEL IN DIFFERENT PLACES, BUT ALSO BECAUSE THE COLORS THEMSELVES ARE BEING BROADCAST IN CERTAIN COMPUTER-GENERATED PATTERNS. THERE IS NO WAY TO PREDICT THE RESULTS, OF COURSE, AND OVER THE COURSE OF TWO NIGHTS I GOT DOZENS OF INTERPRETATIONS OF THIS SAME RIDE.

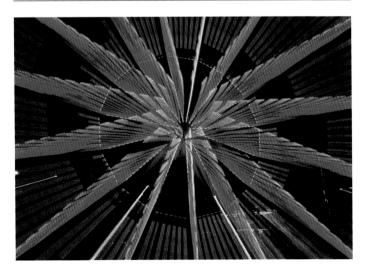

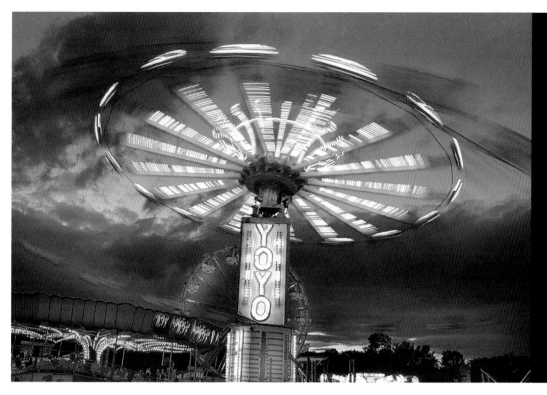

◀ DEPENDING ON THE TIME OF YEAR, THERE IS TYPICALLY ABOUT AN HOUR BETWEEN SUNSET AND FULL DARKNESS. DURING THIS TIME, THE SKY BEGINS WITH A WARM SUNSET GLOW AND THEN SLOWLY TRANSITIONS TO A TWILIGHT BLUE. YOU CAN EASILY STRENGTHEN THE INTENSITY AND ADJUST THE HUE OF THE SKY IN EDITING.

CARNIVALESQUE COLOR CAPTURE

Here are a few tips that will help you get a more productive shoot:

BEGIN SHOOTING AT TWILIGHT: Even though I shoot well into the night once I'm at a carnival, I always try to begin shooting before sunset, just as the ride lights are being turned on. As you can see in the photo of the "Yoyo" ride shown here, the sapphire blue in the sky on a clear night contrasts nicely with the warmer artificial lights. Twilight offers a very short window of opportunity, so it's best to scout potential shots during the late afternoon. By the way, another benefit of starting earlier in the day is that it's easier to scope out places to set up your tripod where you won't be tripping people. Speaking of which…

BRING A TRIPOD: While a Ferris wheel or some other ride might have enough light to be shot handheld, the only way that you can capture motion is by using a long exposure. I typically use exposures as long as 30 seconds to capture creative motion blurs. If you're not allowed to bring the tripod into the event, often you can shoot with a long lens from a parking lot (in fact, I prefer doing that to avoid crowds).

SET A PRECISE WHITE BALANCE: This is one of the most important things that I do at the start of a shoot because in the auto white balance mode most lights will simply record with a warm tungsten color. Even though I shoot in Raw and can adjust colors afterwards, I almost always tweak the white balance to capture the true hue of the lights. If your camera's white balance has a color picker option or manual color temperature settings, experiment with those and compare the LCD to the ride itself.

CARRY AN ND FILTER: Carnival rides can be surprisingly bright (particularly the newer rides with LED lights) and often I'll find myself needing to reduce the light by several stops in order to get shutter speeds long enough to create motion effects even when I'm working at my camera's lowest ISO speed of 200. I carry three neutral-density filters ranging from 2–10 stops so that I can reduce the light and extend my exposure times when necessary.

BRING A FLASHLIGHT: It's pretty much impossible to see camera controls once it gets dark, and it's very handy to have a small penlight with you so that when the colors are far more intense and the lights are quite a bit brighter, you can quickly change settings like shooting modes or exposure compensation.

The Moonlit Landscape

PHOTOGRAPHING THE MOON HAS BEEN AN OBSESSION WITH PHOTOGRAPHERS ALMOST SINCE THE INVENTION OF THE MEDIUM.

In fact, in 1839, the same year that Louis Daguerre introduced his system of photography to the world, John William Draper, an American scientist, physician, and photographer (among many other accomplishments) produced what is regarded as the first detailed photograph of the moon (a Daguerreotype). It's doubtful that Draper or any of his contemporaries could have envisioned that a mere 130 years later men would be shooting photos on the moon and shooting pictures of the Earth from the Moon.

Lacking access to lunar rockets, most of us will have to be satisfied with photographing the moon the old fashioned way: shooting up at it in the evening sky. While the moon rises and sets every day (just as the sun does), it's not always visible because on some days it is below the horizon and so it may seem that on those days there is no moon. The reason that the full moon is almost always visible is that it rises about 12 hours after the sun has risen and is opposite the sun by about 180 degrees—and so the full moon is rising just as the sky is darkening. Also, on days when the moon is full, it always rises completely into the sky. While it's possible to photograph the moon in any of its visible phases it is, of course, at its brightest and most dramatic when it's full.

You can predict roughly where the full moon will rise by going out just as the sun is setting and facing east, preferably in a spot where you have a clear view of the horizon (beaches and harbors work well). You can also photograph the moon as it sets, usually just before dawn, in the western sky. The exact time that the moon rises and sets and its location in the sky will depend on where you are on the planet and what time of year it is. Many online sites like www.timeanddate.com provide a searchable database for finding exact moonrise and moonset times. Tide charts (found in sport and fishing shops) may also list moonrise times and, of course, there are apps that provide the information and many wristwatches show moon phases.

To expose correctly for the moon, take a center-weighted or spot reading of just the moon and avoid including the dark sky. If you include a lot of dark sky in your metering, you will overexpose the moon because the meter will be fooled by the darkness and try to average the two areas: the moon and the dark surroundings. The moon is actually quite bright because it's being illuminated directly by the sun and has a very reflective surface. A proper exposure for the full moon on a clear evening, in fact, is the same exposure you would use for a sunlit landscape—it's that bright.

Most of the time, however, the moon is just an element in a larger composition and you'll want to include some sort of terrestrial foreground and that is where things get a bit more complicated because, in most situations, the moon is going to be many stops brighter than a terrestrial foreground. If you expose for the moon, the foreground will be underexposed; if you expose for the foreground, the moon will wash out. This extreme contrast situation is a very common frustration and one that you've probably experienced.

The solution is really something of a balancing act. The best option is to expose correctly for the moon since you can't recall detail that isn't recorded and then open up shadow areas in editing. Also, being ready to shoot just as the moon begins to rise helps enormously because there is still light from the setting sun on the foreground and that will substantially reduce the contrast. Another potential solution is to use HDRI techniques (see pages 112–113). This method allows you to set a good exposure for the moon itself in one frame and shoot a series of longer exposures to capture detail in the foreground. The one potential hazard of using HDRI is that the Earth is constantly turning; you must shoot the necessary number of frames in rapid succession or the moon may shift slightly in the sky and you'll get an elongated rather than round moon.

Yet another solution is to shoot an in-camera double exposure (if your camera has that feature), making one exposure of moon itself and a separate exposure for the foreground. I used the multiple-exposure mode in my Nikon DSLR to shoot the Harvest Moon rising over a boathouse near the Housatonic River in Connecticut. The image is explained more in the caption.

And finally, of course, in some situations you may not mind that the moon has washed out, particularly if it's risen fairly high in the sky and is not a dominant feature of the composition. In those cases it's best to expose correctly for the foreground and allow the moon record as a milky white orb.

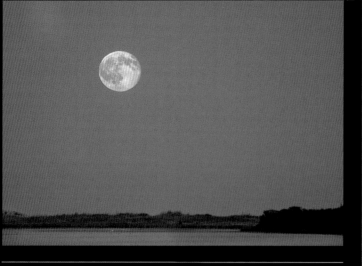

▲ TIMING IS ESSENTIAL TO GETTING SHOTS OF THE RISING MOON BECAUSE THE MOON RISES QUICKLY. I RACED TO FIND A GOOD POSITION TO SHOOT THE MOON THIS NIGHT ON CHINCOTEAGUE ISLAND IN VIRGINIA, BUT IN THE FIVE MINUTES OR SO IT TOOK TO GET SET UP THE MOON HAD RISEN SUBSTANTIALLY. THE EXPOSURE WAS 1/20 SECOND AT f/5.6 AT ISO 400.

▲ HAVING SOME LAND REFERENCE, EVEN JUST HAVING POWER LINES IN THE SHOT HELPS TO EXAGGERATE THE SIZE OF THE MOON. I SHOT THIS IN A MARSH ON THE GULF OF MEXICO, NEAR ROCKPORT, TEXAS AND HAD BEEN PHOTOGRAPHING THE SUNSET. WHEN I TURNED AROUND I SAW THE MOON EXACTLY 180 DEGREES AWAY FROM THE SUN.

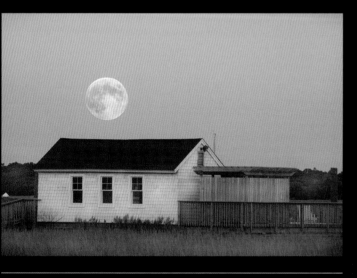

▲ THIS IMAGE IS THE RESULT OF AN IN-CAMERA DOUBLE EXPOSURE. I SET THE CAMERA TO RECORD TO A TWO-IMAGE MULTIPLE-EXPOSURE AND THEN I SHOT TWO FRAMES: THE FIRST USING A 70–300MM LENS ZOOMED OUT FULLY (EQUIVALENT TO 450MM ON MY DSLR) AND USED CENTER-WEIGHTED METERING TO METER JUST THE MOON. THEN I SHOT THE BOAT HOUSE AT 70MM (EQUIVALENT TO 105MM) USING MATRIX METERING. THE CAMERA'S MULTIPLE-EXPOSURE MODE CALCULATED THE CORRECT EXPOSURE FOR COMBINING THE TWO FRAMES.

▶ IF YOU WANT DETAIL IN THE MOON IT'S IMPORTANT TO USE EITHER CENTER-WEIGHTED OR SPOT METERING (OR A HANDHELD SPOT METER) TO METER JUST THE MOON OTHERWISE THE MOON WILL OVEREXPOSE. THIS IS AN UNCROPPED SHOT OF THE MOON SHOT AT THE EQUIVALENT OF 450MM ON A DX SENSOR CAMERA. THE EXPOSURE WAS 1/50 SECOND AT f/5.6, AT ISO 800.

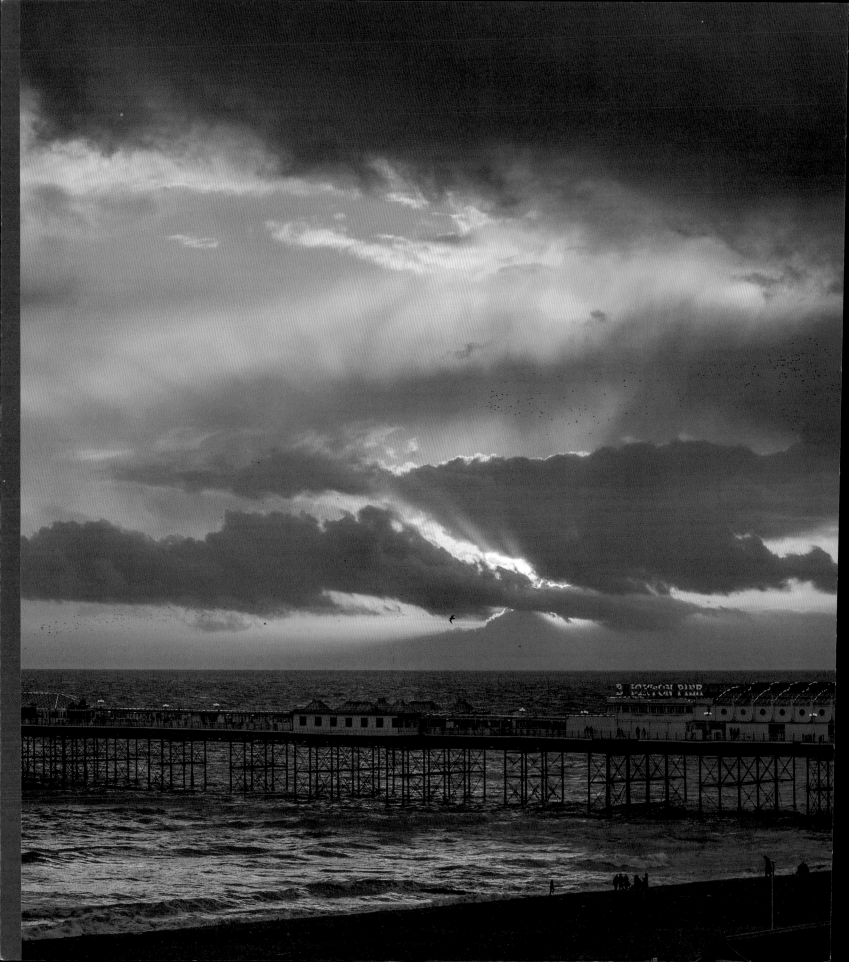

Chapter 7:

Color-editing Tools & Output

The great landscape photographer Ansel Adams has often been quoted as saying, "The negative is comparable to the composer's score and the print to its performance." Adams knew that the negative was only a captured instant, a gathering of latent sounds, and a stepping off point from which the craft of print-making finished his vision. And though Adams and other darkroom masters massaged their prints with cotton balls dipped in various strengths of developer or pulled prints suddenly and dashed them into trays of water to retard development, so too will you learn to transform each unfinished file into a completed piece.

Throughout this book we've talked about the essence of color in the photographic world: its history, the theories of how colors work together, of how you can combine or isolate them to evoke emotional response, and also how nature affects color through changes in the weather, the time of day and time of the year. We have also looked at the use of color as a purely artistic and creative medium, and explored ways to find and capture brilliant color even in the darkness of night. And we've delved into the various important technical choices and considerations that affect colors and how they are recorded.

But all of these lessons, all of this knowledge, is so much pixel dust in the wind if we underestimate or rush the final aspect of working with digital files: carefully carrying those well-chosen and captured colors along the final mile. The process of importing and editing your images and then outputting them, whether it's to a light-based presentation such as a web gallery or to the paper and pigment world of the fine-art print, is just as important to the success of your images as the white balance that you set at the time of exposure. It is in the editing process that the full breadth and depth of your creative ambitions are realized.

From the instant that you download your images to your computer you begin a new visual journey. From simple color and exposure corrections to complete transformations, the realm of digital editing offers possibilities that will either lead to the completion of your original vision or to destinations not only unplanned, but (as you will see in the pages on creating false colors) often shockingly unimagined.

Digital editing is a science and an art all on its own and it takes a lifetime to fully master. But like Adams in his darkroom apron rocking a print slowly in a tray of developer waiting for to hear the sweet music of his vision, each time you sit at the computer, you will begin to see how best to arrange the notes that turn tiny pixels of light and color into a rainbow symphony of light and color.

Color Management

IN A PERFECT WORLD, EVERY STAGE OF CAPTURING AND REPRODUCING COLOR, FROM CAMERA TO COMPUTER TO PRINT, WOULD OFFER YOU EXACTLY THE COLORS THAT YOU HAD ENVISIONED WHEN YOU FIRST EXPOSED A PHOTOGRAPH.

There would be no surprises and you could rely on each piece of hardware and software to faithfully honor your personal vision. Unfortunately, there are a few stumbling blocks, both technological and psychological, along the way and dealing with them is what color management is all about. As anyone who has made their own prints or created their own website knows, colors often seem to have a mind of their own (or at least the devices that create them do).

Part of the problem is that each different mechanical device in the chain of recording and outputting images—cameras, monitors, scanners, and printers—sees color in its own way. There is no common language, for example, that can use to tell your computer monitor precisely what color red the rose you photographed was in reality—or even what your camera saw and captured. Nor is there a common language between the monitor and your inkjet printer. The problem becomes one of frustrating proportions not unlike the one that I described earlier (see page 22) with the infamous Mrs. Blandings trying to describe colors of paint to her interior decorator. Words that describe colors are just words: they are open to an infinite variety of interpretations (and misinterpretations).

▼ BECAUSE HIS IMAGES ARE OFTEN DISPLAYED ONLINE AND SOLD AS FINE-ART PRINTS, PHOTOGRAPHER GREG HARTFORD WHO SHOT THIS INCREDIBLE LANDSCAPE IN MAINE'S ACADIA NATIONAL PARK, MUST TAKE SPECIAL CARE IN MANAGING HIS COLORS FROM CAMERA TO FINAL PRINT. © GREG HARTFORD

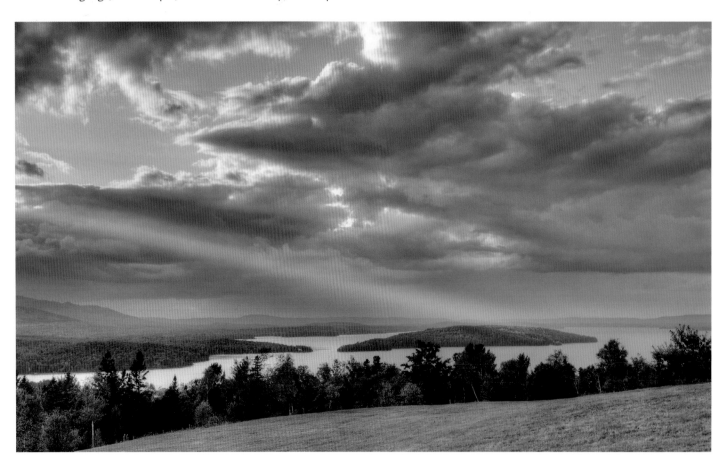

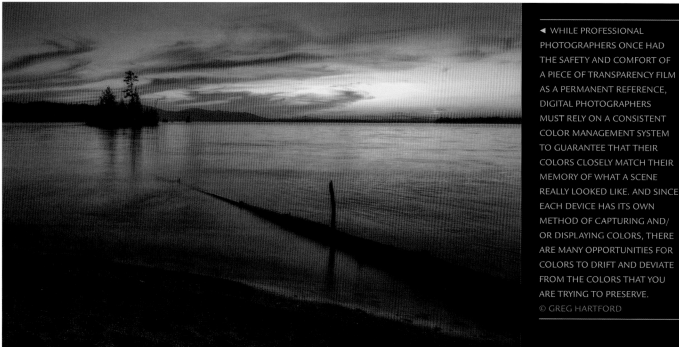

In the days of using color transparency film, whether you liked the way the colors were recorded or not, you still had that piece of film to jog and correct your memory and to compare against your final print. When it comes to working with digital files, there is no fixed or reliable point of reference that you can use to track the accuracy of your colors (or verify your memories) as they go through the various stages of the digital process. Yet another aspect of color management that must be dealt with is the fact that your camera and computer monitor use one color model or space (RGB, the three channels of light) while your inkjet printer uses another (CMYK, the four colors of ink). Video, incidentally, also has its own color space.

Fortunately, there is a process and a science of color management available to help you to manage color from capture to output. Color management provides the missing links of communication between cameras, monitors and printers. Working with a color management system (or CMS) requires a few more accessories (among them a monitor calibration device) and some extra hours in front of the computer, but if you are printing a lot of your images or trying to create a stellar web gallery, it's time and money well invested.

The first step in color management is to calibrate each of your digital tools. Calibration is the process of matching a device's specific color response to known color profiles and thereby giving each color a numerical value that can be shared among the devices. An organization known as the ICC (International Color Consortium) has established color profile standards that enable the color space of one device (a camera, for example) to match the color space of another (your monitor).

Ideally, as we discussed earlier, it is best to begin the color management process by creating a color calibration for your camera. You can do this by including a color checker in some of your images and this enables your computer and monitor to work with a set of colors of known value. The next step is to use a monitor calibration device to measure and correct the output to a known profile. Most monitors can also be calibrated to a limited degree using software tools (Photoshop, for example, has its own software-based profiling system), but they are not as accurate as a hardware device such as the Datacolor Spyder series of monitor calibration tools. The final step in management requires calibrating the output of your inkjet printer, though most printers come with very precise profiles that you can install via drivers into your editing software.

Color Management, continued

COLOR SPACE & GAMUT

Two other issues in color management is those of color space (also known as a color model) and color gamut. Color space describes the theoretical color range or limits that a particular piece of imaging hardware is capable of recording or displaying. It is in essence a particular palette of digital colors that is plotted into a three-dimensional representation or model that looks kind of like a flying wedge of brightly colored cheese. The larger the color space is, the more colors it includes (and the larger the wedge of cheese become). These three-dimensional models are often overlaid on one another so that their size and range of colors can be compared.

There are many different color spaces and each represents a finite set of colors. Cameras and monitors, for example, use an RGB (red/green/blue) color space (either sRGB or Adobe RGB), but there are other variations of RGB color spaces. Adobe RGB offers a theoretically wider color gamut (see below) than sRGB but only the best monitors and printers can display or print all of the colors in this space and there are other inherent problems in using this color space that require substantial knowledge and skill.

▼ SUBTLE BLENDS OF COLORS AND TONALITIES ARE OFTEN MORE DIFFICULT TO REPRODUCE ACCURATELY THAN BRIGHTER AND MORE COLORFUL IMAGES. HAVING A WELL CALIBRATED MONITOR IS IMPERATIVE TO PRESERVING SUCH DELICATE TONALITY. THE SOFT COMBINATIONS OF COLORS IN THIS MISTY MORNING RIVER SCENE WOULD BE EASILY LOST WORKING ON A POORLY CALIBRATED MONITOR. © GREG HARTFORD

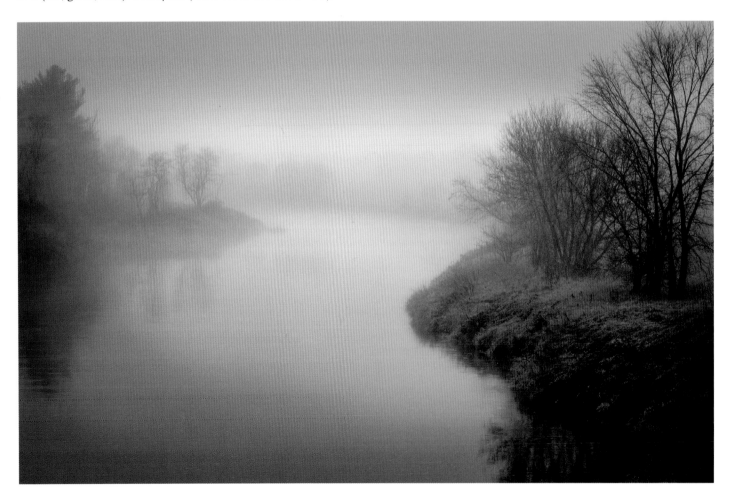

Which color space you choose (either in your camera or during editing) really depends on the eventual destination of your images. There are, however, advantages to both sRGB and Adobe RGB spaces. Images created for web display, for example, are best made in the sRGB model because that is with the range of most monitors. Because his images are intended both for exhibition printing and for high-quality display in his online galleries, Maine landscape photographer Greg Hartford (www.acadiamagic.com) always works in the sRGB color space.

But even within this space, various monitors (Apple vs. Windows, for example) will have their own unique color spaces and each different browser may have yet another level of colors that it can deliver accurately. And if you work regularly in 16 bit images, you may find some advantages to working in Adobe RGB.

There is also a color space called ProPhoto RGB (developed by Kodak), but this requires working in Raw because it is only usable with 16 bit color. Also, because the space is so broad, there are issues of banding and posterization that must be considered. Lab space is the broadest of all color spaces and is very closely aligned to the range of colors that the human brain perceives. It has an extremely broad gamut that exceeds (but includes) both RGB and CMYK. The Lab space is often used in Photoshop when converting colors from RGB to CYMK during the pre-press process and it is particularly important in the graphics industry because it is device independent.

▲ IMAGES LIKE GREG HARTFORD'S VERY INTENSELY COLORED MAINE SUNRISE REQUIRE A CAMERA THAT HAS A GAMUT WIDE ENOUGH TO RECORD AN EXTREMELY BROAD RANGE OF COLORS AND TONES. IN ORDER FOR YOU TO SEE THOSE COLORS ACCURATELY IN EDITING THE MONITOR MUST ALSO SUPPORT THAT GAMUT. A CMS HELPS TO TRANSLATE THE GAMUT FROM ONE DEVICE (YOUR CAMERA, FOR EXAMPLE) TO ANOTHER (YOUR MONITOR).
© GREG HARTFORD

Color gamut is the palette of a particular digital device and is a way of describing the range of colors—within a particular color space—that any hardware element in your CMS is capable of representing or (in the case of a printer) reproducing. If the gamut of one device is substantially more limited than others in the CMS, then not all of the colors can be reproduced. And similarly, if the gamut were to exceed the range of the color space, colors would by necessity be clipped. Colors that cannot be reproduced because they exceed a particular color model are referred to as out of gamut.

Regardless of how aggressively you approach (or ignore) the concept of color management, the proof of the pudding comes when you compare a print to the image on your monitor. If you can get the images on your monitor and those from your printer to match to any satisfying level, you're in the promised land regardless of how you got there.

You can read more about color space and color models on the site of the International Color Consortium: www.color.org.

Raw Conversion

ALTHOUGH PROCESSING RAW IMAGES IS OFTEN DESCRIBED AS AN "EXTRA" STEP IN THE EDITING PROCESS (AND TECHNICALLY IT IS) I THINK THAT IT COULD MORE ACCURATELY BE DESCRIBED AS AN EXTRA OPPORTUNITY TO IMPROVE THE QUALITY OF YOUR IMAGES.

Also, the steps involved in importing and adjusting Raw files can actually save you substantial amounts of time during editing. A lot of photographers are put off by having one more editing chore to contend with but the fact is that the Raw import process is very straightforward, very logical and becomes second nature in time. And, more importantly, there are things you can do in the Raw interface that would be far more complex in editing.

The process of importing Raw files gives you the opportunity to revisit many of the decisions made at the time of shooting and, as we talked about earlier (see page 101), it enables you to make these changes non-destructively. Working with a digital file is very much like starting with a film negative or transparency in that, no matter how many prints you make from that negative or transparency and how much you may alter the final image, the original remains in tact. It is exactly the same with Raw files: as many changes as you make to the file, while you can save myriad different finished versions, the original remains untouched, unaltered and at any time you can revert to the "as shot" image and begin again.

Yes, you can duplicate a jpeg file original and archive it so that you are always working on copies (and therefore no changes are made to the original file), but a lot of changes are made to jpeg files by your camera before they ever reach the computer—and you can not undo those changes. The Raw process really is a remarkable system and it's the closest thing to working in a darkroom that digital has to offer.

RAW PROGRAMS

Raw software is bundled as a part of many editing programs like Lightroom, Photoshop, and Photoshop Elements, but it is also available as a commercial stand-alone program by a number of software companies and as freeware. Most camera companies also offer their own Raw-conversion software that comes with their cameras. However, because many Raw file formats are proprietary, not all can be opened in other editing suites; for example, images from my older Nikon D90 body can't be read directly by Photoshop. But Adobe does offer a .DNG conversion program (DNG stands for digital negative) that enables you to open files from any camera and work them in Photoshop, Lightroom, or Elements. And Adobe has

▲▲ ONE OF THE PRIMARY ADVANTAGES OF SHOOTING IN RAW IS THE ABILITY TO FIX GROSS MISTAKES IN EXPOSURES. IN THIS CASE MY MATRIX METER FOOLED A BIT BY THE BRIGHT FAÇADE OF THIS BUILDING AND THE BLUE SKY AND UNDEREXPOSED THE IMAGE BY SLIGHTLY LESS THAN TWO STOPS. GIVING IT A NON-DESTRUCTIVE FIX WAS SIMPLY A MATTER MOVING THE EXPOSURE SLIDER TO THE RIGHT. I ALSO USED THE FILL CONTROL TO LIGHTEN THE DARKER SIDE OF THE BUILDING A BIT TO REVEAL SOME DETAILS ON THE SHADOWED SIDE OF THE BUILDING.

▲ ▶ AMAZINGLY ENOUGH IT'S ALSO POSSIBLE TO COMPLETELY REVISIT YOUR EXPOSURE DURING RAW CONVERSION WITH A SIMPLY PUSH OF THE EXPOSURE SLIDER. YOU CAN ONLY ADJUST BRIGHTNESS/DARKNESS, HOWEVER, YOU CAN'T CHANGE THE ACTUAL APERTURE OR SHUTTER SPEED. IN THIS SERIES THE MIDDLE IMAGE IS AS SHOT AND THE ONE TO THE LEFT HAS BEEN DARKENED BY APPROXIMATELY ONE STOP, WHILE THE THIRD SHOT VERSION HAS BEEN OVEREXPOSED BY ABOUT ONE STOP. WHILE I'M FAIRLY SATISFIED WITH THE "AS SHOT" (MIDDLE) FRAME, I WOULD PROBABLY DARKEN IT A BIT FOR PRINTING.

promised never to charge for this .DNG converter, so it will always remain free and available.

The Raw interface will look different for each different program, but essentially they all offer the same options in one form or another. It really doesn't matter in which order you adjust the controls and many times you'll jump back and forth between various adjustments. If, for example, you adjust the color balance first and then make an exposure correction, you may want to go back and tweak the color temperature after you have altered the exposure (or vice versa). In time you will develop your own workflow preferences. The following are some of the more important options found in most programs, though the ones describe here are from the Adobe Camera Raw program that is a part of Photoshop.

There are many more options than described here, but on the next page, let's go through the essential controls:

Raw Conversion, continued

WHITE BALANCE: This option allows you to change the white balance (color temperature) to any color temperature, regardless of where the balance was set during the original capture. Occasionally (rarely) a preset may produce exactly the balance that you're after, but more often it's better to adjust the slider to a custom setting. By sliding it to the left the color temperature gets cooler (more blue) and by sliding it to the right it gets warmer (more reddish).

TINT: This adds more green to the images as you slide it to the left and more magenta as you go to the right. By combining color temperature and tint you can make precise WB alterations.

EXPOSURE: This is the master exposure control, pushing your entire histogram as one block toward brighter tones (to the right) or darker ones (to the left). It's a blunt tool, because it will happily push your pixels off the histogram and into pure black or white. It's best used for correcting obvious errors in the original exposure (i.e., unintentional under- or overexposure).

CONTRAST: This splits your histogram right down the middle and pushes the left half into darkness and the right half into brightness. Again, a blunt instrument, but subtle use is often a good starting point for image adjustments.

HIGHLIGHTS: Slide this to the left to bring back areas that have been clipped off the right end of the histogram into pure white. This is an extremely useful tool for quickly recovering highlight detail where is has not been completely lost.

SHADOWS: This slider acts as a kind of fill-in flash light for close subjects and opens shadow areas for more distant scenes. Its purpose is just to open areas lost to shadow. In opening the shadows it also flattens images somewhat so you may see a loss of contrast.

WHITES: This directly manipulates the very brightest parts of your image, pushing them into pure white (to the right) or pulling them down into mid-tone (to the left).

BLACKS: This directly manipulates only the very darkest pixel values. You can use this tool to darken the black areas of a scene. Sliding it to the right darken blacks and sliding it to the left lightens them. It's largely the same as setting your black point in Levels—you're deciding where you want to draw the line between off-the-charts pure black and the beginnings of your shadow regions.

CLARITY: The control increases local contrast and enhances the apparent sharpness of images. This tool works best at 100% image size so that you can see the edges of contrast developing and also to prevent you from getting sharpness "halos" around edges.

VIBRANCE & SATURATION: Both of these controls adjust the intensity of hues in the image. The Vibrance slider will boost other colors while ignoring skin tones. So, if you have people in your images, you can boost surrounding colors without false-looking saturation in skin tones.

TONE CURVE: This allows you to fine tune the tonal relationships and contrast range of your images by adjusting the image's tone curve. This curve is simply a graphic representation of the dynamic range of the image and is one of the primary ways to modulate exposure in any editing program. You can adjust the curve using either a parametric curve (it provides separate slides for highlights, lights, darks, and shadows) or using a point curve where you adjust the tonal curve by placing points on the graph.

HSL/GRAYSCALE: This tool is similar to the hue/saturation control found in all editing programs but it offers more hue choices in terms of colors and provide options for individual colors channels. You can adjust the hue, saturation, and luminance of each color.

▶ HERE YOU CAN SEE THE COMPLETE BEFORE-AND-AFTER EFFECT ON THIS PANORAMA FOLLOWING A COMPLETE SET OF RAW-CONVERSION ADJUSTMENTS. THE ORIGINAL (ABOVE) LOOKS FLAT—TYPICAL OF UNPROCESSED RAW IMAGES. TO ARRIVE AT THE FINISHED PRODUCT, THIS WAS THE COMPLETE WORKFLOW: TEMPERATURE WARMED TO 4000K AND TINT PUSHED SLIGHTLY GREEN TO AVOID A MAGENTA CAST. EXPOSURE PULLED BACK BY JUST 1/3 STOP, AND CONTRAST LEFT ALONE. HIGHLIGHTS PULLED WAY BACK (-42) AND SHADOWS PUSHED TO JUST SHY OF 100%. WHITES WERE PUSHED EVER SO SLIGHTLY, JUST ENOUGH TO ACCENT THE CREPUSCULAR RAYS EMANATING FROM THE SUN BEHIND THE CLOUDS, AND BLACKS WERE RAISING SO THERE'S JUST A TOUCH OF DETAIL IN THE FOREGROUND. CLARITY WAS BOOSTED TO 25% TO SHARPEN THE DETAILS ALONG THE PIER, AND SATURATION WAS RAISED TO 25% TO PULL COLOR OUT OF THE SKY. BUT THAT WASN'T QUITE ENOUGH, SO IN THE HSL PANEL, THE LUMINANCE OF THE BLUE CHANNEL WAS ALSO PULLED DOWN TO MAKE THE BLUE EVEN MORE BOLD. FINALLY, THE TONE CURVE WAS JUST BARELY PULLED DOWN IN THE SHADOWS UNTIL THE FOREGROUND WAS MADE SLIGHTLY LESS DISTRACTING. © FRANK GALLAUGHER

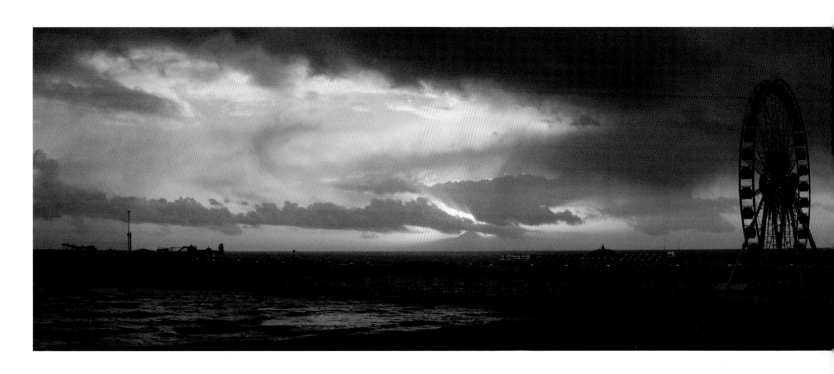

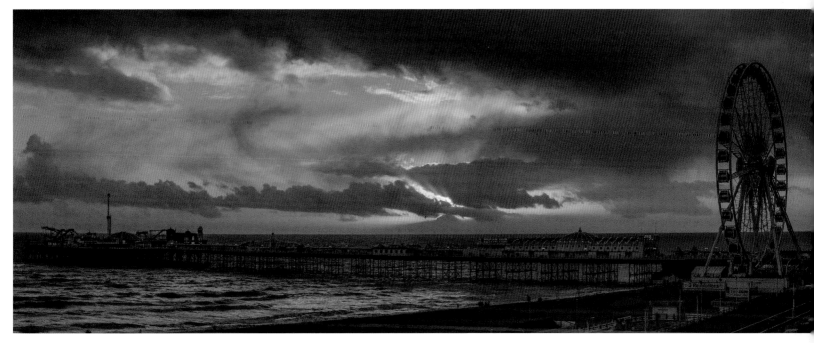

Basic Color Corrections

N O MATTER HOW SKILLED YOU ARE AT CAPTURING COLORS WITH YOUR CAMERA AND HOW STRONG YOUR KNOWLEDGE OF THE PHOTOGRAPHIC PROCESS, YOU WILL ALMOST ALWAYS MAKE SOME ADJUSTMENTS TO THE COLORS IN YOUR FINAL IMAGES.

In some cases you'll want to make adjustments to enhance your personal vision, at other times you'll need to match both colors and dynamic range to their final destinations—the web, making personal prints, or any other form of output such as offset printing. Color accuracy is very much dependent on the final product.

Color corrections can be made on both a global and a local basis and the better your selection skills (isolating particular areas using selection tools) become, the more precise you can get in your fine-tuning. While there are many interrelated paths to color correction, and several more advanced techniques, those on this page and the following pages are some of the basic tools that are common to most image-editing software, including Photoshop, Photoshop Elements, Lightroom and others.

COLOR BALANCE: The color balance tool is a very basic correction that lets you make fast and relatively precise changes to the overall balance of the image (or of a selected area). The dialog box for this tool has three sliders, once for each of the three primary colors of light: red, green and blue. As you can see in the graphic here opposite each primary color is its complement: cyan-red, magenta-green and yellow-blue. As we learned earlier (see page 44) a complementary color is a secondary color that is the result of adding two primary colors: so, cyan is created by mixing green plus blue, magenta is created by mixing red and blue and yellow is formed by mixing red and green.

PHOTO FILTER: This option enables you to add colored filtration providing results very similar to what you would achieve using lens filters on your camera. The filter choices include a variety of warming, cooling and colored filters and you can even make your own filters by selecting a color from a color picker. There are two advantages to adding filtration in editing rather than on the lens: there is no optical degradation issue and you can adjust the intensity of any of the filters using a simpler slider. You would have to pack a suitcase full of lens filters to get the same range of results and even then you could never have all of the options you get in software. In terms of warming or cooling images, in most cases you can get better overall results if you shoot in Raw and adjust the color temperature during import, but filters are quite useful when you want to apply a slight color shift to a selected area only.

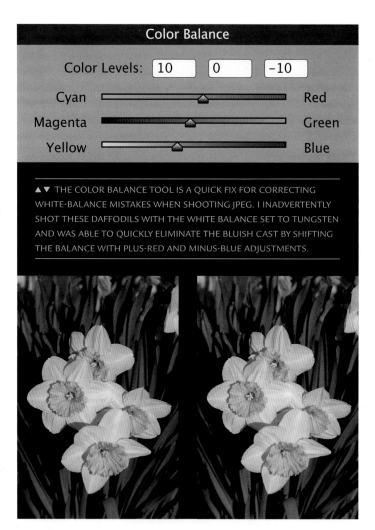

▲▼ THE COLOR BALANCE TOOL IS A QUICK FIX FOR CORRECTING WHITE-BALANCE MISTAKES WHEN SHOOTING JPEG. I INADVERTENTLY SHOT THESE DAFFODILS WITH THE WHITE BALANCE SET TO TUNGSTEN AND WAS ABLE TO QUICKLY ELIMINATE THE BLUISH CAST BY SHIFTING THE BALANCE WITH PLUS-RED AND MINUS-BLUE ADJUSTMENTS.

CURVES CHANNELS: While we talked about using curves to adjust the tonal range of an image in the previous pages, you can also use curves to adjust the individual color channels. The pull-down menu at the top of the curves dialog box enables you to access the individual curve for each of the three primary channels (again, R, G, or B). For example, if you want to add red to an image, you can go to the red channel and either add red (by raising the curve) or reduce red (by lowering the curve). You have to be careful with this technique if you're using it in a global way because it will alter everything that falls within a particular color channel and can create an unwanted color cast very quickly. For that reason this is often better used as a selective color tool.

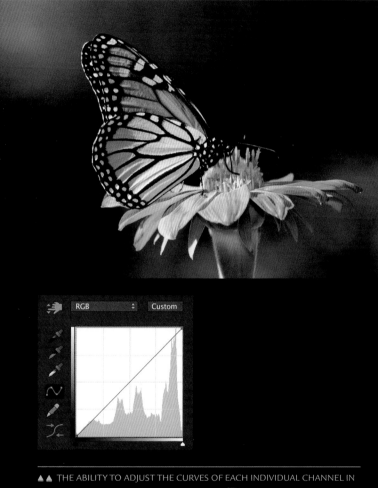

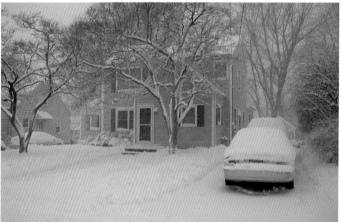

▲▲ THE ABILITY TO ADJUST THE CURVES OF EACH INDIVIDUAL CHANNEL IN AN IMAGE IS MORE OFTEN USEFUL IN CORRECTING SELECTIVE AREAS, BUT HERE I USED IT TO MAKE A QUICK GLOBAL ADJUSTMENT. I FIRST INCREASED THE HIGHLIGHT RANGE OF THE RED CHANNEL TO GET THE BUTTERFLY'S WINGS TO TURN A BIT MORE ORANGE, AND PULLED THE MID-TONE AND HIGHLIGHT AREAS OF THAT CHANNEL DOWN SO THAT IT WOULDN'T AFFECT THE BACKGROUND COLORS. I THEN USED BOOSTED THE MID-TONES OF THE GREEN CHANNEL SLIGHTLY TO FURTHER ENHANCE THE GREENS OF THE BACKGROUND. ONCE YOU GET USED TO USING THE CURVES TOOL THIS IS A MUCH SIMPLER PROCESS THAN IT MIGHT SOUND LIKE.

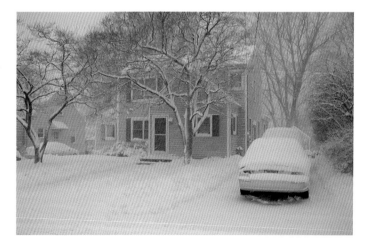

▶ THIS IS THE SAME SHOT, SHOWN FIRST WITHOUT ANY FILTRATION, THEN WITH A WARM FILTER, AND FINALLY A COOL FILTER. IN PHOTOSHOP YOU CAN SIMPLY ADJUST THE INTENSITY OF THE FILTER FROM "0" TO "100" PERCENT.

Hue & Saturation

THE HUE AND SATURATION CONTROL IS ONE OF THE MOST USED (AND SOME WOULD SAY ABUSED) COLOR-CORRECTION OPTIONS COMMON TO ALL EDITING PROGRAMS.

Theoretically this tool was designed to let you restore saturation of colors to their correct levels when lighting or exposure or other factors have either under- or oversaturated the hues in an image or when you simply want to enhance (or reduce) the saturation of any particular hue. In actual practice this tool has become the darling of photographers that want to smack colors with high-intensity jolt of Peter Max purity.

The tool consists of three sliders, one for each of the three attributes of color: hue, saturation and brightness. You can use each of the tools to work on the image globally or you can use the drop down menu at the top to work on to each hue or its complement: red, yellow, green, cyan, blue, and magenta. Though you can use any of the three slides to enhance the image globally—to bump up, say, the saturation of the entire image-it is far more useful when you use them singly or in combination to enhance individual hues.

The hue slider takes you on a tour around the 360 degrees of the traditional RGB color wheel (which, though rarely marked, are though of in terms of a 360-degree circle of color). You'll see the first 180 degrees as you move the slider to the right (0 to +180) and the other half of the circle as you move it to the left (0 to –180). At the bottom of the dialog box you'll also see to linear color bar representations of the color wheel: the upper one is a fixed display of the colors (beginning and ending at a sort of aqua blue) and below it is a second moving bar graph that shows the relative changes of the hues as they shift. In other words the upper bar shows the colors as they were and the one below it shows how they have changed.

The second slider is the saturation slider and it simply increases or decreases hue saturation—again, either globally if you are working in the RGB mode, or in individual hues. If you want to enhance the overall saturation of an image then it's a matter of simply sliding the saturation slider to the right and watching the effect on the image. If you want to increase or decrease the saturation of a particular hue, just pull it down from the drop-down menu. In either case, moving the slider to the left decreases saturation. The thing to remember about saturation is that a little goes a long, long way. While highly saturated colors look pretty jazzy if you're posting them to a photo-sharing site like Flickr or your own web page, they get old fast. Pretty soon all anyone notices about your images is the saturation. In most cases it's best to let your colors be modest and your images speak for themselves.

The lightness slider at the bottom of the dialog box does just that: lightens and darkens whatever hue (or hues) you are working on. The cool and supremely useful thing about this tool is that you can lighten or darken very selective individual hues. If you want a darker blue sky, for example, you can select the blue channel, tweak the hue, set the saturation that you like and then lighten or darken it as desired. Very useful indeed.

While the entire hue and saturation tool is certainly a worthwhile color correction tool and one you will use every time that you edit images, it also has some outlandish artistic applications and we'll visit those later in this chapter.

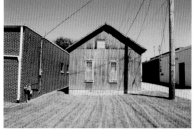

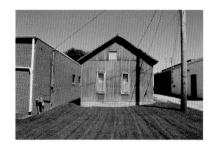

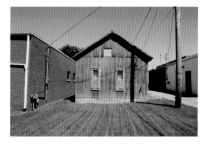

▲ ONE OF THE MORE INTERESTING EFFECTS THAT YOU CAN CREATE WITH HUE AND SATURATION IS TO SELECTIVELY RE-COLOR DE-SATURATED AREAS. TO CREATE THIS EFFECT I FIRST DE-SATURATED THE ENTIRE IMAGE BY MOVING THEN SATURATION SLIDER TO ZERO. THEN, IN THE HUE AND SATURATION ADJUSTMENT LAYER IN THE LAYERS PALETTE, I SELECTED JUST THE EYES USING THE MAGIC-WAND SELECTION TOOL. I THEN USED A PAINTBRUSH (WITH THE FOREGROUND COLOR SET TO BLACK) TO PAINT BACK IN THE ORIGINAL COLORS IN JUST THE EYE AREAS. ANY TIME THAT YOU PAINT WITH BLACK IN THE SELECTED ADJUSTMENT LAYER YOU ARE EFFECTIVELY ERASING ANY CHANGES THAT WERE MADE—IN THIS CASE, RETURNING THE EYES TO THEIR ORIGINAL COLOR. A VERY EFFECTIVE TRICK.

▶ THIS SERIES OF IMAGES SHOWS HOW A GLOBAL ADJUSTMENT OF SATURATION CAN CHANGE AN IMAGE. THE FIRST SHOT WAS NORMALLY PROCESSED AND HAS HAD NO SATURATION APPLIED BECAUSE I FELT THAT WITH THE GREEN LAWN AND RED BRICK WALL, THERE WAS ENOUGH SATURATION ONCE I'D MADE A BASIC CURVES ADJUSTMENT TO SET CONTRAST AND EXPOSURE. IN THE SECOND AND THIRD IMAGES I BUMPED UP THE SATURATION BY 50% AND 80% RESPECTIVELY. THE COLOR IN THE LATTER OF THOSE TWO HAS CLEARLY REACHED POSTERIZATION-LIKE COLORING. FINALLY, IN THE LAST IMAGE, I SELECTED THE RED CHANNEL AND DE-SATURATED THAT BY 100%—THE GREEN AND BLUE CHANNELS WERE NOT AFFECTED.

◀ THE GRASS IN THIS SHOT SEEMED KIND OF PALE TO ME (AT LEAST IN COMPARISON TO MY MEMORY OF IT) AND SO I SELECTED THE YELLOW CHANNEL AND INCREASED THE SATURATION BY 10 PERCENT. INTERESTINGLY GREEN OBJECTS SEEM MORE AFFECTED BY CHANGES IN THE YELLOW CHANNEL THAN IN THE GREEN CHANNEL.

Creating False Colors

U P TO THIS POINT, ALMOST EVERY SENTENCE OF THIS BOOK HAS BEEN DEVOTED TO THE SINGULAR GOAL OF HELPING YOU RECOGNIZE, UNDERSTAND AND RECORD COLORS ACCURATELY AND WITH GREAT PREDICTABILITY.

But that's a very reality-based cosmos to be living in and, as we all know, photographers are people of boundless imagination and originality and sometimes a world of fabricated colors is a far more satisfying balm for artistic passion. Often it's just a lot more fun to step away from realism than to dwell within its confines. And, fortunately, image-editing software offers many opportunities to digress.

Indeed, when these programs first appeared on the market, a great deal of attention was paid to their surrealistic possibilities: you could hardly open a photo magazine without being assaulted by fish leaping over mountains and rainbows seeming to stream directly from the belly of a firefly. By and large we've all calmed down on that front, but creative exploration is still a worthwhile and fun aspect of image editing. You can, in fact, set out on flights

of color fancy by misusing almost any of the editing tools (which is, by the way, much easier to do once you understand how they are meant to be used), but there are a few that will scratch the itch much faster and with more wild abandon. Here are a few fun ways to re-invent the chromatic world:

HUE & SATURATION: The hue and saturation tool is a lot of fun to use experimentally. One trick is to select a particular color channel and then simply run the hue slider through all 360 degrees to see how it affects that particular color. The changes will only take place in that particular color (though there will be some contamination of other hues that contain that hue) and all of the other hues will remain largely untouched. By adjusting the saturation and lightness controls you can further manipulate the false coloring that you've created. On an addiction scale of one to 10, this is clearly a 10.

CURVES: A good "correct" curve typically has an "S" shape to it, but by completely distorting that shape (creating an "M" shape, for example) you can completely transform the correct colors of an image into an abstract and impressionistic palette. There is absolutely no predicting where a radical curves alteration will lead you but the images tend to have a very psychedelic look.

POSTERIZE: If you were a fan of rock music posters in the 1960s, you'll recognize this look. The posterization tool divides images into very distinct patches of color and tonality—creating a look very similar to a Peter Max poster. You can select from two to 255 divisions, but the effect is strongest when you set the value at 10 or lower. I rarely go above six divisions because above that the effect is less obvious and it begins to look more like a flaw than an intentional alteration.

GRADIENT MAPPING: Gradient maps are combinations of colors in various patterns that overlay your either your entire image or a selected portion of an image. There are both color and black and white gradient maps the color maps can be a fun way to add color to black and white images or to convert a color image to black and white. The tones are applied to your images as they appear in their thumbnails: with darker colors (in the upper left of each thumbnail map) going to the darker areas and the lighter colors (in the bottom right of each thumbnail) going to lighter tones, but you can also reverse the order. Creatively gradient maps are just fun to experiment with and are a fast way to create some interesting effects.

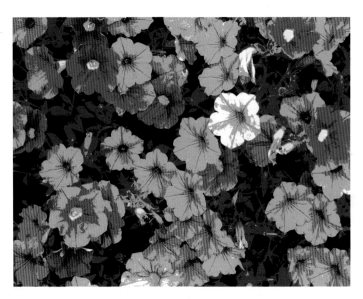

▲ POSTERIZATION GOT ITS NAME FROM THE FACT THAT IT RESEMBLES THE AUDACIOUS BLOCKS OF COLOR OFTEN USED BY POSTER ARTISTS LIKE PETER MAX. MAX GOT FAMOUS IN THE 1960S FOR HIS VERY GRAPHIC INTERPRETATIONS AND BOLD COLORS AND HAS BEEN PRODUCING SOME OF THE WORLD'S BEST POSTER ART FOR MORE THAN 40 YEARS.

◀ DECONSTRUCTING THE TONAL CURVE HAS A RADICAL EFFECT ON COLORS AND OFTEN PRODUCES SOME TRULY SATURATED AND UNEXPECTED COMBINATIONS. AS I EXPERIMENT WITH WILD CURVE ADJUSTMENTS I SAVE INTERESTING RESULTS CHANGING THE FILE NAME SLIGHTLY EACH TIME, THAT WAY I CAN COMPARE VARIOUS ATTEMPTS. I ALSO LEAVE THE LAYERS OPEN WHEN I SAVE ROUGH IMAGES SO THAT I CAN TWEAK THEM LATER FROM THE ORIGINAL CURVE. THE LAST SHOT IN THIS SERIES IS THE ORIGINAL IMAGE AS SHOT.

▶ THE FIRST PHOTO OF A WATER LILY IN THIS SEQUENCE IS THE IMAGE AS IT WAS SHOT AND PROCESSED NORMALLY. THE OTHER VARIATIONS WERE CREATED SIMPLY BY FIRST ADJUSTING THE HUE SLIDER TO ALTER THE HUES, AND THEN SECONDLY BY ADJUSTING THE SATURATION A SMALL AMOUNT (PRIMARILY TO KEEP THE COLORS IN THE CENTRAL PORTION OF THE BLOSSOM FROM BLOCKING UP). EACH NUDGE OF THE HUE SLIDER TAKES YOU FURTHER ALONG THE 360-DEGREES OF THE COLOR WHEEL LEAVING REALITY EVER FURTHER BEHIND.

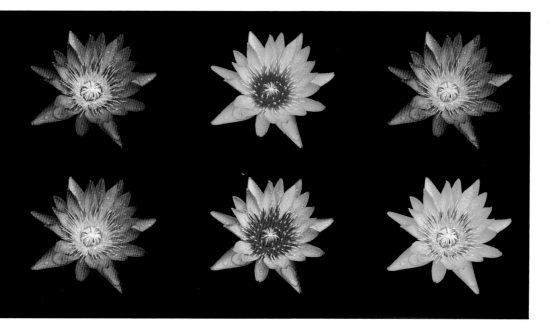

Index

Acknowledgments

One of the great joys of writing books about photography is that I get the chance to include the work of photographers that inspire me and that help me illustrate concepts in a particularly beautiful way. I would like to thank the following photographers for allowing me to include their superb work in this book. I hope that you will visit their sites and learn more about their work and their interesting careers:

Stephanie Albanese
www.whelpleyandalbanese.com

Derek Doeffinger

Rob Greebon
www.imagesfromtexas.com

Greg Hartford
www.acadiamagic.com

Steven Hyatt
www.stevenhyattphotography.com

Janet Loughrey
www.loughreyphoto.com

Jill Reger
www.jill-reger.artistwebsites.com

Jennica Reis
www.photojennica.com

Thanks also to my friends who let me use photos of them in this book and to my friends at Woodstock Records for allowing me to use photos of Professor Louie & the Crowmatix. www.woodstockrecords.com

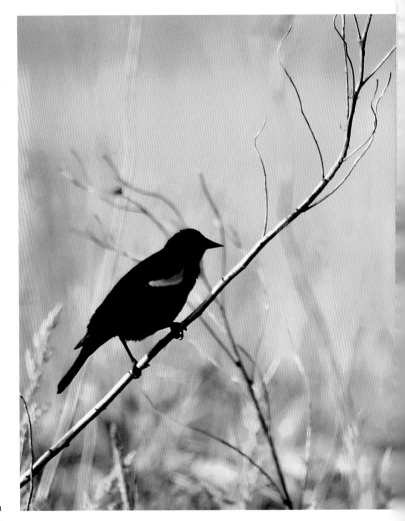